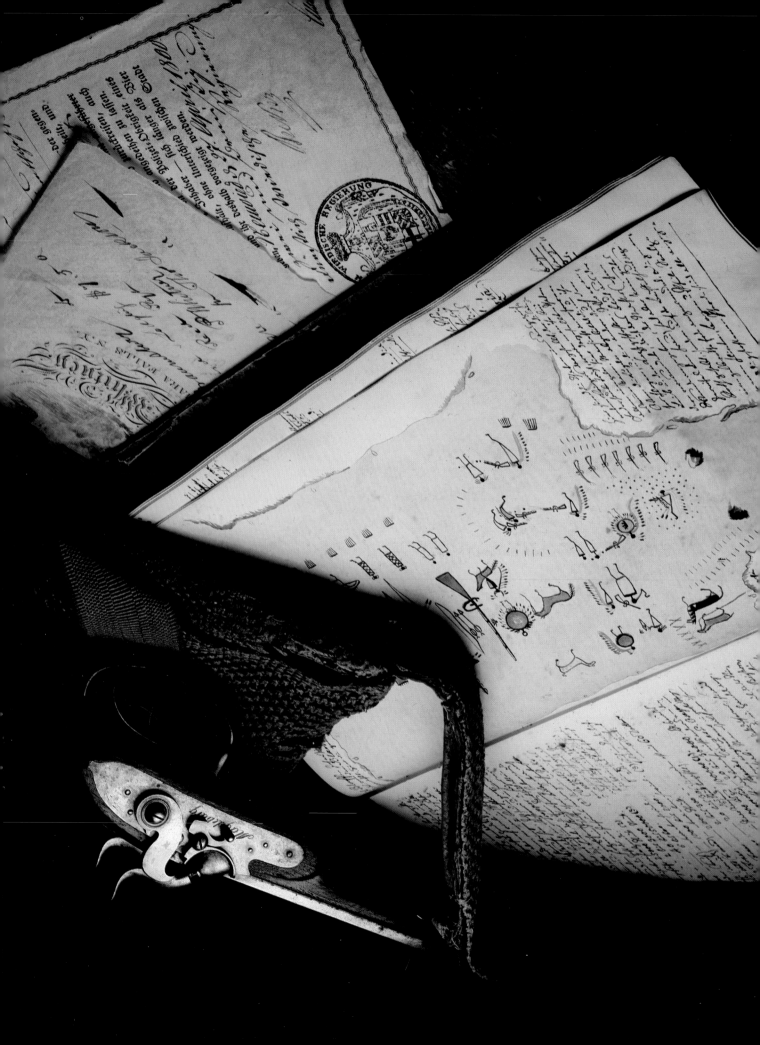

THE WEST AS ROMANTIC HORIZON

Selections from the Collection of
THE INTERNORTH ART FOUNDATION

THE WEST AS ROMANTIC HORIZON

BY WILLIAM H. GOETZMANN

& JOSEPH C. PORTER

WITH ARTISTS' BIOGRAPHIES

BY DAVID C. HUNT

Cover and detail on page 52
Karl Bodmer
Pehriska-Rupa (Two Ravens) Chief of the Hidatsa Dog Dancer
Watercolor on paper
The InterNorth Art Foundation/Joslyn Art Museum

Frontispiece
Maximilian's Diary (Vol. II), Rifle, Hunting Pouch, Passport,
and a Hotel Bill

Illustrations not otherwise credited have been taken from a
folio of Bodmer wood engravings and watercolor studies in
the collection of The InterNorth Art Foundation/Joslyn Art
Museum. Photography for the frontispiece is by Inflight
Studios.

First Edition

Published by
Center for Western Studies, Joslyn Art Museum
The InterNorth Art Foundation
Omaha, Nebraska

Distributed by
University of Nebraska Press
Lincoln, Nebraska and London, England

Editor and Publisher: Henry Flood Robert, Jr.
Copy Editors: Theodore W. James and Audrey S. Gryder
Designers: Lou and Julie Toffaletti
Photography: Lorran Meares
Composition: Alphatype *Olympus* by Compos-it, Inc.
Production: The Arts Publisher, Incorporated. Color
separations and lithography by W. M. Brown & Son, Inc.
Eight thousand soft cover; four thousand casebound. Paper
stock is Wedgewood Gloss.

Library of Congress Cataloging in Publication Data

Goetzmann, William H.
 The West as romantic horizon.
 Includes index.
 1. Art, American—Exhibitions. 2. West (U.S.) in art—
Exhibitions. 3. InterNorth Art Foundation—Art collec-
tions—Exhibitions. 4. Joslyn Art Museum—Exhibitions.
I. Porter, Joseph C., 1946- . II. Hunt, David C., 1935- .
III. Joslyn Art Museum. IV. InterNorth Art Foundation.
V. Title.
N8214.5.U6G63 704.9′ 49978 81-12424
ISBN 0-936364-04-1 (hard cover) AACR2
ISBN 0-936364-05-X (soft cover)

TABLE OF CONTENTS

FOREWORD

Some twenty years ago, Northern Natural Gas, the company which preceded InterNorth, Inc., purchased a unique and beautiful record of a journey taken when the West was new. And with it the Company began a journey of its own into the art and history of its home area, the Great Plains and Rocky Mountains.

Since acquiring its first art collection, InterNorth's commitment has grown. This catalogue contains an introductory sampling of the three InterNorth collections—the Maximilian-Bodmer, the Alfred Jacob Miller, and the Artists of the Western Frontier. They may be found at the Joslyn Art Museum in Omaha, Nebraska.

During the nineteenth century, Americans pushed westward onto the prairies and into the mountains toward the hope of a fresh start, free land, and new horizons. Such journeys also promised rewards for the daring and talented artists who ventured west—a rich bounty of dazzling colors splashed across wide, open spaces that encompassed one of the great American adventures.

Their paintings, drawings, and statues sparked the American imagination because they provided the first views of the Western frontier. Those artists left us an invaluable record of the now vanished wilderness. In the end, they created a truly American art which was as vivid and enduring as the place which brought it forth.

Together, The InterNorth Art Foundation collections form a concise summary of the Western frontier from its early exploration to the 20th century. They can be viewed as depictions of the life of the Indians, explorers, and pioneers, appreciated as individual works of lasting value, and considered together as an epoch in American art.

To further that end, InterNorth is providing for the establishment of the Center for Western Studies at the Joslyn Art Museum in Omaha to serve those engaged in the scholarly pursuit of the history and art of the early American West.

Many corporate foundations own art collections, each for reasons of its own. The InterNorth Art Foundation collections are devoted to the time, place, and people of the West in the firm conviction that they were and are the crucible of the nation. The collections are held in trust that a nation may know its history as it looks to the future.

Sam F. Segnar
President and Chief Executive Officer
InterNorth, Inc.

INTRODUCTION

The West as Romantic Horizon is the result of a unique relationship between the Joslyn Art Museum and The InterNorth Art Foundation. Nearly every significant artist of the Western frontier is included in The InterNorth art collections, and the Foundation is dedicated to broadening the horizons of scholarship and interpretation concerning the Western frontier.

The West as Romantic Horizon is an introduction to the InterNorth collections, but also provides fresh insight into the art of the West. By viewing the art of Western America in the context of major historical trends in Europe and America, *The West as Romantic Horizon* offers a new interpretation of Western art. The essays by William H. Goetzmann and Joseph C. Porter, and the artists' biographies by David C. Hunt are based on artists represented in the InterNorth collections, although their points can be extended to the entire body of art of the American frontier. Where some have suggested that Western American art was derivative, Professor Goetzmann shows that the opposite was the case, demonstrating that Western art and artists helped to shape nineteenth century romanticism in the United States and Europe. He also notes the dual role of the artists as participant in and witness to the vanishing frontier. Mr. Hunt deals with the individual artists who are represented in the InterNorth collections, and Dr. Porter demonstrates how this body of art has contributed and still makes a vital contribution to the understanding of the American past.

This book for the first time identifies all of the artists in InterNorth's three collections. It also contains complete biographical and provenance entries on all of the works in the Artists of the Western Frontier collection, therefore serving as a raisonné to this collection. Complete raisonné entries of the Maximilian-Bodmer and Alfred Jacob Miller collections will be included in forthcoming publications.

One of The InterNorth Art Foundation's three collections is the Maximilian-Bodmer collection, a product of the expedition of Prince Maximilian of Wied-Neuwied in North America from 1832-34. It consists of original journals, diaries, aquatints, and correspondence from the journey in addition to 427 watercolors and sketches by the artist Karl Bodmer. An unmatched written and visual record of early nineteenth century America, these documents and sketches fell into obscurity after Maximilian's death, and were re-discovered in the archives of Neuwied Castle near Coblenz at the end of World War II. Initially they were brought to this country in 1953 under the auspices of the Smithsonian Institution. Recognizing its paramount historic and artistic significance, InterNorth purchased the Maximilian-Bodmer collection in 1962, and placed it on permanent loan to the Joslyn Art Museum.

In 1964 the interest in Bodmer spurred InterNorth to purchase a collection of beautifully rendered watercolors by Alfred Jacob Miller, a Baltimore artist. In 1837 Miller accompanied Sir

William Drummond Stewart across the Northern Plains to the Wind River region. Miller's sketches and watercolors depicted the Rocky Mountain fur trade at its peak, and his portrayals of Indians and landscapes captured scenes that soon changed forever. Similar to the documentary and artistic efforts of Bodmer and Maximilian, Miller's original watercolors and sketches were forgotten for decades. Historians Bernard DeVoto, Mae Reed Porter, and Marvin C. Ross perceived the great value of Miller's work, and they brought Miller the prominence that he deserved. Today the Miller collection is at the Joslyn Art Museum, where the art of Karl Bodmer and Alfred Jacob Miller continues to reveal much about the American frontier that vanished so long ago.

The third InterNorth collection, acquired in 1967, is the Artists of the Western Frontier consisting of eighty-six works by thirty-seven artists. This series adds varied chronological, regional, and artistic dimensions to the Maximilian-Bodmer and Alfred Jacob Miller collections. George Catlin, Albert Bierstadt, Frederic Remington, and Charles M. Russell are represented in Artists of the Western Frontier as well as lesser known but important artists like Seth Eastman, John Mix Stanley, and Charles Deas.

Henry Flood Robert, Jr.
Director
Joslyn Art Museum

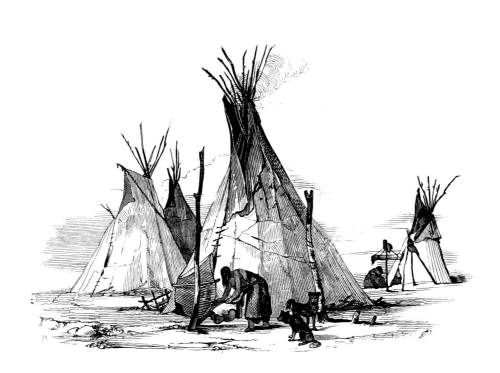

THE WEST AS ROMANTIC HORIZON

BY WILLIAM H. GOETZMANN

The nineteenth century's artistic representation of the American West constitutes an almost unmatched adventure in exploration and discovery. When the artists of the American West crossed the infinite prairies, made their way up the endless Missouri, penetrated the vastness of the Rockies, and participated in one of the largest mass migrations in world history, they were stunned by the "shock of the new." They discovered a romantic horizon that offered endless possibilities for their imaginations already fired by the Romantic Movement in Europe where many of them were trained or from which they took their cue. Long dismissed as documentary and derivative, the art produced by these explorers of the Romantic Horizon, on the contrary, represents one of the clearest examples of the confrontation of the collective romantic imagination with new experience in nature. They did not have to conjure up an Arcadian past out of antiquity. It was there before them without benefit of Virgil or Roman shepherds. They did not have to reimagine the Apollo Belvedere, for he stood before them in paint and feathers. They did not have to envision a world before the Fall for it stretched all around them in the pristine work of the Creator. The moment in time—when time, in fact, stood still or even moved backward to an age of innocence—was too good to be true. It was too good to last, and most of the artist-explorers of the Romantic Horizon knew it. In all of their work, it seems apparent that they knew that however fresh and novel and sublime the scene before them, it was, in reality, only a vision of a fast-vanishing America which they were somehow privileged to witness.

There have been as many definitions of Romanticism as there have been romantics, but it is important at the outset to be clear about its nature as it applies directly to the artists of the American West. Essentially, Romanticism was an attempt to depart from the norms of rational analysis of the world. It sought truth and meaning in the emotions and individual inspiration through which it was thought that one could penetrate beyond the apparition of nature to a more profound and transcendent truth. Louis Agassiz, the great romantic scientist, believed nature to be the "thoughts of the Creator." The poet Ralph Waldo Emerson wrote in a famous passage, "Standing on the bare ground—my head bathed by the blithe air and uplifted into infinite space—all mean egotism vanishes. I become a transparent eyeball; I am nothing; I see all; the currents of the Universal Being circulate through me; I am part or parcel of God."[1] The Romantic thus sought meaning in the direct, very personal experience of nature.

But the romantic sensibility never stood still. As befits an age that rediscovered time and history and evolution, it grew and evolved through the nineteenth century. Certain programmed attitudes became characteristic of the romantic observer at different points in time. These changing attitudes or sensibilities are apparent in the works of the InterNorth Collections. They are variously: the pastoral, elegaic vision, the Ruskinian sublime image so characteristic of the great virtuoso, the melodramatic and theatrical, the epic heroic, and the nostalgic.[2] All of these attitudes were informed by the sense of history or more accurately the historical process, seen somehow as a whole, which becomes the means of ordering that very special experience that comes from within. Thus one way of understanding the artists of the American West is to see them as representative of these various attitudes, stances, perceptions, or stages of sensibility. In this way they become part of the mainstream of Euro-American thought and provide unique insights into it. These insights have the incalculable advantage of

having been made at the moment of discovery—the discovery of a new horizon upon which the artist in his excitement ascertained the fresh meaning of age-old truth.

In no other painter is the pastoral elegaic so well represented as in the works of the young Baltimore painter Alfred Jacob Miller. Reputedly a pupil of Thomas Sully, Miller also studied in Paris and was influenced by Delacroix. He also traveled to Italy and to England where works as various as the Parthenon friezes and the misty landscapes of Turner made a lasting impression on him. He was thus well steeped in the romanticism of his time when he was discovered in a New Orleans studio by Captain William Drummond Stewart of Murthly Castle, Scotland. Stewart, a British sportsman who had spent years hunting with the mountain men, employed Miller to accompany him on one last ramble through the Rockies and to record the wild, free life of the mountain men before onrushing civilization overtook them. Thus in the summer of 1837, Miller joined Stewart's great caravan to the Rockies where he undertook by means of brush and pen to immortalize the beaver trappers and their Indian counterparts.

Miller was no ethnologist; rather, he succeeded in capturing a vision of the pastoral drama inherent in the early days of Rocky Mountain life. His sketches, gouaches, and watercolors depicted with a spontaneous freshness, typical scenes of the trapper's life or exotic views of the Indian, at home, on the hunt, or at war. His paintings are full of life, swirling and dynamic in composition, echoing in this the work of Delacroix but with far less artificiality. He did not have to reinterpret old legends, the drama was there before him. Characteristically he painted the redman on the wild chase after buffalo, sometimes driving thousands over cliffs in "buffalo jumps," a practice that goes as far back as the prehistoric hunters. At other times he portrayed them as the superb horsemen they were, racing across the prairie among the herds of great shaggy beasts and then howling in triumph after the kill. In most of his pictures, he somehow catches the sounds as well as the sights of the drama unfolding before him. This is apparent as well in his portrayals of Stewart's cavalcade moving out across the prairie, his oft-painted scenes of the Rocky Mountain rendezvous and his depiction of the teeming life around Fort Laramie—which is now no more, except in historical restoration.

In his tableaux of the mountain men around their campfire, one can almost hear their voices swapping tall tales. By the same token, one can feel the cold silence of dawn in his classic view of a mountain man planting his beaver traps, or the solitary grandeur of a lake scarcely ever seen by white men, high up in the Wind River Mountains. There is humor, wit, tragedy, and dignity in his genre scenes. Clearly, Miller caught the spirit of life in the Rockies as Stewart and the others felt it, and as George Frederick Ruxton, Washington Irving, and Stewart himself described it in literary works.[3] The overwhelming impact of Miller's art is a dramatic, yet loving view of a whole way of life that, at the same time, makes clear that it is transitory, passing, and will never come again. Without sentimentalizing, he evokes strong Byronic emotions in his candid survey of a horizon of human existence. That is the special quality of his

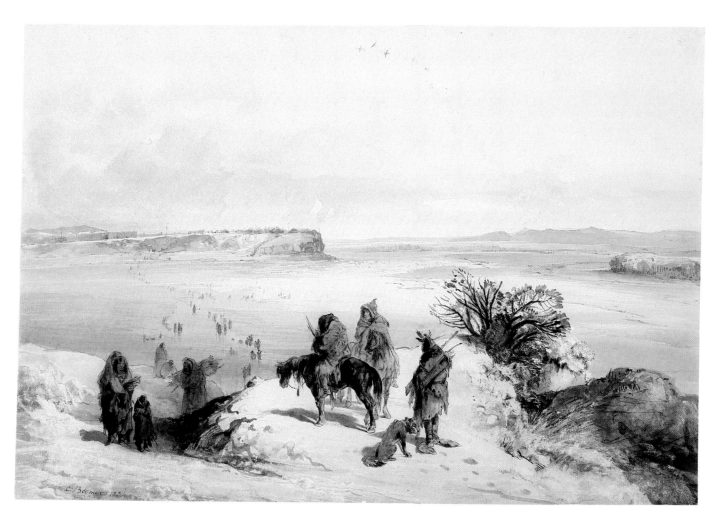

1. KARL BODMER, *View of the Mandan Village Mih-Tutta-Hang-Kush*

work, comprehensive yet candid, down to earth yet bearing a certain elegance, fresh yet hardly naive. To assess the quality of this achievement, one must ask where in the entire corpus of the Euro-American tradition have we ever seen its like? Individual works may certainly have surpassed those of Miller but as a series of linked images his paintings stand almost alone as an achievement.[4] Unfortunately, Stewart, his patron, knew this and so did many others of his day. Consequently, Miller spent much of the rest of his life repainting these memorable scenes, first in more finished watercolors, then in oils to be hung in MacBeth's seat, Murthly Castle, and then to adorn what came to be the Walters Art Gallery in Baltimore. As he repeated the scenes and translated them into oil, Miller's paintings became ever more stylized. Even his paintings of the buffalo hunt became icons rather than an experience. They became clichés in the work of those who followed after him.

One other interesting painter of the period who deserves mention is William Tylee Ranney. Born in Middletown, Connecticut, Ranney was learning to become a painter in Brooklyn, New York, when he became inspired by the siege of the Alamo. A true romantic, he rushed halfway across the continent to join the Texan Army just in time to be present at the climactic battle of San Jacinto. The experience stuck with him so powerfully that, according to one authority, he made his New York studio resemble "a pioneer's cabin or a border chieftain's hut."[5] Like Charles Deas, an artist who wandered over the western prairie in the 1840s dressed like a "fur hunter," Ranney, in true romantic fashion, affected a "persona," that of the plainsman, though he had spent less than one year in the West. Deas, who painted only a very few wildly dramatic works, died in an asylum in St. Louis.[6] Ranney, who also died young, painted a number of scenes depicting the West as a place of pastoral adventure. His moods fluctuated however. This can be seen in two paintings by Ranney in this collection. One, *Hunting Wild Horses,* is full of the action inherent in the capture of wild horses out on the prairie. Wild-eyed horses and riders form a swirling vortex around the captured horse who is connected to the vortex by the taut lasso. The other picture, *The Trappers,* portrays two trappers headed for the mountains in rather stately fashion engaged in casual conversation. Ranney, who possessed a genuine talent for genre painting, nonetheless had an uncertain vision of the West.

This was not at all true of his great contemporaries George Catlin and Karl Bodmer. They combined a romantic vision of nature with a scientific and ethnological approach to its description. Yet, though they traversed the same upper Missouri country at nearly the same time, and even painted the same scenes and subjects, there were significant differences between them. Catlin was a zealot on behalf of the Indian whom he believed was doomed to vanish forever. He was also largely self-trained and hasty in his work. Bodmer, a young Swiss protégé of Prince Maximilian of Wied-Neuwied near Coblenz on the Rhine River, had been trained as an engraver. Even at the comparatively youthful age of twenty-three, he was an accomplished painter when he arrived in America. Moreover, thanks to the constant guidance of Maximilian, who was in turn himself a protégé of the greatest naturalist of the age, Alexander von Humboldt, Bodmer also brought a trained ethnologist's eye to his work. Both men, Catlin and Bodmer, whether acting as historian, ethnologist, reformer, or artist, were conditioned by the romantic paradigm of the day, the one captivated perhaps more by the freshness of his subjects, the other by their incredible and mysterious exoticism.

Though few have made much of it, one important key to Catlin's work was the years he spent in Philadelphia as a young portraitist. There, in that city's important naturalist circle, the artist and the scientist performed interchangeable functions, since the naturalist frequently made his own drawings of specimens in the field; Catlin absorbed this dual vision. Philadelphia after all was the home of the illustrious Peale family, one of whose members, Titian, had been among the first Americans to paint the flora, fauna, and even the Indians of the Great Plains. The Peale Museum was, in effect, the national museum.

In Philadelphia such illustrious artist-naturalists as William Bartram, George Ord, Alexander Wilson, and John James Audubon had practiced or were practicing their curious dual roles. The list of such men is very long, but the important thing to remember is that in the early nineteenth century, since field collecting and classification were the major forms of American science and mere words would not suffice for accurate description, the artist was the scientist and vice versa. Thus Catlin must be considered a key figure in the emergence of romantic science. The same applies to Bodmer who came from a similar, even more developed background in Europe. As artists these two men pursued knowledge in the comprehensive, rationalized tradition of the eighteenth century Enlightenment, but their contact with the exotic in America—the figure on the romantic horizon—impelled them to value the richness and quality of their subjects and this in turn evoked their deepest emotions.

Catlin dated his first real interest in the Indians to the visit of a delegation of chiefs en route to Washington. He was profoundly taken by their "silent and stoic dignity." But he was even more taken by their exotic appearance as they "strutted about the city for a few days, wrapped in their pictured robes, with their brows plumed with the quills of the war-eagle, attracting the gaze and admiration of all who beheld them."[7] This determined his life's work. As he put it, "the history and customs of such a people, preserved by pictorial illustrations, are themes worthy the lifetime of one man, and nothing short of the loss of my life, shall prevent me from visiting their country and of becoming their historian."[8]

Thus armed with this grandiose and romantic plan, Catlin set out from St. Louis in 1832 and traveled far up the Missouri River aboard the steamer *Yellowstone* on its maiden voyage. At first he painted portraits of famous chiefs. Then he shifted his attention to rituals, dances, feasts, customs, everyday village activities, even specific articles of clothing or weaponry, and most of all, the hunt and the chase. His pictures of the buffalo hunt across the prairies became the primary western iconographic image of the century—immortalized by imitation in Currier and Ives prints distributed in the hundreds of thousands.

Before Catlin concluded his long career, he had captured on canvas virtually every aspect of Indian life in both North and South America, tribe by tribe, custom by custom. He had traversed the endless prairies and the mountains of North America and later the jungles of South America as well. By 1840 alone he had visited forty-eight different tribes and made some 500 paintings. By the end of his career, he estimated that he had visited 128 tribes in the Western Hemisphere.[9] He had been lionized in England and France and personally praised and encouraged by the great Humboldt himself. He had created the first wild west show that captivated all of Europe. Catlin was the first American to advocate the creation of national wilderness parks, or as he put it in 1832, "a *nation's Park,* [emphasis in original] containing man and beast, all in the wild and freshness of their nature's beauty."[10]

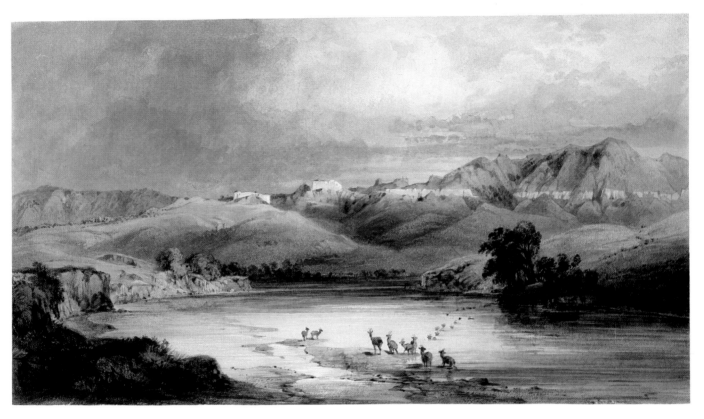

5. KARL BODMER, *The White Castles on the Missouri*

Karl Bodmer had nothing like Catlin's spectacular, many-sided career, but he and Prince Maximilian were impelled by the same kind of Humboldtian scientific vision as the flamboyant American. The Prince had actually followed in Humboldt's footsteps and explored the Amazon regions of South America before he ever came to the United States.[11] He had published a careful account of his expedition, but his illustrations fell so far short of the exotic views expected in Europe that even Humboldt himself advised the Prince to get a first-rate artist for his next global adventure. Maximilian did just that when he selected Karl Bodmer.

Bodmer was only twenty-three years old when he accompanied Maximilian to America but he already had considerable experience as a draftsman and engraver at his uncle's shop in Zurich. In addition he had studied with the artist Cornu in Paris. There he quite clearly absorbed the style of the French romantic-classicists, Ingres and David, as well as that of Cornu.[12] The sense of sculptural solidity, color massing, and crisp, clean lines is everywhere apparent in his finished work. Just as science was moving from the mathematized and abstract to the concrete and the exotic specimen, so too was painting in transition and nothing illustrates this better than the French school of the Napoleonic Era. Thus Bodmer, when he journeyed to the western frontier was "programmed" from at least two mainstreams of romanticism, one stemming from Humboldtian science and the other from the Paris salons.

Two further occasions enhanced Bodmer's vision of the West. When he and the Prince reached Philadelphia, they immediately made contact with the same naturalist circle that had conditioned Catlin.[13] Indeed, Bodmer had extensive discussions with Titian Peale and Samuel Seymour, the artists who accompanied Major Stephen H. Long's expedition across the Great Plains to the Rockies in 1819-20. Peale and Seymour must certainly have advised the young Swiss artist what to look for in the Missouri River country which they knew well as far west as present-day Omaha. Beyond that he was on his own except for the descriptions in the Lewis and Clark journals (based on their famous expedition of 1803-06) and some few specimens to be found in the Peale Museum. In St. Louis, however, at the home of Major Benjamin O'Fallon, he was able to study a collection of George Catlin's paintings from the Upper Missouri, made only the year before. Bodmer's training for the West was thus a continuous learning experience in the basics of romantic ethnography as it related to the artist. When he arrived back in St. Louis after reaching Fort McKenzie far up the Missouri, Bodmer once again had an opportunity to compare his work with that of Catlin and possibly correct for error.[14] Though there is no evidence of explicit rivalry between the two men, certainly Bodmer knew before he ever started upriver into the Indian country that he faced formidable artistic competition. He was, of course, greatly aided by Catlin's work, and he had a tremendous advantage in that he had better equipment, more leisure time to paint, and the highly intelligent guidance of Prince Maximilian as to *what* to paint, especially as regards ethnographic detail. Consequently, Bodmer was more precise than Catlin. To aid him in his work, he also had the Prince's rapidly expanding collection of

Indian costumes and artifacts. Indeed there is evidence, especially in his portraiture, that Bodmer attempted to capture the faces first and then he filled in the details of the costumes later.

This is, of course, not the place to chronicle Bodmer's trip up the Missouri from April of 1833 to April of 1834. He traveled far up the river aboard the steamers *Yellowstone* and *Assiniboin,* and then by keelboat to Fort McKenzie at the junction of the Marias and Missouri Rivers in present-day Montana. This was the last American outpost in the Upper Missouri country. It rested in the heart of the Blackfoot country whose fierce warriors had long bitterly resisted the intrusion of the white man. Along the way, Bodmer and the Prince made contact with at least twenty Indian tribes including the Blackfeet, Assiniboin, Cree, Mandan, Hidatsa, Arikara, and Sioux. They came to know many of these Indians well. In fact, Bodmer's painting so fascinated Mato-Tope, a chief of the Mandans, whom Catlin had also painted, that the chief demanded brush and paints and proceeded in imitation of the two white men to enhance his own considerable talents as an artist. Fortunately, many of these works survive today. Mato-Tope and most of the Mandans died in a smallpox epidemic within four years after Bodmer and Maximilian passed through their village.

How can one characterize the profusion of Bodmer's incredible work in brief compass? For one thing, he thoroughly documented every aspect of the expedition. He captured a multitude of ethnological detail with a discernment and exactitude that has perhaps never been matched. The Prince saw to that. He also captured the sense of the Missouri River and the fantastic landforms that dominated its upper reaches. He painted the river with its sandbars and snags and crumbling shorelines. He caught the strangely sculpted rock formations far upriver with their volcanic dikes and white isolated table mountains that resembled ancient castles and versions of the Great Wall of China. He painted vast panoramas, and he also caught the river country and its people in all weather conditions. Indeed his painting of Indians crossing the iced-over river near Fort Clark is one of his most striking works. It was not easy for an artist to be a "plein air" painter in sub-zero weather.

Most of all, however, Bodmer depicted the Indian as no other, save Catlin, has ever done. Both men were fortunate to arrive in the West before the Euro-American acculturation process had fully overwhelmed traditional Native American life, though paintings like that of Addih-Hiddish, a Hidatsa chief, clad in what looks like a military helmet and a Great White Father medal, clearly show that this process had begun. Still, Bodmer's portraits of individual Indians, most of them full length to capture the effect of their costumes, are surprises even today. They startle in their freshness and overwhelm us with a sense of the Plains Indians' pride and exotic elegance. These are not the snapshot views of Alfred Jacob Miller or even of the hurried Catlin. Still, stately, and hauntingly eternal, the black, blue, red, and tatooed faces stare off proudly into eternity. Here indeed was "the noble savage," the "lord of creation," people of an archaic past that went far beyond memory and even beyond myth suddenly resurrected not as symbols but as flesh and blood people who still walked the earth, just over the romantic horizon.

Their dances and ceremonies, the streets of their villages, and the mysterious interiors of their huts and lodges were not casually presented by Bodmer. They conjured up pre-history itself, something far older than even the Greeks who were thought to have begun time. Bodmer

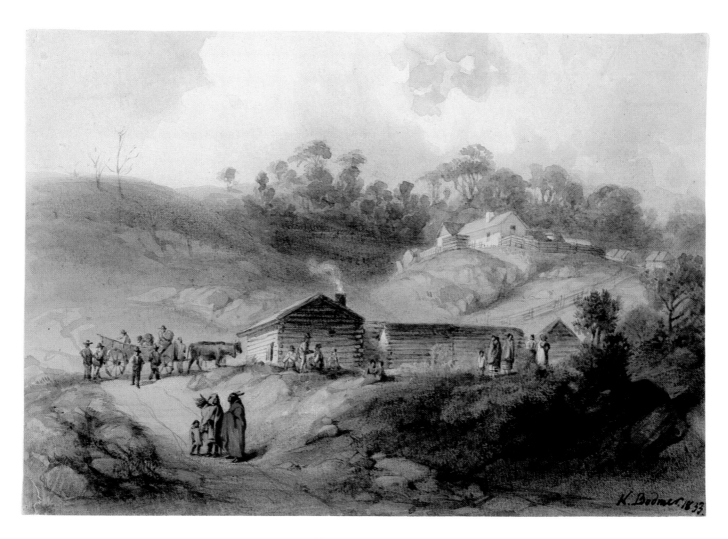

6. KARL BODMER, *Bellevue Agency—Post of Major Daugherty*

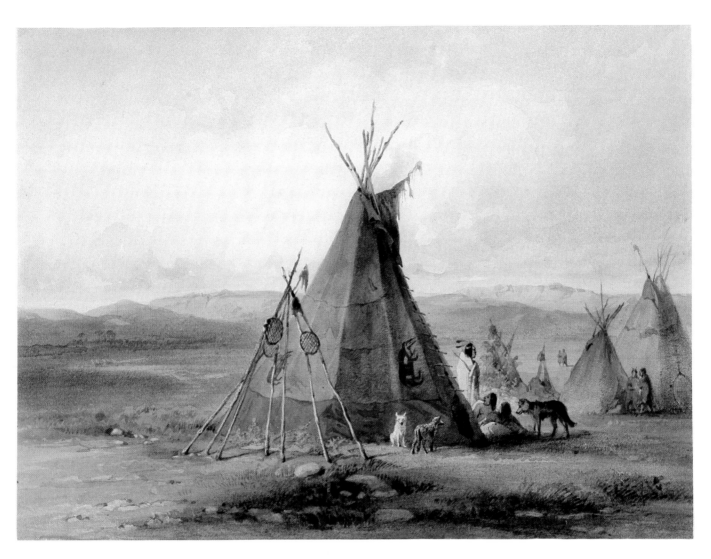

20. KARL BODMER, *Leather Tent of the Dakota Tribe and Its Inhabitants*

revealed, in a sense, a forgotten stage of history to a history-conscious age with a solemnity appropriate to that momentous discovery. His paintings of the Buffalo Dance of the Mandan and the Scalp Dance of the Hidatsa are paganism brought to a moment of solemn glory as if one had preceded Caesar across the Danube and stood with Orgetorix and the ancient Saxons before recorded time began. Both the German scholar Maximilian and the painter Karl Bodmer must certainly have been aware of this, and Bodmer's classical grouping of the figures indicates that these occasions, full of mystery and terror in their barbaric sights and sounds, were also recognized by him as being of universal meaning. As an artist, Bodmer was not after the documentary only, or the merely picturesque, he was reaching for that transcendent reality that lies at the very heart of Romanticism.

There would, of course, be many others who painted Native Americans after Catlin and Bodmer, but none that reached their intensity and profundity. Most would be confined to the documentary, the picturesque, and the pastoral.

Captain Seth Eastman, a military topographer and for a time drawing instructor at West Point, sketched and painted hundreds of Indian scenes from Fort Snelling in Minnesota to the plains of Texas. His forte was the accurate representation of everyday Indian life, and, as such, his work is an invaluable visual record of the redman's varied cultures. This is especially true of the 300 works that Eastman executed for Henry Rowe Schoolcraft's massive six-volume compendium on the Indians of North America.[15] As art, however, Eastman's work was picturesque rather than profound, and it could be contrived and anecdotal as in *Indian on the Lookout.* Still he followed faithfully, if not self-consciously, in the "snapshot" tradition of Alfred Jacob Miller.

John Mix Stanley, a self-taught painter from Detroit, made a career out of the pastoral-picturesque mode. One of his paintings from the great Pacific Railroad Surveys of 1853, *Crossing the Milk River,* is anecdotal and parallels the work of another artist on the expedition, Private Gustavus Sohon, who became well known for his paintings of Indians of the far Northwest. Stanley's *On the Warpath* is pure melodrama, while his paintings of *Young Chief Uncas* and *Snake in the Grass,* executed in the late 1860s in a studio in Buffalo, New York, fade into sentimental nostalgia. The young Uncas appears sad, as if he already knew the tragic fate of the noble Mohicans of whom he was to be the last. These paintings are of course not a fair sample of Stanley's widely varied work, most of which was destroyed in a fire at the Smithsonian Institution in 1865. But they do indicate what was happening to the pastoral mode in Western painting as the nineteenth century wore on. It was becoming either merely picturesque and anecdotal, or, as the professional illustrators for mass circulation magazines took over, melodramatic and unabashedly sentimental.

Beginning with his first trip West in 1859, Albert Bierstadt brought an entirely different kind of romantic sensibility to the portrayal of the West. Trained in Dusseldorf, Germany, where he studied with Emmanuel Leutze (of *Washington Crossing the Delaware* fame) and with an American friend, Worthington Whittredge, Bierstadt acquired the mystical affinity for land-scape so characteristic of that school.[16] His earlier paintings were pastoral and sought the quieter contrasts of light and shade. But then he crossed over the Alps to Italy, and the experience seems to have attached him forever to the romantic convention so well described by

Marjorie Nicolson as "mountain gloom, mountain glory,"[17] Whenever possible, Bierstadt reached for Wagnerian effects in his paintings which were often large and grandiose— comparable to Wagner's operas. But seldom noticed in Bierstadt's paintings was his habitual use of Italian light which also captivated him as did the sense of the Italian Piedmont and such beauty spots as Lake Como. Thus, when he went to the American West, Bierstadt had a rich stock of European images in his memory. He took along a daguerreotype apparatus to enable him to capture, as it were, the "real west," but he soon abandoned any pretense at documentary art.

Rather, Bierstadt sought a whole ensemble of emotional effects which he drew from the towering mountain landscapes and the incredible western sky. His works were atmospheric in the extreme as the landscapes in this collection indicate. But at base was his sense of wonder at the work of the Creator. It was invariably sublime, and far beyond the grasp of ordinary man. Only God and a virtuoso like Bierstadt could comprehend its majesty and at the same time its essential sweetness. There was no blood and thunder, nor was there much real tragedy in Bierstadt's work. The closest he came to this was his depiction of a buffalo killed in slow stages by his companions in 1863. *Bison with Coyotes* portrays the poor beast slowly expiring with a kind of resigned grandeur not unlike that of a mountain. Instead of the actual hunters, Bierstadt put scavenging coyotes in his picture which is thus highly symbolic.[18] Bierstadt never really forgot the death of the buffalo—perhaps he associated himself with the majestic beast. Near the end of his life, he painted one of his iconographic masterpieces, *The Last of the Buffalo,* depicting one of the last Indians slaying one of the last buffalo amid a litter of skulls and carcasses on a broad plain with his beloved Wind River Mountains looking down on the scene like some indifferent god.[19] Thus Bierstadt was well aware of the fact that the Old West was passing away before his eyes. But he was intent upon pointing up not only the transient aspects of the West, but also the permanent in all its sublime, ineffable glory of mountain, plain, meadow and sky, even the relentless crashing tides of the Pacific Ocean.

Other painters of the post-Civil War era fixed on this theme of the West as grand and sublime—the work of an all-powerful Creator. The names of Thomas Moran, Sanford Robinson Gifford, Gilbert Munger, Thomas Hill, and William Keith come to mind. But Bierstadt's old teacher and companion, the American Worthington Whittredge, expressed many of these same emotions in a different way. Despite his Dusseldorf background and his familiarity with the Alps, Whittredge concentrated on the sublime, endless infinitude of the prairie and sky. This, rather than the mountains, might be considered uniquely American. Few places in the world had such endless prairies and such burning light that made the horizon itself almost a mirage. Though far less theatrical than Bierstadt, and certainly far less popular, Whittredge also was struck by the awesome quality of western space.

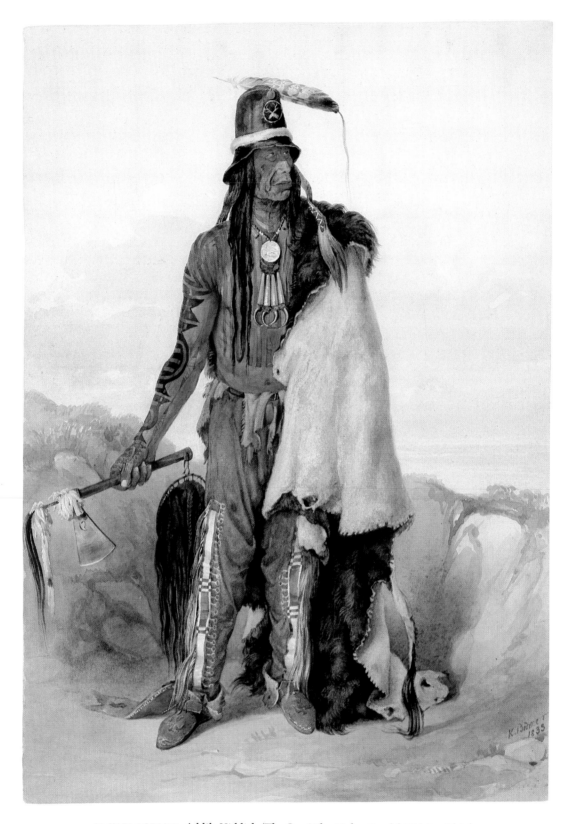

15. KARL BODMER, *Addih-Hiddish (The One Who Makes Roads) Hidatsa Chief*

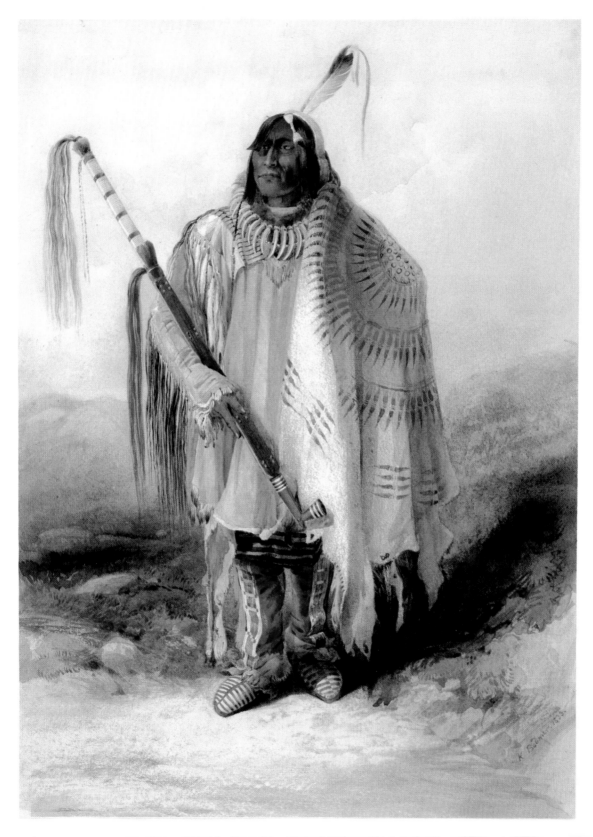

10. KARL BODMER, *Pehriska-Rupa (Two Ravens) Hidatsa Chief on the Upper Missouri*

Thus by the 1880s, the romantic's view of the West had reached a kind of apogee of grandeur. The artist as virtuoso had summoned, in effect, a mighty orchestra to sound its glories in resounding chords and symphonies—even operas. In looking at Bierstadt's paintings, it is virtually impossible not to hear this soaring music in all its grandiose organ-tone climaxes.

Other artists, however, turned not to symphonic or operatic themes but rather to theatricality, melodrama and finally, to nostalgic sentimentalism. This was the stock-in-trade of a whole host of illustrators who went West after the Civil War. The best of these was one of Walter Camp's football players from Yale, Frederic Remington.

When he went to Montana in 1881, Remington could not foresee making his living as an artist. For nearly five years, he roamed about the West from Montana to Kansas to Arizona searching for a way to carve out a fortune from the frontier. As early as 1882, he discovered that there was interest in the sketches he made out West when *Harper's Weekly* purchased one of them. By the late 1880s, he was well launched on a career as America's most popular illustrator. As one authority points out, in the year 1888 sixty-four of his works were reproduced in *The Century Magazine*, fifty-four in *Harper's Weekly*, thirty-two in *Outing*, and twenty-seven in *Youth's Companion*.[20] His work appealed to the great mass of American people because he portrayed, in the most dramatic terms possible, the saga of the old frontier which was on the verge of passing away forever. The key to both Remington's illustrations and his paintings was that they invariably told a story. They were exciting narratives, sagas on canvas that appealed to American pride in the conquest of the frontier in much the same way the ancient epics of Europe told the heroic story of a people. Remington was late-nineteenth century America's mythmaker.

His stories of the frontier were always composed of heroic men and their animals who struggled against not only one another in a Darwinian fight for survival of the fittest, but against nature itself. In burning deserts, wintry blizzards, or blinding lightning storms, Remington's subjects struggled heroically—never giving up. This sense of heroic struggle made for excellent theater, and very often Remington's canvases resembled Buffalo Bill's Wild West Show. Everything was foreground and foreground action. The landscape was mere backdrop, in theatrical terms, to the actions and predicaments of the main characters. Remington once wrote, "I paint for boys, boys from ten to seventy."[21] And because he was meticulously faithful to costumes and equipment, few suspected that he was self-consciously painting an alternate reality that existed in his own romantic mind. From his own day to the present, people go to Remington's paintings for a view of the West "as it really was." His plausibility was his great talent just as it is with a great novelist. One could and still can enter Remington's world and quite easily suspend disbelief.

The works of Remington in this collection portray some of the artist's heroes. Because he loved horses, cavalry, and cavalrymen, he even viewed the German Uhlan as one of this special fraternity of heroes. And yet quite clearly, Remington saw the Uhlan as slightly foppish and in no real sense comparable to the rugged American Plains soldier. He wrote as much when he went to Germany to observe cavalry maneuvers in 1892.[22] His real heroes were the Southwest and Plains cavalry whose varied images seemed forever stored in his mind whether they were the soldiers on parade, *Troop "L" First Cavalry*, or the struggling black "buffalo soldiers" of the

10th Cavalry in *Leaving the Canyon.* In the latter Remington was very specific in portraying black cavalrymen; he knew the regiment numbered three winners of the Medal of Honor. Though there are no Indians (except for the wounded warrior being rescued by the gallant buffalo soldiers) in the Remingtons reproduced here, we have included another of his favorites, the cowboy and his horse at a desert waterhole, definitely in conflict with nature and struggling for survival. Often described as a man impatient with abstract ideas, Remington's work still reveals the thread of Spencerian Darwinism—the code of the rugged individual locked in a never-ending struggle for survival. This struggle, one can see from Remington's other work, inevitably meant the end of wild game, the end of the Indian and, for that matter, the end of the effete and enfeebled races of Europe. As he grew older, Remington appeared to believe that all men, no matter what their heroic struggle, were governed by fatalistic forces beyond their control. He became a naturalist and a fatalist akin to his fellow storyteller, Jack London. Perhaps his fatalism was Remington's way of lamenting the end of the frontier—a tremendous irony, since through his works the saga of the Far Western Frontier lives on in perpetuity.

The theme of nostalgia for the vanishing Western horizon is embodied in the work of Charles M. Russell. This self-taught Western artist from Montana by way of Oak Hill, Missouri and military school in New Jersey, carried the theme of nostalgia to the verge of sentimentality. Fully as theatrical as Remington, Russell, in his use of lurid colors and furious action as well as his worship of the outdoor hero, turned the American saga into pure melodrama of immense mass appeal. Unlike Remington, he was not attuned to any Darwinian philosophy, however, and his Indians and drifters prevailed as often as not. Indeed, his fascination with and knowledge of Indian life far surpassed that of Remington. In addition, as the superb pen and ink sketch *The Whispering Disturbs Mr. Bear* indicates, Russell laces his art with a broad sense of humor. He did not dwell on tragedy when he painted the passing frontier. Instead very often he turned to irony and wit, two qualities that characterize that final stage of Romanticism which made twentieth century Modernism possible. The literary critic Morse Peckham describes this final ironic phase of Romanticism as the province of the "dandy."[23] One immediately thinks of Oscar Wilde, then perhaps Buffalo Bill, who, however, saw nothing ironic about his life, and finally the early movie cowboys, especially William S. Hart, whose steely eyes and mock heroic poses redeemed his banal roles with obvious wit. But what of Charlie Russell, the self-made "cowboy painter" whose "persona" was evident and whose sense of irony and wit carried even into his self-conscious illustrated letters?[24] Like Will Rogers, Charlie Russell was a twentieth century man using the great mythical saga of the nineteenth century frontier to comment eloquently upon what he didn't like about his own time. The "Romantic Horizon" was long gone but it still had its profound utility—as it does indeed today.

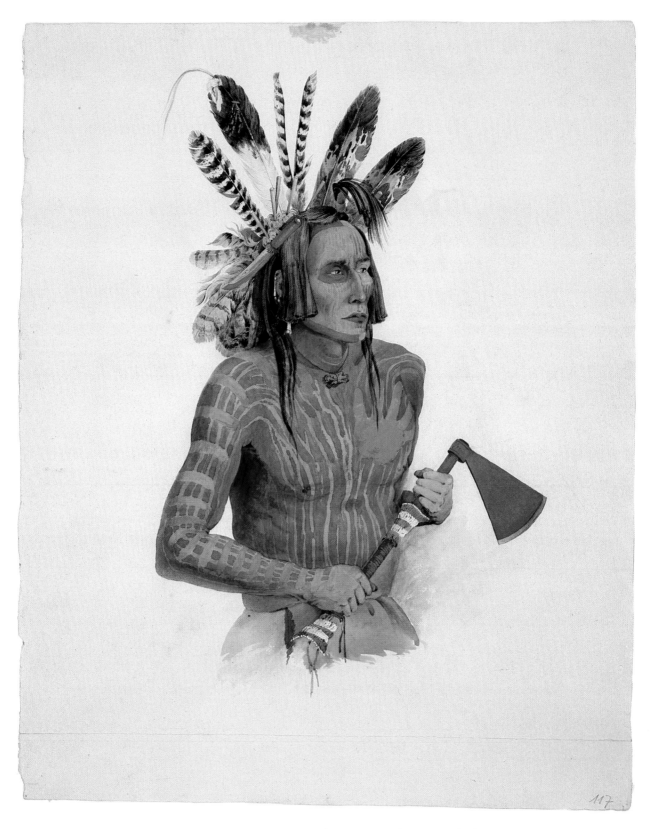

12. KARL BODMER, *Mato-Tope (The Four Bears) Mandan Chief*

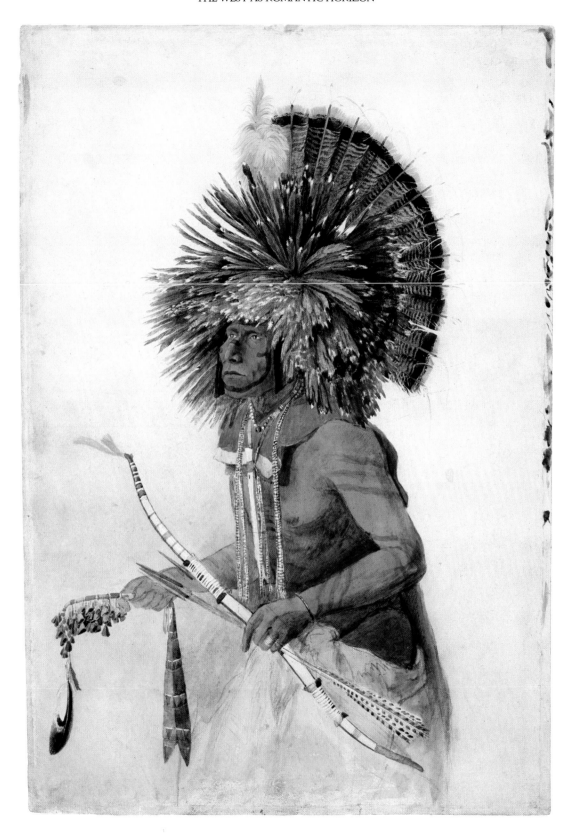

9. KARL BODMER, *Pehriska-Rupa (Two Ravens) Chief of the Hidatsa Dog Dancer*

FOOTNOTES

[1]See Louis Agassiz, *Methods of Study in Natural History,* 17th ed. (Boston: Houghton-Mifflin Co., 1886), p. 64, and Ralph Waldo Emerson, *Nature* (Boston: Monroe & Co., 1836).

[2]Morse Peckham in "The Dilemma of a Century: the Four Stages of Romanticism," reprinted in *The Rise of Romanticism* (Columbia, SC: Univ. of South Carolina Press, 1970), pp. 36-57, outlines the stages of Romanticism as successively embodied in such roles as the Byronic, the Visionary, the Virtuoso, and the Dandy, each denoting a different sensibility within the mainstream of the Romantic Movement. I have adopted Peckham's approach, but have modified it somewhat in accordance with the artistic data as I see them.

[3]Their relevant literary works are Ruxton, LeRoy R. Hafen, ed., *Life in the Far West* (Norman, OK: Oklahoma Press, 1951), Irving, *The Rocky Mountains: or Scenes, Incidents and Adventures in the Far West,* 2 vols. (Philadelphia: Carey, Lea, and Blanchard, 1837), Stewart, *Altowan; or Incidents of Life and Adventure in the Rocky Mountains by an Amateur Traveler,* ed., J. Watson Webb, 2 vols. (New York: Harper and Brothers, 1846).

[4]The artistic significance of images in linked sequences is brilliantly described by George Kubler in *The Shape of Time* (New Haven: Yale University Press, 1962).

[5]Peggy and Harold Samuels, *The Illustrated Biographical Encyclopedia of Artists of the American West* (Garden City, NY: Doubleday & Co., Inc., 1976), p. 389.

[6]Ibid., p. 130.

[7]George Catlin, *Illustrations of the Manners, Customs and Condition of the North American Indian with Letters and Notes Written During Eight Years of Travel and Adventure among the Wildest and Most Remarkable Tribes Now Existing,* 9th ed., 2 vols. (London: H. G. Bohm, 1857), Vol. I, p. 2.

[8]Ibid., I, p. 2.

[9]Ibid., I, p. 4. Also see William H. Goetzmann, *Exploration and Empire: the Explorer and the Scientist in the Winning of the American West* (New York: Alfred Knopf, 1966), p. 191.

[10]Catlin, *Letters and Notes,* I, p. 262.

[11]See Alexander Phillipp Maximilian of Wied-Neuwied, *Reise nach Brasilien in den Jahren 1815 bis 1817* (Frankfurt: H. L. Brönner, 1820-21).

[12]Samuels, op. cit., p. 52. See also Davis Thomas and Karin Ronnefeldt, *People of the First Man* (New York: E. P. Dutton & Co., 1976), pp. 10-12.

[13]Ibid., pp. 52-53.

[14]Ibid.

[15]The full title of Schoolcraft's work is *Historical and Statistical Information Respecting the History, Condition, and Prospects of the Indian Tribes of the United States,* 6 vols. (Washington, Government Printing Office, 1851-57).

[16]See Gordon Hendricks, *Albert Bierstadt, Painter of the American West* (New York: Harry N. Abrams, Inc., 1974) for biographical details.

[17]See Marjorie Nicholson, *Mountain Gloom and Mountain Glory* (New York: W. W. Norton, 1963).

[18]Hendricks, op. cit., pp. 120-123. Hendricks provides one illustration of this buffalo in his book, see p. 124, but he has obviously overlooked the one included in this exhibition which has been called by Larry Curry, "one of the most eloquent images of the buffalo ever printed." See Curry, *The American West* (New York: Viking Press, 1972), p. 28.

[19]This painting is reproduced in Hendricks, op. cit., pp. 282-283, illus., p. 205.

[20]Matthew Baigall, *The Western Art of Frederic Remington* (New York: Ballantine Books, 1976), pp. 10-11.

[21]Ibid., p. 18.

[22]Ben M. Vorpahl, *Frederic Remington and the West: With the Eye of the Mind* (Austin: University of Texas Press, 1978), pp. 130-131.

[23]Peckham, op. cit., pp. 43-44.

[24]See Brian W. Dippie, *Paper Talk: Charles Russell's American West* (New York: Alfred Knopf, 1979) for an edition of Russell's famous illustrated letters.

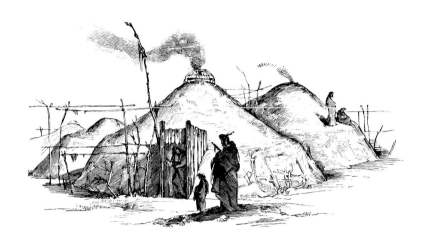

THE ROMANTIC
HORIZON IN HISTORY
& ETHNOLOGY

BY JOSEPH C. PORTER

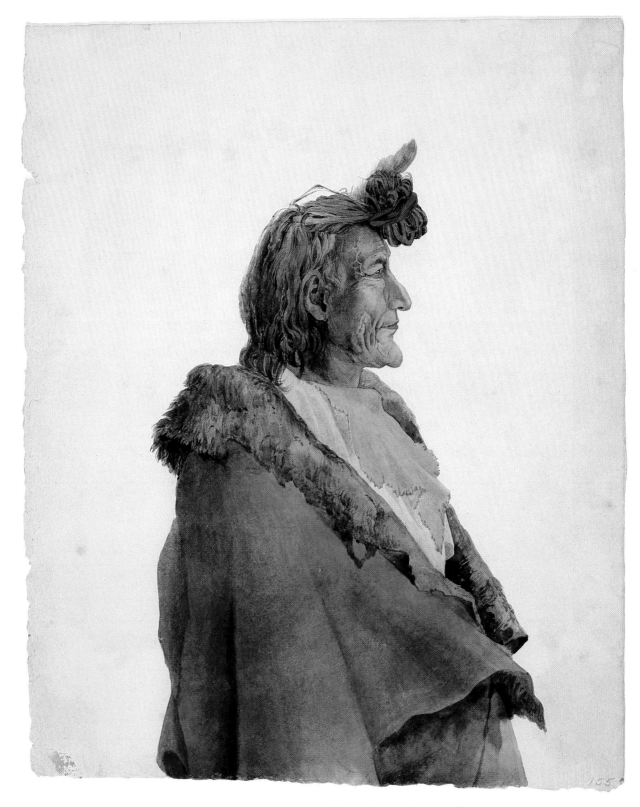

14. KARL BODMER, *Pioch-Kiein (Distant Bear) A Piegan Indian*

The popularity and beauty of the art of the American frontier has obscured its important dual legacy. This body of art left a permanent record of the frontier experience that is invaluable to historians and ethnologists. At the same time, the art of the frontier helped forge a visual mythology of the frontier that is still vibrant today. Indicative of the intellectual complexity of the art of the frontier is the fact that it simultaneously contributed to both the realistic assessment of westward expansion and to the formation of our national mythology. In its own day and today, the art of the frontier reflects both fact and fancy.

A part of the American experience for three centuries, the frontier shaped American history and culture. Three hundred years of expansion into wilderness areas created ideas, values, and myths that became a part of the American national character. These uniquely American concerns about the wilderness are revealed in history, literature, and art. The art of the frontier gave visual validation to wilderness themes and concerns in other areas of American culture. Thus this body of art can be appreciated for its intrinsic beauty, while at the same time, it informs us about the reality of the frontier past and reveals how it influenced the American imagination.

The artists, George Catlin, Karl Bodmer, and Alfred Jacob Miller, left behind work that is essential to the historians and ethnologists of today. Alfred Jacob Miller painted many facets of frontier life. His landscapes, known for their haunting beauty, tell historians much about the prairie and mountain environments of the 1830s. His depictions of the Rocky Mountain fur trade left a record of this significant economic enterprise that spurred westward expansion and drew the Indian tribes into the white man's economic and cultural world.

Resulting from his journey with Captain William Drummond Stewart, Miller's art left a parable of frontier history. His watercolors of the prairies, the Wind River Mountains, the Rocky Mountains, lakes, rivers, and forests show the wilderness as it existed just before white settlement permanently altered those scenes. While Miller depicted the pristine prairie and mountain environment, he also recorded the changes that rapidly transformed the frontier. Miller illustrated nearly every facet of the fur trade, from the hard-working, wilderness-wise mountain men to the trading forts. *Setting Traps for Beaver* pictures the basic technique that nearly depopulated the Rocky Mountains of beaver. Despite his reliance on artistic conventions, Miller's watercolors of the mountain men revealed the hard, often brutal lives of these individuals who were often the opening American wedge into the wilderness and into Indian lands.

The fur trade involved much more than trapping the beaver, and Miller left a pictorial record of its other aspects. Trade goods were essential to purchase good-will and furs from the Indians as well as supplying the mountain men. Miller and Captain Stewart had accompanied the supply caravan of Pratte, Chouteau and Company across the plains. *The Cavalcade or Caravan* shows the wagon train en route to the mountains. The supplies were destined for the distant Green River rendezvous where mountain men, businessmen, and adventurers like Stewart met to exchange goods for furs, trade with the Indians, and supply the trappers for another year.

The rendezvous served important economic and social functions. The mountain men swapped the past year's news and gossip while the fur companies dealt with the Indians. Miller painted scenes of these annual meetings of trappers, Indians, and entrepreneurs. He also

carefully painted the trading fort, another frontier institution that performed the same economic functions as the colorful rendezvous. Veteran fur traders William Sublette and Robert Campbell built a trading fort at the junction of the North Platte and Laramie Rivers in 1834. Initially named Fort William and later changed to Fort Laramie, the fort played a vital role in Western history for the next fifty-six years.

Fort Laramie or Sublette's Fort demonstrates how the entire body of Miller's art, so influenced by the Romantic trends of his day, remains a valuable tool for historians. "Miller was the first artist to picture this famous post," writes ethnologist John C. Ewers, "and the only one to show it as it was originally built of vertical log palisades, with rectangular bastions at two corners, and a log blockhouse overhanging the main gate."[1] The Indians in the painting indicate Fort Laramie's economic function. In this watercolor Miller depicted the confrontation of cultures— red and white—on the frontier. At first glance *Fort Laramie* seems an idyllic, peaceful work, showing an Indian village going about its daily routine. Against the activities of the Indians, Miller juxtaposed the monolithic Fort Laramie with its palisades and blockhouses, showing the precarious situation of the intruding traders and trappers. It is the inhabitants of the fort, peering nervously over the walls, and not the Indians, who seem afraid. Yet it is the Indians who are truly beseiged. From this fort and others like it emanated trade goods, alcohol, and new ways that eventually dispossessed the Plains Indians. Alfred Jacob Miller painted just before the final onslaught against the Plains Indians, and historians are fortunate that he did. Ewers assessed Miller's importance to modern scholars:

> [H]e was the first artist to travel the historic Oregon Trail and the only one to know the Rocky Mountains during the brief reign of the mountain man, and many of his works are not only unique in their subject matter but leave a powerful and lasting impression. Were it not for Alfred Jacob Miller's vivid pictures, the significance of the Rocky Mountain fur trade in the development of the west would be much more difficult for us to visualize. As explorers, trappers, and Indian traders, the rough mountain men represented the first wave of white expansion into the Rocky Mountain region.[2]

Prince Maximilian and Karl Bodmer visited a different region than Alfred Jacob Miller. In the summer of 1833, Maximilian's entourage ascended the Missouri to Fort McKenzie. Returning downriver, they spent the winter of 1833-34 at Fort Clark, near the Mandan and Hidatsa villages. Maximilian's journey was symbolic of the Romantic urge to explore the wilderness and to inventory and to classify the unknown. A careful draftsman and superb watercolorist, Bodmer produced over 420 watercolors and sketches, many portraying the Indian peoples, flora and fauna, and terrain of the Missouri River Valley.

The work of Bodmer has made immense contributions to the scholarship of the American frontier, and it aptly demonstrates the uses of art for historians of the frontier. Bodmer emerged as the artist-illustrator for two very important expeditions of exploration: Maximilian's in 1832-34, and the earlier, more famous journey of Meriwether Lewis and William Clark in 1803-06. The relationship between the two expeditions was more than mere coincidence. While in St. Louis in 1833, Maximilian sought the advice of General Clark. Although only twelve years apart in age, Clark and Maximilian symbolized two separate intellectual generations of explorers. A talented, largely self-taught man who typified the American Enlightenment of the

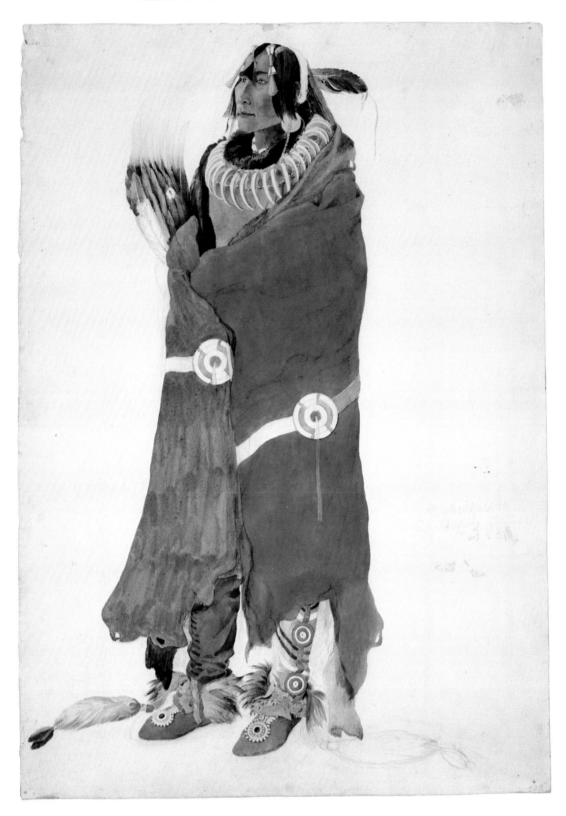

8. KARL BODMER, *Mahchsi Karehde, Mandan Indian*

new, young republic of President Thomas Jefferson, Clark encouraged Maximilian, a disciple of the Romantic horizon of nineteenth century science. Indicative of Clark's cooperation was a set of maps from his expedition that he presented to Maximilian.

Because of the route of Maximilian and the precise detailed realism of Bodmer's exquisite work, Bodmer became the highly skilled artist that the Lewis and Clark expedition did not have. The art of Bodmer reveals how this vast unknown frontier appeared to Lewis and Clark. Bodmer's sketches of the flora and fauna, the terrain, and the Indians complement the notes of Lewis and Clark. In addition to learning about the frontier of Lewis and Clark, careful comparison of the work of Bodmer and the notes of Maximilian to those of Lewis and Clark permits scholars to discern the subtle changes overtaking the Missouri River region during the years between these two remarkable journeys of discovery. Of his contribution to Lewis and Clark, one scholar writes, "Bodmer's beautifully executed pencil sketches and delicate water-colors have appeared in Lewis and Clark literature with more frequency than the drawings of any other artist."[3] The magnitude of Bodmer's contribution to scholarship is underscored by the fact that this one artist made the work of three great explorers, Meriwether Lewis, William Clark, and Prince Maximilian, come alive for succeeding generations of Americans.

The frequency of the phrases "near Fort Clark," "not far from Fort Union," "above Fort McKenzie" in Bodmer's work indicates the increased presence of the fur companies along the Upper Missouri since the passage of Lewis and Clark. The conduct of the Missouri River fur trade differed from the Rocky Mountain trade, and Bodmer's watercolors complement those of Alfred Jacob Miller. Similar to Miller's study of Fort Laramie, Bodmer's watercolor of Fort McKenzie, the American Fur Company outpost at the junction of the Marias and Missouri Rivers, shows the temporary stand-off between the fur company and the Indians. The Indians were becoming dependent upon trade goods while the traders needed the furs harvested by the Indians.

The fur companies needed consent to build their posts on Indian lands. Bodmer's *Fort McKenzie at the Mouth of the Marias River* illustrates the tenuous existence of this post among the three tribes of the militant Blackfeet. Mounted warriors on the bluffs survey the fort that existed only at their sufferance. While powerful tribes like the Blackfeet or the Dakota tolerated trading forts as convenient outlets of goods, historical circumstances forced other tribes to depend upon the posts for survival.

Bodmer's *View of the Mandan Village Mih-Tutta-Hang-Kush* provides a stark historical contrast to Miller's watercolor of Fort Laramie and to Bodmer's portrayals of Fort McKenzie. A century before the Journey of Maximilian and Bodmer, the Mandan were a powerful economic and political force along the Upper Missouri, numbering nearly ten thousand people in nine fortified villages. The prowess of Mandan warriors prevented Dakota expansion westward into the buffalo-filled Great Plains. In the 1770s an epidemic of smallpox reduced the Mandan to less than 2,000 people. Dakota warriors forced the beleagured Mandans northward. In 1833 Maximilian encountered them at the villages of Mih-Tutta-Hang-Kush and Ruhptare, near the Hidatsa who were also severely reduced by disease and the belligerent Teton Dakota. *View of the Mandan Village Mih-Tutta-Hang-Kush* pictures the mutual dependence of the Mandan and Fort Clark in the face of the surrounding tribes.

The above examples from Bodmer and Miller briefly indicate how *all* the art of the Romantic Horizon helps to understand the past dimensions of the wilderness frontier. Another group of scholars, the ethnologists, also depend upon the art of the Romantic Horizon as they study the cultures of the Plains Indians. This art has been as crucial to scholars of the Northern Plains tribes as it has been to historians of the fur trade and western exploration. The work of Miller, Bodmer, and George Catlin remains an excellent source of information about the Plains Indians before the reservation period. Their art is also a record of the very changes that undermined the hunting and nomadic cultures of these people.

These artists left a remarkable visual record of the Plains Indian cultures. Bodmer's accomplishments at Forts McKenzie and Clark and those of Catlin at Fort Clark attest to the ethnological usefulness of art. At Fort McKenzie Bodmer worked feverishly to draw individual Indians and scenes from Indian life, especially relating to the three Blackfeet tribes: the Piegan, Blood, and Blackfoot. *Pioch-Kiein (Distant Bear) a Piegan Indian* is indicative of the quality of the twenty-seven studies that Bodmer made of the Blackfeet. Based on his field sketches, *Encampment of the Piekann Indians* is a magnificent panorama that gives an unforgettable impression of a large Indian village as he and Maximilian saw it. From the picture a scholar can derive much information about the population of this village, its construction, and general appearance.

Bodmer's close attention to detail provides information about the material culture of the Piegans. The exquisite buffalo robe worn by the pipe-smoking warrior in the left foreground recounts that individual's battlefield exploits. Another warrior appears to be wearing a trade blanket rather than the traditional buffalo robe, indicating the subtle changes introduced by the traders. Traditional Indian weapons as well as trade guns are in evidence. The camp is filled with warriors, women, children, dogs and horses, constants of the life of the nomadic buffalo hunters. Hundreds of buffalo hides would have been necessary for the tipis that comprise this village, indicating a thriving native economy. The work is a bonanza of facts about the Piegan.

An exciting and equally significant work is Bodmer's polychrome aquatint *Fort McKenzie, August 28, 1833* which depicts an Assiniboin-Cree attack on a Piegan camp near Fort McKenzie, graphically showing the nature of warfare that existed between the Plains tribes. Other observers and participants have left written accounts of Indian warfare on the Great Plains, but Bodmer's pictorial record is significant because of the realistic, nearly relentless attention to detail. His realism is so complete that the aquatint vividly relays the fury, sights, sounds, and smell of this deadly fight. The acrid stench and blue haze of the black-powder muskets permeates the scene. The work conveys the dull sound of musket fire, the screeching whoop of the battling warriors, frightened horses, and the thud of war clubs against bodies.

Bodmer, in addition to giving an overall impression of the battle, shows weapons and methods of combat. The attackers stand face-to-face with their Piegan foes, both groups firing muskets, arrows, thrusting lances and wielding war clubs. Indicative of his care for picturing detail, Bodmer recorded the varieties of war clubs used. Casualties attest to the deadly skills of the warriors. A Piegan parent and child lay dead. Plains warriors scrupulously tried to evacuate

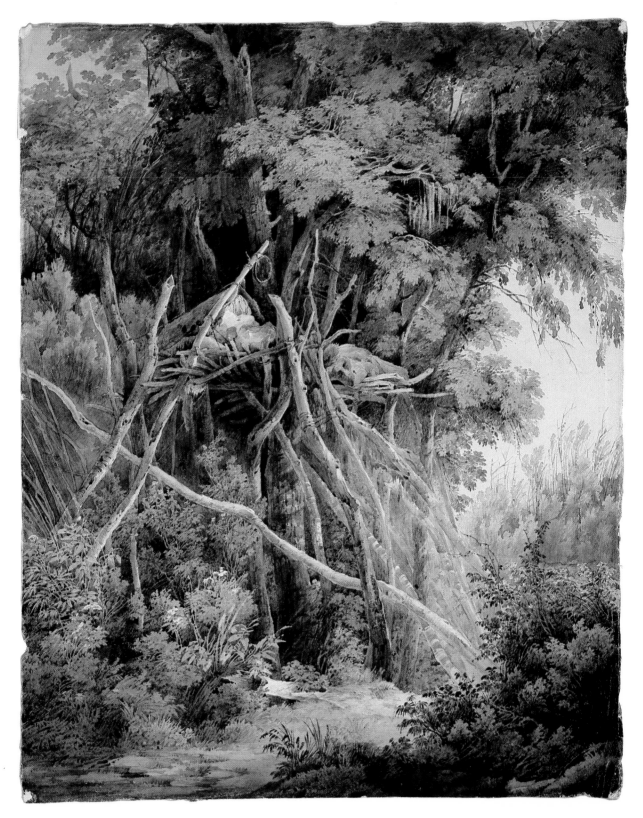

16. KARL BODMER, *Forest with Burial Scaffold near Fort Union*

their dead or wounded. Amidst the fighting, two Assiniboin or Cree warriors frantically try to get the body of an injured comrade on a frightened horse. Brandishing a fresh scalp taken from a fallen Piegan, an Assiniboin or Cree warrior furiously rushes his enemies. Bodmer's feelings as he frantically sketched this battle can only be imagined. This aquatint is an important ethnological account of war which played such a major role in the culture of the Plains Indians.

Miller, Bodmer, and Catlin were on the very edge of the frontier where red and white culture met. In their studies of the trading forts, Miller and Bodmer showed confrontation. Miller's *Crossing the Divide* portrayed the Shoshoni watching the arrival of trade caravans and trappers who were instrumental in changing Indian culture. Other works revealed the gradual, more subtle process of acculturation. In several works Miller depicted the apparently cordial relationship between the trappers, traders, and their Indian hosts. The outsiders sit around the campfires, bantering with the Indian men. Miller's scenes of Indians and mountain men together hint at a more personal facet of red-white cultural contact.

Trappers, traders, hunters, and rivermen frequently married Indian women. Occasionally the motive was marital companionship, but often as not it involved economic and political considerations. If a trader could marry the daughter of a powerful family within a tribe, he gained the friendship and support of his red in-laws and often the entire band or tribe. The trader hoped to work the complex system of Indian kinship regulations and obligations to his own economic advantage. Likewise, ambitious chiefs and warriors often sought the traders as sons-in-law, thereby gaining privileged access to more and cheaper trade goods which added to the economic and political prestige and power of that family or chief.

The work of Karl Bodmer and George Catlin among the Mandan and Hidatsa makes the most dramatic statement about the ethnological significance of the art of the Romantic Horizon. Catlin visited the Mandans in 1832, and in a few days painted the portraits of various individuals. He painted scenes from the Mandan's Okipa, a ceremony that dramatized the Mandan myth of creation. Leaving Fort McKenzie in the fall of 1833, Maximilian and Bodmer returned to Fort Clark where they spent the winter.

That winter Bodmer sketched and painted studies of individuals and of the daily life of the Mandan and Hidatsa. His two portraits of Pehriska-Rupa record the minutest detail of the chief's clothing. Ornamentation, weapons, bead and quill work, and the marvelous bear paw necklace are carefully drawn. One portrait is of the chief in his best attire while the other, *Pehriska-Rupa (Two Ravens) Chief of the Hidatsa Dog Dancer* shows him dressed for his role as head of the Dogs, an age-graded society among the Hidatsa. Note the precise depiction of ornamentation on the mocassins, leggings, the weapons, and Pehriska-Rupa's magnificent turkey feather headdress. Maximilian, who witnessed the Hidatsa Dog dance, verified the accuracy of Bodmer's watercolor. Ewers called the work based on the watercolor of the Dog Dancer, "an outstanding representation of the beauty and intricacy of the primitive Plains Indian ceremonial costume."[4]

Mato-Tope, a Mandan chief who impressed Catlin in 1832, was also the subject of two excellent portraits by Bodmer. Both portraits are remarkable in what they reveal of this extraordinary Mandan and of his culture. Bodmer's watercolor *Mato-Tope (The Four Bears) Mandan Chief* catches the mental and physical strength of the man, and the careful rendering

of detail graphically records the deeds necessary to make a man a chief among this culture of warriors. Each mark or object on Mato-Tope signifies a specific act of warpath valor. Mato-Tope killed a Cheyenne chief with a knife in hand-to-hand combat, and the red wooden knife in his hair indicates this exploit. Each of the colored wooden pegs represent a musket wound received in battle, and each wing feather of the turkey signifies an arrow wound. The owl feathers, dyed yellow with red tips, show that Mato-Tope was a member of the Dog band of warriors. The yellow stripes or "hash marks" that range down his arm each indicate bravery on the battlefield, probably the counting of a primary coup, the touching or striking of an enemy during battle. The yellow hand painted on Mato-Tope's chest reveals that he captured prisoners.

Bodmer's portrait reveals the history of Mato-Tope. He killed at least one opponent in hand-to-hand combat. Since the victim was a chief, it may be presumed that he was a worthy match for Mato-Tope. Maximilian said that Mato-Tope was reputed to have killed as many as five chiefs from enemy tribes. He was wounded at least six times, captured prisoners, and counted at least nineteen primary coups. Warriors carefully scrutinized the exploits of other warriors, and any warrior who attempted to exaggerate would be publicly humiliated. Mato-Tope's decorations were an accurate record of his valor. "A warrior so adorned takes more time for his toilette than the most elegant Parisian belle," noted Maximilian.[5]

The portraits by Catlin and Bodmer are more than idealized representations of the Plains Indians. Careful study of these Indian portraits reveals their subjects as individual people and provides a glimpse of the diversity of personalities within Indian cultures. Studying the art of Catlin and Bodmer allowed Ewers to describe Mato-Tope, as "likely to have been an active hunter and warrior, a fierce competitor, a wide-awake participant in the affairs of his tribe who enjoyed picturing the most exciting, heroic and memorable of his rich experiences."[6] The competition for honor among warriors of the same tribe or of friendly tribes was keen. Maximilian caught something of the universal foibles of human nature when he noted that Mato-Tope and Pehriska-Rupa regarded each other with haughty disdain.[7]

During the winter at Fort Clark, Bodmer sketched and painted, eventually producing twelve watercolors of the Hidatsa and thirty-six of the Mandan in addition to studies of specific artifacts. All are consistent with his skill, and the subject matter dealt with the full gamut of Mandan and Hidatsa life. In *Skull Medicine near Mih-Tutta-Hang-Kush* and *Idols of the Mandan Indians,* Bodmer pictured a part of Mandan religious life. In other works he sketched Mandan beds, weapons, domestic utensils, knife sheaths, and a conquest bundle that kept count of a Hidatsa warrior's sexual exploits. The care and detail of these drawings permit ethnologists to carefully study the Mandan and Hidatsa crafts.

Certain warriors were prominent in their cooperation with Maximilian and Bodmer. Mato-Tope posed for two portraits, painted a record of his own exploits, and helped Maximilian study the languages of the Mandan and other tribes. An aging Hidatsa chief with a powerful physique posed for Bodmer resulting in *Addih-Hiddish (The One Who Makes Roads) Hidatsa*

Chief. Initially reluctant as a model, Addih-Hiddish willingly told the history of the Hidatsa tribe to Maximilian.[8] A Mandan chief, Dipauch, greatly contributed to the study of Mandan religious beliefs and material culture. Dipauch outlined the complex religion of the Mandan for Maximilian, telling of such superior beings as Ohmahank-Numaski, the lord of life, and of Numank-Machana, the first man.[9]

A cooperative effort between Dipauch and Bodmer resulted in *Interior of Mandan Earth Lodge,* an example of ethnographic art at its finest. While the rest of the Mandan moved from their summer lodges to winter dwellings in December of 1833, Dipauch and his family remained behind several extra days so that Bodmer could complete the study.[10] It portrays the family and material belongings of a man who was prominent and wealthy among his people. *Interior of Mandan Earth Lodge* permits ethnologists to study the lesser-known domestic side of Mandan life.

Catlin, Maximilian, and Bodmer were keenly aware that their notes, sketches, watercolors, and canvases would be a permanent record of people that faced uncertain futures. Knowing how white incursions had drastically weakened or destroyed tribes east of the Mississippi River, they feared for the Plains nomads once settlement pushed westward. Maximilian asked that the white men treat the Indians with simple justice and open-mindedness. Catlin wanted a large tract of land set aside for the Plains Indians and the buffalo. There the Indians could continue their traditional way of life. Given the belief in manifest destiny and the American impetus for westward expansion, Catlin and Maximilian asked for the impossible. In the years after the Civil War, the buffalo were nearly exterminated. Deprived of this staple in their hunting economy, Indian resistance to the whites collapsed, and they were pushed onto reservations.

Disease contributed heavily to weakening Indian resistance. From the fifteenth to the nineteenth centuries, diseases introduced from Europe continued to attack Indian populations. Disease makes a most compelling statement about the legacy of the art of the Romantic Horizon. Statistics leave a cold, impersonal account of the epidemics that destroyed entire Indian nations. Visually barren statistics do not give human definition to the destruction of a culture or people. Such calamities must be personalized to be understood. Catlin, Maximilian, and Bodmer show in human terms the impact of one epidemic on one tribe. Their art portrayed individuals and a culture that was later struck down. Perceiving the disaster of the Mandan in 1837 in personal and human terms allows one to comprehend the magnitude of four centuries of epidemics among the Indians of an entire continent.

In 1837 still another epidemic of smallpox struck, sparing less than 150 survivors and destroying the Mandan as a tribe. The epidemic nearly eradicated the Mandan culture that had flourished along the Missouri River for over three hundred years. Only the foresight of Catlin, Maximilian, and Bodmer preserved much of what is known about the Mandan. That singular warrior, Mato-Tope, symbolically encapsulates the history of his people. Mato-Tope and the Mandan had befriended the Whites. They had cordially welcomed the La Verendryes, explorers from New France in the 1730s and Lewis and Clark in 1804. Mato-Tope was an expansive host to traders, trappers, artists, and explorers. As the smallpox killed his people, Mato-Tope regretted his friendship for the white man. Trader Francis Chardon penned the embittered words of the dying Mato-Tope's last address to his stricken warriors:

17. KARL BODMER, *Medicine Sign of the Assiniboin Indians*

18. KARL BODMER, *Skull Medicine near Mih-Tutta-Hang-Kush*

My Friends one and all, Listen to what I have to say—Ever since I can remember, I have loved the Whites. I have lived With them ever since I was a Boy, and to the best of my Knowledge, I have never Wronged a White Man, on the Contrary, I have always Protected them from the insults of Others, Which they cannot deny. The 4 Bears never saw a White Man hungry, but what he gave him to eat, Drink, and a Buffaloe skin to sleep on, in time of Need. I was always ready to die for them, Which they cannot deny. I have done every thing that a red Skin could do for them, and how have they repaid it! With ingratitude! I have Never Called a White Man a Dog, but today, I do Pronounce them to be a set of Black harted Dogs, they have deceived Me, them that I always considered as Brothers, has turned Out to be My Worst enemies. I have been in Many Battles, and often Wounded, but the Wounds of My enemies I exhalt in, but to day I am Wounded, and by Whom, by those same White Dogs that I have always Considered, and treated as Brothers. I do not fear Death my friends. You Know it, but to die with my face rotten, that even the Wolves will shrink with horror at seeing Me, and say to themselves, that is the 4 Bears the Friend of the Whites—

Listen well what I have to say, as it will be the last time you will hear Me. I think of your wives, Children, Brothers, Sisters, Friends, and in fact all that you hold dear, are all Dead, or Dying, with their faces all rotten, caused by those dogs the whites, think of all that My friends, and rise all together and Not leave one of them alive. The 4 Bears will act his Part—[11]

After living dangerously and bravely and accomplishing much by the standards of his people, Mato-Tope died "that even the Wolves [would] shrink with horror" from him. The art of George Catlin and Karl Bodmer made it possible to know this man and his people. They and the other hard-working, courageous artists who depicted America's Romantic Horizon left a pictorial record of the wilderness frontier and its native peoples. Those artists are long dead and their frontiers have vanished, but the art remains, a permanent legacy that continues to show the reality of the American past.

To fully understand the past, historians must also examine the shared concepts, ideas, and myths that governed how individuals or a people responded to their world. Three hundred years of westward expansion into the wilderness had a decided impact on American thought. By the 1830s when Catlin, Bodmer, and Miller were painting, Americans already shared a complex and often contradictory group of ideas about the wilderness and the frontier. The art of the Romantic Horizon, so important in deciphering the past, has also shaped the American mythology of the frontier.

Nineteenth century Americans were ambivalent about the wilderness frontier. It represented a cluster of cultural values based on a dichotomous view of the wilderness as a dangerous, potentially evil area, and also as the "natural" wilderness, a place of renewal and rejuvenation. On the one hand, the wilderness frontier with its anarchy and lack of social controls represented an insult to the bourgeois work ethic of the settled East, while on the other it served as a dream and as a quest that promised new beginnings.[12]

Conquest of the wilderness promised material gain, the hope of avoiding failure and escaping past tragedy and obligations, and it provided opponents of epic proportions in its native peoples and its hostile environments.[13] By struggling against the wilderness, one could hope for both personal profit and an antidote to the vices of civilization. Because of these notions, the wilderness-frontier became a powerful symbol that stimulated an appetite for empire which, in turn, created a continental nation from coast to coast.

While compelled to conquer the wilderness, Americans were very fearful about what would happen once the wilderness had vanished. They consciously came to believe that many values that they regarded as important resulted from the frontier experience. Some felt that the wilderness was a positive good compared to the sins, corruption, and venality of civilization. Although deeply confused about the relative values of the wilderness and civilization, nineteenth century Americans did believe that the westward march of civilization into the wilderness was inevitable.

After the Civil War, settlement extended into the trans-Mississippi West, and Americans became convinced that the three hundred year saga of the wilderness-frontier was almost over. Many believed that the West, the "Wild West," would be the last American frontier. Fearful that the frontier was vanishing, certain novelists, artists, and other Americans dedicated their work to perpetuating images of the last frontier in the public mind. Their efforts created a nostalgia for the wilderness and the West. By 1900 the art of the wilderness-frontier was transformed from the romantic documentary of Catlin, Miller, Bodmer, Seth Eastman, or Albert Bierstadt, to the romantic nostalgia of Frederic Remington, Harvey Dunn, Charles M. Russell, and N.C. Wyeth. In the work of the latter artists, historical fact and epic myth overlap.

The most accomplished of the artists of the mythic Wild West is Frederic Remington. The strength of his illustrations, paintings, and bronzes derives from the juxtaposition of fact and fancy, and from this great contempt for what he saw as the corrupt, dishonest, effete civilization of industrial and urban America.[14] He believed that the changes of the 1890s were perverting and destroying traditional American values. "I knew the railroad was coming—I saw men already swarming into the land. I knew the derby hat, the smoking chimneys, the cord-binder, and the thirty-day note were upon us in a resistless surge." Remington wrote, "I knew the wild riders and the vacant land were about to vanish forever, and the more I considered the subject the bigger the Forever loomed. I saw the living, breathing end of three American centuries of smoke and dust and sweat, and I now see quite another thing where it all took place, but it does not appeal to me."[15] His intense antipathy for the America of his day added a compelling, forceful quality to his work.

Remington admired the West, its arid terrain and its people. In the West among the cowboys, cavalry soldiers, and Indians, Remington believed he had found individuals who truly represented the values of toughness, honesty, virility, and straight-dealing that he found so lacking in the East. "Men with the bark on," he called them. He believed that these rugged, solitary western men constantly proved themselves against each other and against the mountain, plains, and desert environment. Violence or the potential for violence became a theme in Remington's work as he pitted his subjects against human or natural foes. His work reveals his admiration for the survivors of these life-or-death struggles. Remington's cowboys, cavalrymen, and Indians are up to any challenge.

Remington combined his deeply held personal beliefs about the merits of the Wild West with great artistic talent. When painting or sculpting the men or animals that he portrayed as

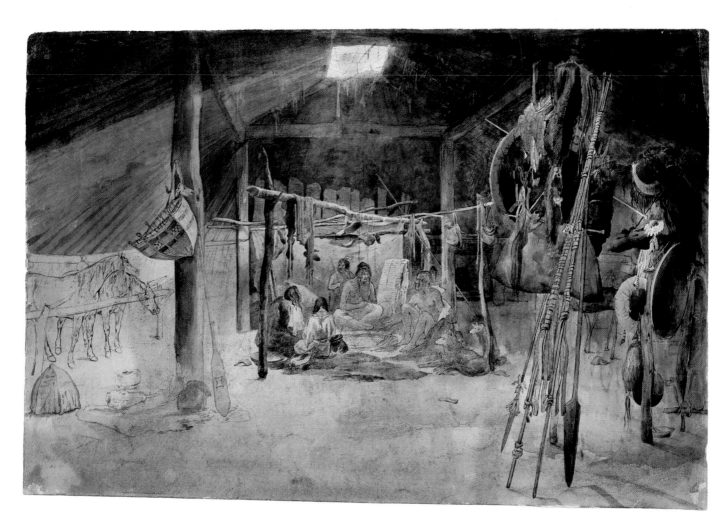

19. KARL BODMER, *Interior of Mandan Earth Lodge*

1. ALFRED JACOB MILLER, *Prairie*

mythic, he still closely attended to the details of dress, anatomy, terrain, and light. Compulsive in his love of the West and dislike of "civilization," Remington suffered a final irony. He became incapable of living the hard, rugged western life of the cowboys, Indians, or soldiers that he so admired. Addicted to those civilized habits of exorbitant eating and drinking, Remington gained so much weight that he could not ride a horse. The fat, talented, troubled artist had to live his fantasies vicariously in his canvases, illustrations, and bronzes.

The wash drawing *Leaving the Canyon* and the oil painting *The Waterhole* are representative of Remington's art and its impact on the emerging mythology of the Wild West. These two works contain all the staples of what would later be dubbed "the Western." Taut, hard men face danger in the form of hostile Indians or the desert. The danger is real and permeates both works. Had the jaded, broken-down horse fallen a mile short of the waterhole, both animal and rider could have died. The black "buffalo soldiers" of the 10th Cavalry evacuate a wounded Apache scout. The action of the drawing and the oil is set against the backdrop of a harsh environment that can be as deadly as any human enemy.

Leaving the Canyon and *The Waterhole* display Remington's facility for combining realism and myth. Before his weight became excessive, Remington spent much time in the West. He had experienced the heat, the sunlight, and the aridity depicted in *The Waterhole.* In 1888 he rode with a patrol of the 10th Cavalry in Arizona, studying the soldiers and their harsh routine. Remington spent time with the Apache who impressed him with their absolute competence in such a rugged and demanding environment. In telling of his own experiences with the buffalo soldiers, Remington was describing the environment that framed his art. "On we marched over the rolling hills, dry, parched, desolate, covered with cactus and loose stones," he wrote. "It was nature in one of her cruel moods, and the great silence over all the land displayed her mastery over man."[16]

The Waterhole is the epitome of Remington's West and how he wanted Americans to remember this last frontier. A solitary masculine hero, nature's anarchist unfettered from the civilization that Remington despised, struggles against nature. Eventually Remington believed that twentieth century civilization had actually destroyed his West. "As civilization continued its advance upon him, even memories became painful,"[17] writes one historian. The memories were so painful that Remington burned seventy-five of his old canvases in 1907, and in 1908 he destroyed twenty-seven "more of his best-known western paintings."[18] Civilization permanently altered the West, but Frederic Remington was not a failure. With his art he succeeded in perpetuating the great national epic of the frontier in the American mind.

George Catlin, Karl Bodmer, Alfred Jacob Miller, and Frederic Remington demonstrate the rich, vital contributions of all the artists of the Romantic Horizon. Together they preserved a visual record of an important chapter in American history. Without their art we would not know as much about the Native Americans or the new Americans who came to the wilderness. Ranging from the Great Lakes to the Marias River, the Wind River Mountains, the Rio Grande, and the Pacific, the artists of the Romantic Horizon sketched, painted, and immortalized the nineteenth century American wilderness. Their work informs American history and fills the American imagination. This is their legacy.

FOOTNOTES

[1]John C. Ewers, *Artists of the Old West,* enlarged ed. (Garden City, NY: Doubleday & Co., 1973), p. 105.

[2]Ibid., p. 115.

[3]Paul Russell Cutright, *A History of the Lewis and Clark Journals* (Norman, OK: University of Oklahoma Press, 1976), p. 234.

[4]Ewers, op. cit., p. 90.

[5]Reuben Gold Thwaites, ed. *Maximilian, Prince of Wied's Travels in the Interior of North America, 1832-1834,* 3 vols. (Cleveland, OH: The Arthur H. Clark Company, 1906), Vol. 2, p. 261.

[6]John C. Ewers, *Indian Life on the Upper Missouri* (Norman, OK: University of Oklahoma Press, 1968), p. 109.

[7]Thwaites, op. cit., Vol. 3, p. 48.

[8]"Journals of Prince Maximilian in North America" (Center for Western Studies, Joslyn Art Museum, unpublished) III, pp. 133-162.

[9]Thwaites, op. cit., Vol. 2, pp. 300-302; Vol. 3, pp. 17-18.

[10]"Journals of Prince Maximilian in North America," III, p. 44.

[11]Francis Chardon quoted in Davis Thomas and Karin Ronnefeldt, eds. *People of the First Man: Life Among the Plains Indians in Their Final Days of Glory* (New York: E. P. Dutton & Co., Inc., 1976), p. 207.

[12]Gerald D. Nash, *The American West in the Twentieth Century: A Short History of an Urban Oasis* (Englewood Cliffs, NJ: Prentice-Hall, Inc., 1973), p. 6; Joseph C. Porter, "The End of the Trail; The American West of Dashiell Hammett and Raymond Chandler," *The Western Historical Quarterly,* VI (October 1975), p. 412.

[13]Ibid.

[14]G. Edward White, *The Eastern Establishment and the Western Experience: The West of Frederic Remington, Theodore Roosevelt, and Owen Wister* (New Haven, CO: Yale University Press, 1968), Chapter Five, "Remington's West: Men with the Bark On."

[15]Frederic Remington quoted in *Persimmon Hill,* X (Summer 1980), p. 10.

[16]Frederic Remington, "A Scout With the Buffalo Soldiers," rep. ed. (Palmer Lake, COLO: The Filter Press, 1974), p. 36.

[17]White, op. cit., p. 120.

[18]Ibid.

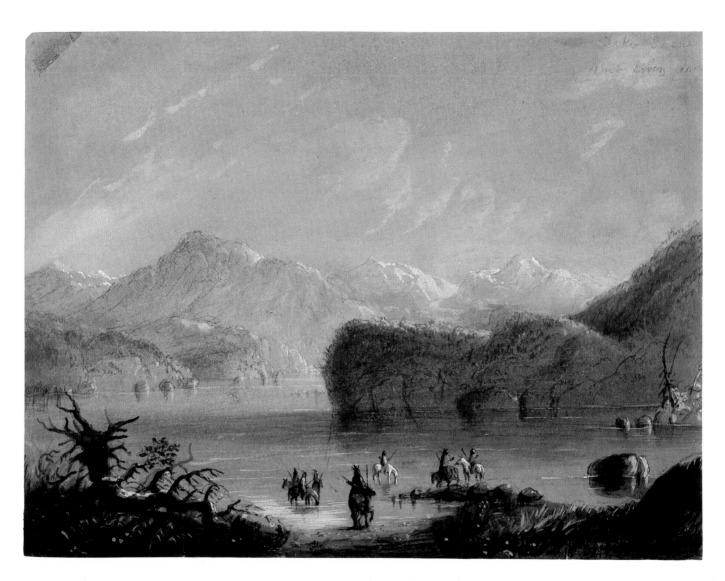

2. ALFRED JACOB MILLER, *Lake, Wind River Mountains*

ARTISTS'
BIOGRAPHIES
& CATALOGUE
ENTRIES

BY DAVID C. HUNT

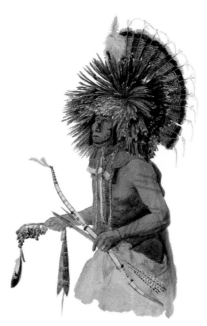

CATALOGUE ENTRY EXPLANATION

In citing dimensions, height precedes width.

Location of inscriptions is indicated
by the following abbreviations:
upper left u.l.
upper center u.c.
upper right u.r.
lower left l.l.
lower center l.c.
lower right l.r.

All works that are signed or inscribed are so noted.

KARL BODMER 1809 - 1893

Born at Riesbach near Zurich, Switzerland in 1809, Karl Bodmer at an early age came under the influence of his maternal uncle, the noted watercolorist Johann Jacob Meier. Subsequent studies in Paris further prepared him for a career as a painter. By the age of twenty-three, he was sufficiently skilled as a draftsman and watercolorist to gain the attention of zoologist Heinrich Schinz. Schinz in turn recommended him to Alexander Philip Maximilian, Prince of Wied Neuwied in Rhenish Prussia, as the artist to accompany a forthcoming expedition to North America.

An experienced world traveler and respected naturalist in his own right, Prince Maximilian had made a scientific exploration in Brazil in 1815-16. A detailed account of the venture was published at Weimar in two volumes between the years of 1820-31. No illustrator had accompanied this expedition, and Maximilian was anxious to insure that a complete pictorial documentary would be made of his intended travels in the United States and its western territories.

On July 4, 1832 Bodmer and his patron arrived in Boston and afterward visited New York and Philadelphia before traveling on to St. Louis, then gateway to the frontier. There they were welcomed in March of 1833 by retired explorer William Clark. Having first made plans to accompany a cross-country caravan bound for the annual trappers' rendezvous on the Green River in Oregon, Maximilian decided instead to visit the American Fur Company outposts along the Upper Missouri River where he felt that better opportunities for scientific research and the observation of native tribes could be obtained.

His party set out in April from St. Louis aboard the steamer *Yellowstone,* following the historic route into the continental interior discovered by Lewis and Clark nearly thirty years before. This was also the same course taken by artist George Catlin the previous year when he accompanied the *Yellowstone* on its maiden voyage upriver which at that time had not been navigated by steamboat above Council Bluffs.

After stopping at Forts Pierre and Clark, Maximilian's party continued on to Fort Union on the present North Dakota-Montana border. Not content to remain at Fort Union, Maximilian and Bodmer pushed further upriver to Fort McKenzie near the modern Great Falls, Montana. The prince took copious notes on the geology, flora, and fauna of the area while Bodmer made watercolor portraits among the Indians and sketched the wild scenery and animal life of the region.

Wintering at Fort Clark on the downward voyage, the explorers made extensive studies of the Mandan and Hidatsa tribes in the area. Bodmer captured the likenesses of Mandan chief Mato-Tope and other representatives of a nation soon to be decimated by the smallpox epidemic that swept the upper Missouri country in 1837. After nearly thirteen months spent traveling in the interior, Bodmer and Maximilian once again reached St. Louis where they packed their collections for shipment abroad and made plans to return home to Europe.

Maximilian returned to Germany to edit his field journals and afterward published an account of his travels in North America which was issued in successive German, French, and English language editions between the years of 1839-43. A supplemental picture atlas of eighty-one polychrome aquatint plates after paintings by Bodmer is now regarded as one of the most comprehensive visual surveys of the Far West ever made. This series remained of unique importance to the history of the American frontier until the middle of the present century when a more complete record of the Maximilian expedition in the form of original diaries, journals, correspondence, and more than four hundred of Bodmer's pencil sketches and watercolors was discovered in the family archives at Neuwied Castle near Coblenz at the end of World War II. Acquired in 1962 by the then Northern Natural Gas Company of Omaha, this remarkable inventory was placed on permanent loan at the Joslyn Art Museum. Today it forms one of the most important features of the Museum's western art collection.

Other reports had been published on the continental interior of North America before Maximilian's voyage up the Missouri River. The journals of the Lewis and Clark expedition of 1803-06 had contained many observations of this region's natural history and anthropology although unaccompanied by any illustrations of importance in their published form. The report of Major Stephen Long's expedition from Pittsburgh to the Rocky Mountains in 1819-21 also contributed much scientific information relative to the trans-Mississippi West as well as a few engraved views of the country by or after

Samuel Seymour. It was Maximilian's narrative, however, that revealed this vast region to an international audience. Bodmer's pictures, as reproduced in the accompanying atlas, were the first to illustrate in full color the American frontier of the early nineteenth century.

For Bodmer, his brief acquaintance with the American West gave him practical experience as an observer of nature and sharpened his skills as an illustrator, an occupation at which he later excelled. Returning to Europe in 1834 to supervise the production of the picture plates for Maximilian's account of their travels, Bodmer exhibited a selection of his American scenes at the Paris Salon with marked success. He did not again visit North America but remained in Paris eventually becoming a French citizen. He married in 1849 and moved to Barbizon near the forests of Fontainebleau, the subject of a great many of his later works. Here he associated with Millet, Corot, and other notable painters of the Barbizon School, of which he became a lifelong and distinguished member.

Bodmer was a frequent contributor to *Pictorial Magazine, L'Illustration,* and other periodicals over the years. Also an accomplished printmaker, he collaborated on at least one series of paintings with Millet which were reproduced as lithographs in the 1850s. His *Inside the Forest in Winter,* exhibited at the Paris Salon in 1850, won him a medal and afterward was purchased by the government of France and displayed at the Luxembourg Museum. He received other medals from the Salon in 1863 and at the Universal Exposition of 1865. In 1876 he was named a Chevalier of the French Legion of Honor. He remained chiefly devoted to landscape painting until his death at Barbizon in 1893.

Of further interest to students or collectors: the first or German edition of Maximilian's narrative, issued at Coblenz under the title *Reise in das Innere Nord-America in den Jahren 1832 bis 1834,* gives as its publication dates the years of 1839-41 although final delivery was not actually made until 1843. A French edition appeared in 1841. Both were sold by subscription in a continuing series that eventually numbered twenty parts, with subscribers left to make their own arrangements for binding. A London edition translated into English by H. Evans Lloyd was published as a single volume in 1843 by Ackermann and Company. The Picture Atlas (Bildatlas) of eighty-one hand-colored plates was also issued by Ackermann and Company. It featured thirty-three vignettes and forty-eight larger plates on Imperial Atlas folio paper. Respective titles for all pictures were simultaneously rendered in German, French, and English.

The vignettes were originally intended to be bound into the volume of the text, the larger plates to be issued separately. Over the four years of production the total number of aquatints was reduced to eighty-one and all were bound together in one volume. After publication

the Bodmer illustrations and the copperplates used in producing the atlas were deposited at Maximilian's estate on the Rhine near Coblenz. They remained there until rediscovered by U. S. military occupation personnel in the early 1950s. A selection of 118 of the Bodmer watercolors was brought to the United States and exhibited under the auspices of the Smithsonian Institution and the Newberry Library in Chicago in November of 1953. Continuing on tour throughout the country, this exhibition closed in Cody, Wyoming in 1959. The Bodmers were subsequently exhibited in Omaha in the fall of 1961. They were acquired the following summer with the related Maximilian material by the Northern Natural Gas Company and are at the Joslyn Art Museum.

One of Bodmer's Barbizon sketchbooks and a few sketches of Indians are included in the Lucas Collection at the Walters Art Gallery in Baltimore, Maryland. Other examples of Bodmer's work, mostly aquatints, are found in the United States at the Smithsonian Institution, the New York Historical Society, the Thomas Gilcrease Institute of American History and Art in Tulsa, and in a number of private collections both in this country and abroad.

I. GREAT AMERICAN LANDSCAPES

1. KARL BODMER
View of the Mandan Village Mih-Tutta-Hang-Kush
Watercolor on paper
11¼ x 16⅝ in. (28.5 x 42 cm.)
Signed l.l.: C. Bodmer 1834
The InterNorth Art Foundation/Joslyn Art Museum (PL 382)

Provenance:
Collection Schloss Neuwied, Germany.
M. Knoedler & Co., Inc., New York.
Northern Natural Gas Co., Omaha, Nebraska.

Literature:
American Heritage, "Carl Bodmer's Unspoiled West," Vol. XIV, no. 3, April 1963, pp. 58-59; American Heritage, *To the Pacific with Lewis and Clark,* 1967, pp. 58-59; Davidson, *The Artists' America,* 1973, p. 140; Speck, *Breeds and Half-Breeds,* 1969, p. 64; *Smithsonian,* "a great painter, a royal naturalist on the wild Missouri," Vol. 7, October 1976, p. 61; Thomas and Ronnefeldt, *People of the First Man,* 1976, pp. 226-227; Joslyn, *The Art of Exploration,* 1980, p. 18.

2. KARL BODMER
Fort McKenzie at the Mouth of the Marias River
Watercolor on paper
10¾ x 16⅞ in. (27.5 x 42.75 cm.)
Inscribed l.r.: Fort McKenzie 1833
The InterNorth Art Foundation/Joslyn Art Museum (PL 211)

Provenance:
Collection Schloss Neuwied, Germany.
M. Knoedler & Co., Inc., New York.
Northern Natural Gas Co., Omaha, Nebraska.

Literature:
Smithsonian, *Carl Bodmer Paints the Indian Frontier,* 1954,
no. 21; Joslyn, *Catlin Bodmer Miller,* 1963, p. 22 (p. 24 in 1967
ed.); McDermott, *Travelers on the Western Frontier,* 1970, fig.
12; Thomas and Ronnefeldt, *People of the First Man,* 1976,
pp. 112-113.

3. KARL BODMER
View of the Junction of the Missouri and Yellowstone Rivers
Watercolor on paper
10⅜ x 16¾ in. (26.5 x 42.5 cm.)
Signed l.l.: C. Bodmer 1833
The InterNorth Art Foundation/Joslyn Art Museum (PL 376)

Provenance:
Collection Schloss Neuwied, Germany.
M. Knoedler & Co., Inc., New York.
Northern Natural Gas Co., Omaha, Nebraska.

Literature:
Neihardt, *Cycle of the West,* 1963, jacket cover; American
Heritage, *Natural Wonders,* 1963, p. 191; American Heritage,
To the Pacific with Lewis and Clark, 1967, pp. 62-63.

4. KARL BODMER
First Chain of the Rocky Mountains
Watercolor on paper
11¾ x 16⅞ in. (30 x 43 cm.)
The InterNorth Art Foundation/Joslyn Art Museum (PL 210)

Provenance:
Collection Schloss Neuwied, Germany.
M. Knoedler & Co., Inc., New York.
Northern Natural Gas Co., Omaha, Nebraska.

Literature:
American Heritage, "Carl Bodmer's Unspoiled West," Vol.
XIV, no. 3, April 1963, p. 59; Joslyn, *Life on the Prairie,* p. 11;
Thomas and Ronnefeldt, *People of the First Man,* 1976, pp.
130-131.

5. KARL BODMER
The White Castles on the Missouri
Watercolor on paper
9 x 16⅜ in. (22.75 x 41.5 cm.)
The InterNorth Art Foundation/Joslyn Art Museum (PL 176)

Provenance:
Collection Schloss Neuwied, Germany.
M. Knoedler & Co., Inc., New York.
Northern Natural Gas Co., Omaha, Nebraska.

Literature:
Today's Art, February 1963, p. 7; *American Heritage,* "Carl
Bodmer's Unspoiled West," Vol. XIV, no. 3, April 1963, pp.
56-57; *Museum News,* November 1963, front cover; American
Heritage, *Natural Wonders,* 1963, p. 191; Cheyenne Centenni-
al, *150 Years in Western Art,* 1967, p. 9; Art in America, *The
Artist in America,* 1967, p. 61; Art in America, "The
Artist-Explorers," July-August 1972, p. 57; *Audubon Maga-
zine,* September 1974, p. 15; Thomas and Ronnefeldt, *People
of the First Man,* 1976, pp. 92-93; Joslyn, *The Art of
Exploration,* 1980, front cover.

6. KARL BODMER
Bellevue Agency - Post of Major Daugherty
Watercolor on paper
6½ x 9½ in. (16.5 x 24 cm.)
Signed l.r.: K. Bodmer, 1833
The InterNorth Art Foundation/Joslyn Art Museum (PL 371)

Provenance:
Collection Schloss Neuwied, Germany.
M. Knoedler & Co., Inc., New York.
Northern Natural Gas Co., Omaha, Nebraska.

Literature:
Today's Art, February 1963, p. 7; *American Heritage,* "Carl
Bodmer's Unspoiled West," Vol. XIV, no. 3, April 1963, p. 56;
Nicoll, *Nebraska, A Pictorial History,* 1967, p. 17; Hafen, ed.,
Mountain Men and the Fur Trade, Vol. VIII, 1971, frontis-
piece; Nebraska State Historical Society, *Nebraska History,*
Winter 1972, front cover; *Nebraska History,* "Bellevue: The
First Twenty Years, 1822-1842," Vol. 56, no. 3, Fall 1975, p.
365; Joslyn, *Artists of the Western Frontier,* 1976, p. 36;
Thomas and Ronnefeldt, *People of the First Man,* 1976, p. 44.

7. KARL BODMER
Buffalo and Elk on the Upper Missouri
Watercolor on paper
9¾ x 12¼ in. (24.75 x 31.25 cm.)
The InterNorth Art Foundation/Joslyn Art Museum (PL 214)

Provenance:
Collection Schloss Neuwied, Germany.
M. Knoedler & Co., Inc., New York.
Northern Natural Gas Co., Omaha, Nebraska.

Literature:
Museum News, "Records of a Lost World," November 1963,
p. 14; Thomas and Ronnefeldt, *People of the First Man,* 1976,
pp. 162-163.

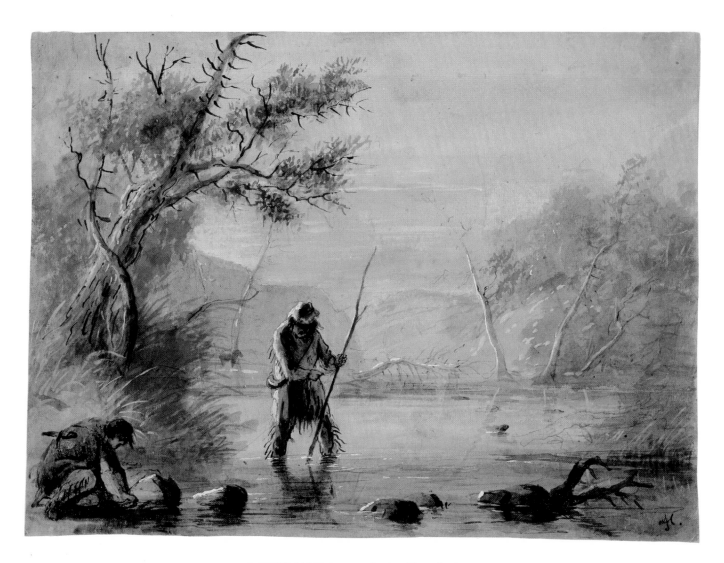

6. ALFRED JACOB MILLER, *Setting Traps for Beaver*

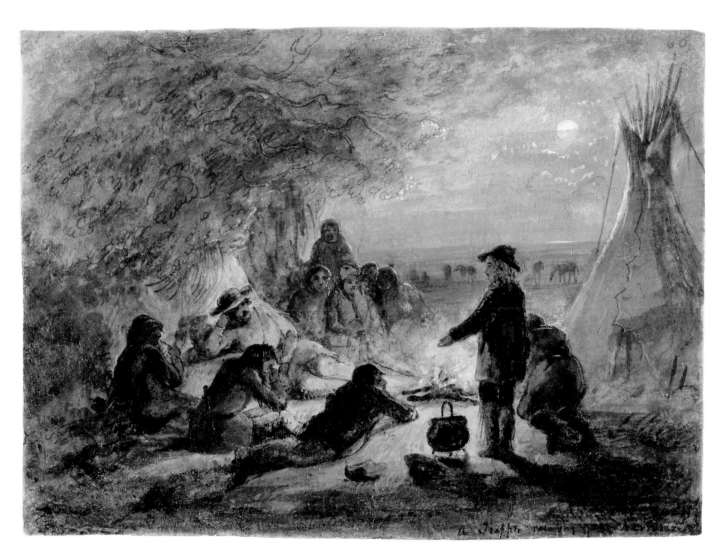

8. ALFRED JACOB MILLER, *Campfire at Night: Trapper Relating an Adventure*

II. PORTRAITS

8. KARL BODMER
Mahchsi Karehde, Mandan Indian
Watercolor on paper
16⅞ x 12 in. (43 x 30.5 cm.)
Inscribed l.r.: Machsi Karede _____ Psichida _____
The InterNorth Art Foundation/Joslyn Art Museum (PL 266)

Provenance:
Collection Schloss Neuwied, Germany.
M. Knoedler & Co., Inc., New York.
Northern Natural Gas Co., Omaha, Nebraska.

Literature:
Thomas and Ronnefeldt, *People of the First Man,* 1976, jacket
cover, p. 237; *Smithsonian,* "a great painter, a royal naturalist
on the wild Missouri," Vol. 7, October 1976, p. 67; Joslyn, *The
Art of Exploration,* 1980, p. 13.

9. KARL BODMER
*Pehriska-Rupa (Two Ravens) Chief of the Hidatsa Dog
Dancer*
Watercolor on paper
17 x 11¾ in. (43.25 x 30 cm.)
The InterNorth Art Foundation/Joslyn Art Museum (PL 275)

Provenance:
Collection Schloss Neuwied, Germany.
M. Knoedler & Co., Inc, New York.
Northern Natural Gas Co., Omaha, Nebraska.

Literature: IBM Gallery, *Art of the Western Frontier,* 1964;
Joslyn, *Life on the Prairie,* p. 12; Hollman, *Fine Artists of the
Old West,* p. 61; Thomas and Ronnefeldt, *People of the First
Man,* 1976, p. 223; Joslyn, *The Art of Exploration,* 1980, p. 20.

10. KARL BODMER
*Pehriska-Rupa (Two Ravens) Hidatsa Chief on the Upper
Missouri*
Watercolor on paper
15⅞ x 11½ in. (40.25 x 29.5 cm.)
Signed l.r.: K. Bodmer 1833
The InterNorth Art Foundation/Joslyn Art Museum (PL 390)

Provenance:
Collection Schloss Neuwied, Germany.
M. Knoedler & Co., Inc., New York.
Northern Natural Gas Co., Omaha, Nebraska.

Literature:
Mountain Plains Library Quarterly, May 1964, p. 16; Murray,
Pipes of the Plains, 1968, back cover; Thomas and Ronnefeldt,
People of the First Man, 1976, p. 222; Joslyn, *The Art of
Exploration,* 1980, p. 12.

11. KARL BODMER
Tukan-Heton (The Horned Rock)
Watercolor on paper
10⅞ x 8½ in. (27.5 x 21.5 cm.)
The InterNorth Art Foundation/Joslyn Art Museum (PL 259)

Provenance:
Collection Schloss Neuwied, Germany.
M. Knoedler & Co., Inc., New York.
Northern Natural Gas Co., Omaha, Nebraska.

Literature:
Thomas and Ronnefeldt, *People of the First Man,* 1976, p. 46.

12. KARL BODMER
Mato-Tope (The Four Bears) Mandan Chief
Watercolor on paper
13¾ x 11¼ in. (35 x 28.5 cm.)
The InterNorth Art Foundation/Joslyn Art Museum (PL 260)

Provenance:
Collection Schloss Neuwied, Germany.
M. Knoedler & Co., Inc., New York.
Northern Natural Gas Co., Omaha, Nebraska.

Literature:
American Heritage, "Carl Bodmer's Unspoiled West," Vol.
XIV, no. 3, April 1963, p. 60; Forte, *The Warrior in Art,* 1966,
p. 20; Taylor, *The Warriors of the Plains,* p. 78; *The Brand
Book,* "The O-Kee-Pa and Four Bears: An Insight into
Mandan Ethnology," Vol. 15, no. 3; *National Geographic,* "In
the Footsteps of Lewis and Clark," 1970, p. 78; Flexner,
Nineteenth Century American Painting, 1970, p. 124; University of Nebraska School of Journalism, *As Long as the Grass
Shall Grow,* June 1971, front cover; *Smithsonian,* "a great
painter, a royal naturalist on the wild Missouri," Vol. 7,
October 1976, p. 60; Thomas and Ronnefeldt, *People of the
First Man,* 1976, p. 218; Joslyn, *The Art of Exploration,* 1980,
p. 17.

13. KARL BODMER
Pachtuwa-Chta (Arikara Indian)
Watercolor on paper
17 x 12 in. (43 x 30.5 cm.)
The InterNorth Art Foundation/Joslyn Art Museum (PL 258)

Provenance:
Collection Schloss Neuwied, Germany.
M. Knoedler & Co., Inc., New York.
Northern Natural Gas Co., Omaha, Nebraska.

Literature:
Thomas and Ronnefeldt, *People of the First Man,* 1976, p. 234.

14. KARL BODMER
Pioch-Kiein (Distant Bear) A Piegan Indian
Watercolor on paper
12⅜ x 10⅛ in. (31.5 x 25.5 cm.)
The InterNorth Art Foundation/Joslyn Art Museum (PL 296)

Provenance:
Collection Schloss Neuwied, Germany.
M. Knoedler & Co., Inc., New York.
Northern Natural Gas Co., Omaha, Nebraska.

Literature:
Thomas and Ronnefeldt, *People of the First Man,* 1976, p. 133.

15. KARL BODMER
Addih-Hiddish (The One Who Makes Roads) Hidatsa Chief
Watercolor on paper
16½ x 11⅝ in. (42 x 29.75 cm.)
Signed l.r.: K. Bodmer 1833
The InterNorth Art Foundation/Joslyn Art Museum (PL 388)

Provenance:
Collection Schloss Neuwied, Germany.
M. Knoedler & Co., Inc., New York.
Northern Natural Gas Co., Omaha, Nebraska.

Literature:
Thomas and Ronnefeldt, *People of the First Man*, 1976, p. 209;
Joslyn, *The Art of Exploration*, 1980, p. 22.

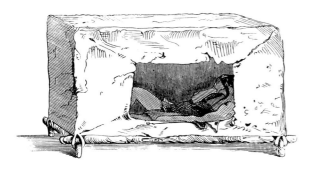

III. INDIAN LIFE AND CUSTOMS

16. KARL BODMER
Forest with Burial Scaffold near Fort Union
Watercolor on paper
12½ x 9⅞ in. (31.75 x 25.25 cm.)
The InterNorth Art Foundation/Joslyn Art Museum (PL 173)

Provenance:
Collection Schloss Neuwied, Germany.
M. Knoedler & Co., Inc., New York.
Northern Natural Gas Co., Omaha, Nebraska.

Literature:
Los Angeles County Museum of Art, *The American West*,
1972, p. 52; Joslyn, *Artists of the Western Frontier*, 1976, p. 12.

17. KARL BODMER
Medicine Sign of the Assiniboin Indians
Watercolor on paper
9⅝ x 12¼ in. (24.25 x 31 cm.)
The InterNorth Art Foundation/Joslyn Art Museum (PL 172)

Provenance:
Collection Schloss Neuwied, Germany.
M. Knoedler & Co., Inc., New York.
Northern Natural Gas Co., Omaha, Nebraska.

Literature:
American Heritage, "Carl Bodmer's Unspoiled West," Vol.
XIV, no. 3, April 1963, p. 58; Montreal Museum of Fine Arts,
The Painter and the New World, 1967, p. 291; *National*

Geographic, "In the Footsteps of Lewis and Clark," 1970, p.
96; Joslyn, *A Sense of Place*, 1973, p. 26; Thomas and Ronne-
feldt, *People of the First Man*, 1976, pp. 66-67.

18. KARL BODMER
Skull Medicine near Mih-Tutta-Hang-Kush
Watercolor and pencil on paper
8 x 10⅜ in. (20.25 x 26.25 cm.)
The InterNorth Art Foundation/Joslyn Art Museum (PL 168)

Provenance:
Collection Schloss Neuwied, Germany.
M. Knoedler & Co., Inc., New York.
Northern Natural Gas Co., Omaha, Nebraska.

Literature:
Joslyn, *Catlin Bodmer Miller*, 1963, p. 23; Thomas and
Ronnefeldt, *People of the First Man*, 1976, pp. 210-211.

19. KARL BODMER
Interior of Mandan Earth Lodge
Watercolor and ink on paper
11¼ x 16⅞ in. (28.5 x 43 cm.)
The InterNorth Art Foundation/Joslyn Art Museum (PL 261)

Provenance:
Collection Schloss Neuwied, Germany.
M. Knoedler & Co., Inc., New York.
Northern Natural Gas Co., Omaha, Nebraska.

Literature:
Flexner, *Nineteenth Century American Painting*, 1970, p.
126; Thomas and Ronnefeldt, *People of the First Man*, 1976,
pp. 230-231; *Smithsonian*, "a great painter, a royal naturalist
on the wild Missouri," Vol. 7, October 1976, p. 65; Joslyn, *The
Art of Exploration*, 1980, p. 63.

20. KARL BODMER
Leather Tent of the Dakota Tribe and Its Inhabitants
Watercolor on paper
7⅝ x 10⅜ in. (19.5 x 26.25 cm.)
The InterNorth Art Foundation/Joslyn Art Museum (PL 375)

Provenance:
Collection Schloss Neuwied, Germany.
M. Knoedler & Co., Inc., New York.
Northern Natural Gas Co., Omaha, Nebraska.

Literature:
Joslyn, *Catlin Bodmer Miller*, 1963, front cover; Thomas and
Ronnefeldt, *People of the First Man*, 1976, pp. 70-71; Joslyn,
The Art of Exploration, 1980, p. 10.

21. KARL BODMER
Leather Tents of the Assiniboins
Watercolor on paper
7½ x 10⅜ in. (19 x 26.5 cm.)
Signed l.r.: K. Bodmer
The InterNorth Art Foundation/Joslyn Art Museum (PL 379)

Provenance:
Collection Schloss Neuwied, Germany.
M. Knoedler & Co., Inc., New York.
Northern Natural Gas Co., Omaha, Nebraska.

Literature:
Museum News, "Records of a Lost World," November 1963, p.
15; Montreal Museum of Fine Arts, *The Painter and the New
World,* 1967, p. 294; Honour, *The New Golden Land,* 1975, p.
233.

22. KARL BODMER
Idols of the Mandan Indians
Watercolor on paper
10¼ x 7⅞ in. (25.5 x 20 cm.)
Signed l.r.: C. Bodmer 1833
The InterNorth Art Foundation/Joslyn Art Museum (PL 386)

Provenance:
Collection Schloss Neuwied, Germany.
M. Knoedler & Co., Inc., New York.
Northern Natural Gas Co., Omaha, Nebraska.

Literature:
American Heritage, "Carl Bodmer's Unspoiled West," Vol.
XIV, no. 3, April 1963, p. 64; *Today's Art,* "_____," February
1963, p. 6; *Museum News,* "Records of a Lost World,"
November 1963; Thomas and Ronnefeldt, *People of the First
Man,* 1976, p. 216; *Smithsonian,* "a great painter, a royal
naturalist on the wild Missouri," Vol. 7, October 1976, p. 64.

IV. THE SCIENTIFIC EYE

23. KARL BODMER
A Bison Painted Robe
Watercolor on paper
12 x 16¾ in. (30.5 x 42.5 cm.)
The InterNorth Art Foundation/Joslyn Art Museum (PL 309)

Provenance:
Collection Schloss Neuwied, Germany.
M. Knoedler & Co., Inc., New York.
Northern Natural Gas Co., Omaha, Nebraska.

Literature:
Thomas and Ronnefeldt, *People of the First Man,* 1976, p. 220.

24. KARL BODMER
Indian Artifacts
Watercolor and ink on paper
16½ x 10⅝ in. (42 x 27 cm.)
The InterNorth Art Foundation/Joslyn Art Museum (PL 310)

Provenance:
Collection Schloss Neuwied, Germany.
M. Knoedler & Co., Inc., New York.
Northern Natural Gas Co., Omaha, Nebraska.

Literature:
Joslyn, *Catlin Bodmer Miller,* 1963, p. 23 (p. 25 in 1967 ed.);
Thomas and Ronnefeldt, *People of the First Man,* 1976, p. 233.

25. KARL BODMER
Indian Weapons and Calumets
Watercolor over pencil on paper
16⅛ x 10⅛ in. (41 x 25.5 cm.)
The InterNorth Art Foundation/Joslyn Art Museum (PL 311)

Provenance:
Collection Schloss Neuwied, Germany.
M. Knoedler & Co., Inc., New York.
Northern Natural Gas Co., Omaha, Nebraska.

Literature:
Thomas and Ronnefeldt, *People of the First Man,* 1976, p. 20.

26. KARL BODMER
Pehriska-Rupa's Robe of Buffalo Hide
Watercolor on paper
14 x 17⅝ in. (35.5 x 44.5 cm.)
The InterNorth Art Foundation/Joslyn Art Museum (PL 307)

Provenance:
Collection Schloss Neuwied, Germany.
M. Knoedler & Co., Inc., New York.
Northern Natural Gas Co., Omaha, Nebraska.

27. KARL BODMER
Indian Ornaments
Watercolor over pencil on paper
16¼ x 10½ in. (41.25 x 26.75 cm.)
The InterNorth Art Foundation/Joslyn Art Museum (PL 313)

Provenance:
Collection Schloss Neuwied, Germany.
M. Knoedler & Co., Inc., New York.
Northern Natural Gas Co., Omaha, Nebraska.

28. KARL BODMER
Indian Moccasins
Watercolor and ink on paper
15⅜ x 9⅜ in. (39 x 24 cm.)
The InterNorth Art Foundation/Joslyn Art Museum (PL 314)

Provenance:
Collection Schloss Neuwied, Germany.
M. Knoedler & Co., Inc., New York.
Northern Natural Gas Co., Omaha, Nebraska.

29. KARL BODMER
Indian Weapons of the Dakotas
Watercolor over pencil on paper
10⅛ x 10⅜ in. (25.75 x 26.25 cm.)
The InterNorth Art Foundation/Joslyn Art Museum (PL 317)

Provenance:
Collection Schloss Neuwied, Germany.
M. Knoedler & Co., Inc., New York.
Northern Natural Gas Co., Omaha, Nebraska.

ALFRED JACOB MILLER 1810 - 1874

Although he was one of the first artists of ability to travel west of the Mississippi during the first half of the nineteenth century, Alfred Jacob Miller had less actual experience in the West than almost any of his contemporaries in the field. Nevertheless, because of the great number of the western views he produced following an excursion to the Rocky Mountains in 1837, he is usually included with George Catlin and Karl Bodmer as one of the three most important artists of this early period.

Born in Baltimore, Maryland, the son of a grocer, Miller showed a marked talent for drawing as a youth and studied for a period of time under Thomas Sully in Philadelphia before traveling in 1833 to Paris where he enrolled for a year at the Ecole des Beaux-Arts. After a visit to Rome and Florence, he returned to the United States in 1834 and set up a studio in Baltimore. He was not very successful at this time in establishing himself as a painter, however, and he subsequently moved to New Orleans, where he attempted to make a living as a portraitist.

It was during his first year in New Orleans that he met British sportsman and ex-military officer Captain William Drummond Stewart, who was about to embark upon one of his periodic hunting expeditions into the Far West. Impressed by what he saw of Miller's work, Stewart engaged Miller as an artist for the proposed trip which, in the company of a caravan of wagons and men of the American Fur Company, was made in the summer of 1837 along what was later designated as the Oregon Trail to Fort William on the Laramie River in present day Wyoming.

This journey took Miller eventually across the northern Rockies to the Fur Company's rendezvous on the Green River in Oregon. There he observed first-hand the life of the Indians and fur trappers of that distant country. Stewart's party returned eastward in October of that year, and Stewart proceeded on to Scotland to claim a title and estates recently inherited from a deceased brother. Miller stayed behind in New Orleans to work on a number of paintings from sketches he had made during the summer's brief excursion.

By 1838 he had completed enough pictures to mount an exhibition in Baltimore in the summer of that year. In 1839 a collection of eighteen large canvases prepared for Stewart were exhibited in New York City and the following year shipped to Scotland to decorate Stewart's

hunting lodge at Murthly Castle. Miller himself sailed for Scotland in the fall of that year, remaining abroad throughout the next year and a half. During the winter of 1841, Miller was in London where he saw the exhibition of George Catlin's celebrated Indian Gallery at the Egyptian Hall in Piccadilly and visited with Catlin himself. His later report of this interview was not altogether favorable.

Miller returned to Baltimore in 1842 and settled down to what proved to be a long and successful career as a portrait painter. He continued to reproduce his views of the Far West over the next twenty years, painting for an appreciative group of private patrons that included William T. Walters, who in 1858 ordered 200 watercolor replicas of western studies from the artist. When he died in 1874, Miller left a large volume of work illustrating his earlier western experiences with Stewart. Ignored by critics and forgotten altogether by art historians until more recently, Miller's paintings have again received attention because of their considerable documentary value in relating the details of the life of the Indian and Rocky Mountain fur trapper.

Miller recreated what was to him the colorful and exotic life of the West, emphasizing the dramatic content of his pictures which belong for the most part to the general category of narrative art. Not interested in a documentary approach, he conceived his pictures largely as souvenirs of the journey for himself and Stewart, neither of whom was concerned with the mere recording of life in the Far West. Many of Miller's paintings were admittedly anecdotal although he also painted landscapes and views of landmarks such as Independence Rock and Devil's Gate, guideposts for subsequent western migrations which had never before been recorded by an artist's brush. Attempting to record and preserve the spirit of adventure in the West, he idealized the wilderness which he saw through the eyes of a romantic. Thus, his impressions of that time and place convey to the viewer a different idea than the works of such contemporaries as Bodmer and Catlin.

Some of his western scenes were reproduced as salable prints in the 1850s. Others appeared in books such as *The Hunter-Naturalist* by C. W. Webber, published in 1851 and featuring several lithographs by or after the drawings of Miller. The largest collections of his original work are found today at the Walters Art Gal-

lery in Baltimore, the Joslyn Art Museum in Omaha, Nebraska, and the Thomas Gilcrease Institute of American History and Art in Tulsa, Oklahoma. Another important collection is owned by the Nelda C. and H. J. Lutcher Stark Foundation in Orange, Texas.

A volume of manuscript notes to 166 of his western studies, collected under the title "Rough Draughts to Notes on Indian Sketches," is preserved in the Gilcrease Library in Tulsa, and a similar volume containing the studies themselves is owned by the Walters Gallery. Based upon internal evidence, these notes seem to have been made by the artist sometime after 1859 and may have served as an outline for the text of a proposed publication. They were reproduced for the most part in *The West of Alfred Jacob Miller* by Marvin C. Ross, published in 1951 (2nd ed., 1968) by the University of Oklahoma Press at Norman.

Miller was the first American artist of his time to explore the interior of the central Rocky Mountains which Karl Bodmer never reached and George Catlin may have visited only afterward in the 1850s. Miller produced the only known views of the first Fort Laramie, then called Fort William, a wooden stockade trading post near the confluence of Laramie's Fork with the North Platte River in eastern Wyoming. After 1840 a second Fort Laramie was constructed of adobe and became a much frequented stopping place along the California-Oregon Trail. A third Fort Laramie built by the U.S. Army served for a time as the most important military installation on the far western plains until the coming of the railroad and increasing settlement following the Civil War. The first Fort Laramie was simply abandoned and the second was built a short distance downstream. Thus there were actually two separate establishments in this area. What we know of the former stockade is largely derived from Miller's descriptions of that place following his visit there in 1837.

The body of Miller's western works is thought to have eventually numbered around 700 pieces, only a portion of which was exhibited in his own day. What might be termed the rediscovery of Miller as a western painter dates from an exhibition of his work at the Peale Museum in Baltimore in 1932. The exhibition was organized by the museum's director, Macgill James, who had for some years maintained an interest in the artist and had located a number of his works with Miller's descendants in the Baltimore area. Later, authors such as Bernard DeVoto, Mae Reed Porter, and Marvin C. Ross began to take an interest in Miller's career, publishing articles and books on the subject.

Mrs. Porter eventually acquired over 100 of the paintings exhibited at the Peale Museum. Placed on the market in 1960, the Porter collection was subsequently acquired by Northern Natural Gas Company, now Inter-North, Inc., of Omaha and placed on permanent loan at the Joslyn Art Museum. Among the finest examples of Miller's early watercolors extant, some of these were reproduced as illustrations in DeVoto's book, *Across the Wide Missouri* (Boston, 1947) as well as in Porter's biography of Miller's patron Stewart entitled *Scotsman in Buckskin* (New York, 1963). A further account of Miller's adventures in the West is found in *The Fort Laramie of Alfred Jacob Miller* by Robert Combs Warner published in 1979 by the University of Wyoming at Laramie. This contains a catalogue of all known illustrations by Miller of the first Fort Laramie.

In addition to the collection acquired by InterNorth, the Joslyn also lists eight oils and one watercolor by Miller in its inventory of paintings.

I. GREAT AMERICAN LANDSCAPES

1. ALFRED JACOB MILLER
Prairie
Watercolor on paper
7⅝ x 11¾ in. (19.5 x 30 cm.)
Signed l.r.: AJM (monogram)
The InterNorth Art Foundation/Joslyn Art Museum (PL 684)

Provenance:
Mrs. Clyde Porter, Kansas City, Missouri.
M. Knoedler & Co., Inc., New York.
Northern Natural Gas Co., Omaha, Nebraska.

Literature:
City Art Museum of St. Louis, *Westward the Way*, 1954, p. 40; Buffalo Bill Historical Center, *Land of Buffalo Bill*, 1959, no. 13; Joslyn, *Artists of the Western Frontier*, 1976, p. 14.

2. ALFRED JACOB MILLER
Lake, Wind River Mountains
Watercolor on paper
9⅛ x 12⅛ in. (23.25 x 30.75 cm.)
Inscribed u.r.: Lake Scene/Wind River _____
Signed l.c.: AJM (monogram)
The InterNorth Art Foundation/Joslyn Art Museum (PL 687)

Provenance:
Carrie C. Miller, Annapolis, Maryland.
Mrs. Clyde Porter, Kansas City, Missouri.
M. Knoedler & Co., Inc., New York.
Northern Natural Gas Co., Omaha, Nebraska.

Literature:
City Art Museum of St. Louis, *Westward the Way*, 1954, p. 43 (as *Lake Scene, Wind River Mountains*).

3. ALFRED JACOB MILLER
Lake, Wind River Chain of Mountains
Watercolor on paper
7⅜ x 11⅞ in. (18.75 x 20.25 cm.)
Inscribed u.l.: Wind River Mountains
The InterNorth Art Foundation/Joslyn Art Museum (PL 689)

Provenance:
Mrs. Clyde Porter, Kansas City, Missouri.
M. Knoedler & Co., Inc., New York.
Northern Natural Gas Co., Omaha, Nebraska.

Literature:
Art Institute of Chicago, *Hudson River School and the Early American Landscape Tradition,* 1945, p. 75; DeVoto, *Across the Wide Missouri,* 1947, pl. XXIX; Buffalo Bill Historical Center, *Land of Buffalo Bill,* 1959, no. 18; Los Angeles County Museum of Art, *American West: Painters from Catlin to Russell,* 1972, p. 53; Getlein, *The Lure of the Great West,* 1973, p. 87; Joslyn, *Artists of the Western Frontier,* 1976, p. 15.

4. ALFRED JACOB MILLER
Lake - Wind River
Watercolor, gouache, and ink on paper
7⅝ x 10½ in. (19.5 x 26.75 cm.)
The InterNorth Art Foundation/Joslyn Art Museum (PL 753)

Provenance:
Carrie C. Miller, Annapolis, Maryland.
Mrs. Clyde Porter, Kansas City, Missouri.
M. Knoedler & Co., Inc., New York.
Northern Natural Gas Co., Omaha, Nebraska.

5. ALFRED JACOB MILLER
Lake Scene - Rocky Mountains
Watercolor, gouache, ink, and pencil on paper
4¾ x 7¼ in. (12 x 18.5 cm.)
Inscribed l.r.: AJM (monogram)
The InterNorth Art Foundation/Joslyn Art Museum (PL 769)

Provenance:
Mrs. Clyde Porter, Kansas City, Missouri.
M. Knoedler & Co., Inc., New York.
Northern Natural Gas Co., Omaha, Nebraska.

II. CAMPFIRES AND MOUNTAIN MEN

6. ALFRED JACOB MILLER
Setting Traps for Beaver
Watercolor, gouache, and ink on paper
8 x 11 in. (20.5 x 28 cm.)
Inscribed l.r.: AJM (monogram)
The InterNorth Art Foundation/Joslyn Art Museum (PL 680)

Provenance:
Carrie C. Miller, Annapolis, Maryland.
Mrs. Clyde Porter, Kansas City, Missouri.
M. Knoedler & Co., Inc., New York.
Northern Natural Gas Co., Omaha, Nebraska.

Literature:
Fortune, "West to the Rendezvous . . . ," Vol. 29, no. 1, January 1944, p. 120; DeVoto, *Across the Wide Missouri,* 1947, pl. XLVII; Corcoran Gallery of Art, *American Processional: The Story of Our Country,* 1950, no. 144; *American Heritage,* "Wild Freedom of the Mountain Men," Vol. 6, no. 5, August 1955, pp. 6-7; Buffalo Bill Historical Center, *Land of Buffalo Bill,* 1959, no. 9; *American Heritage, Book of the Pioneer Spirit,* 1959, pp. 162-163; Jones, *Trappers and Mountain Men,* 1961, pp. 94-95; Ewers, *Artists of the Old West,* 1965, p. 135 (p. 112 in 1974 ed.); Rasky, *The Taming of the Canadian West,* 1967, p. 120; Blassingame, *Bent's Fort, Crossroads of the Great West,* 1967, p. 20; Glendinning, *When Mountain Men Trapped Beaver,* 1967, p. 54; Shepard, ed., *Mountain Man, Indian Chief, The Life and Adventures of Jim Beckwourth,* 1968, p. 88; Hine, *American West: An Interpretive History,* 1973, p. 46; *American West,* "World of the Mountain Men . . . ," Vol. XII, September 1975, p. 30.

7. ALFRED JACOB MILLER
Group of Trappers and Indians
Watercolor and pencil on paper
5¼ x 7⅜ in. (13.5 x 18.75 cm.)
Inscribed l.r.: AJM (monogram)
The InterNorth Art Foundation/Joslyn Art Museum (PL 697)

Provenance:
Carrie C. Miller, Annapolis, Maryland.
Mrs. Clyde Porter, Kansas City, Missouri.
M. Knoedler & Co., Inc., New York.
Northern Natural Gas Co., Omaha, Nebraska.

Literature:
DeVoto, *Across the Wide Missouri,* 1947, pl. XLVI; Buffalo Bill Historical Center, *Land of Buffalo Bill,* 1959, no. 26; *Antiques,* "A 'New' Painting by Alfred Jacob Miller," Vol. 101, no. 1, January 1972, p. 224, fig. 2.

8. ALFRED JACOB MILLER
Campfire at Night: Trapper Relating an Adventure
Watercolor, gouache, ink, and pencil on paper
7½ x 10 in. (19 x 25.5 cm.)
Inscribed u.r.: 60
Inscribed l.r.: Camp Scene/A Trapper relating an adventure
The InterNorth Art Foundation/Joslyn Art Museum (PL 700)

Provenance:
Carrie C. Miller, Annapolis, Maryland.
Mrs. Clyde Porter, Kansas City, Missouri.
M. Knoedler & Co., Inc., New York.
Northern Natural Gas Co., Omaha, Nebraska.

Literature:
DeVoto, *Across the Wide Missouri,* 1947, pl. XLIV, (as *Trapper Relating an Adventure*); William Rockhill Nelson Gallery and Atkins Museum of Fine Arts, *Last Frontier,* 1957, no. 37, (as *Trapper Relating an Adventure*); Buffalo Bill Historical Center, *Land of Buffalo Bill,* 1959, no. 29; *Life,* "How the West Was Won: Part I," Vol. 46, no. 14, April 1959, p. 92; Porter and Davenport, *Scotsman in Buckskin,* 1963, p. 148; Brown, ed., *Exploring with American Heroes,* 1967, p. 167; Hine, *American West: An Interpretive History,* 1973, p. 49; St. Stephens

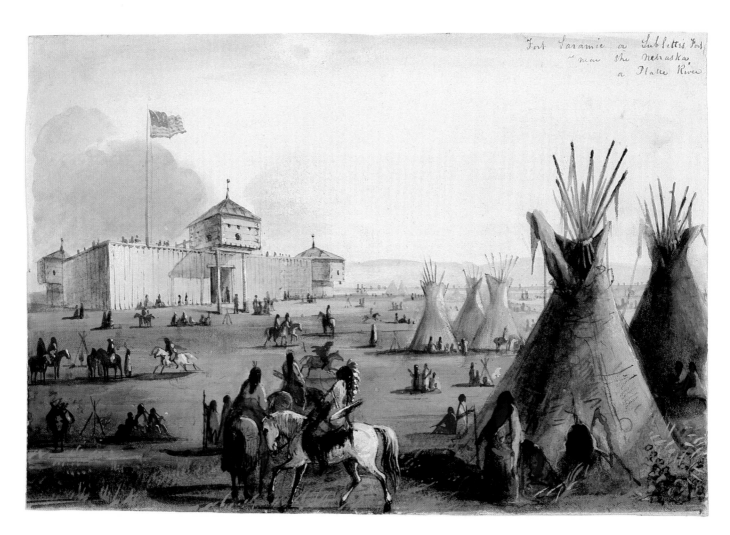

11. ALFRED JACOB MILLER, *Fort Laramie or Sublette's Fort*

Indian Mission, St. Stephens, Wyoming, *The Wind River Rendezvous,* Vol. VI, no. 5, 1976, p. 7.

9. ALFRED JACOB MILLER
Making Presents to Snake Indians
Watercolor on paper
7 x 6¼ in. (17.75 x 16 cm.)
Inscribed u.c.: Presents to the Snake Indians
The InterNorth Art Foundation/Joslyn Art Museum (PL 741)

Provenance:
Carrie C. Miller, Annapolis, Maryland.
Mrs. Clyde Porter, Kansas City, Missouri.
M. Knoedler & Co., Inc., New York.
Northern Natural Gas Co., Omaha, Nebraska.

Literature:
DeVoto, *Across the Wide Missouri,* 1947, pl. LXXIII; Buffalo Bill Historical Center, *Land of Buffalo Bill,* 1959, no. 70; Blassingame, *Bent's Fort: Crossroads of the Great West,* 1967, p. 36; Muench & Pike, *Rendezvous Country,* 1975, p. 110; Bennett, *Adventurers in Buckskin,* p. 57.

10. ALFRED JACOB MILLER
Sunrise, Trappers and Voyageurs at their Meals of Buffalo Hump Rib
Watercolor on tracing paper
7⅝ x 9 in. (19.5 x 23 cm.)
Inscribed u.r.: Trappers & Voyageurs at their meal of buffalo hump rib
The InterNorth Art Foundation/Joslyn Art Museum (PL 743)

Provenance:
Carrie C. Miller, Annapolis, Maryland.
Mrs. Clyde Porter, Kansas City, Missouri.
M. Knoedler & Co., Inc., New York.
Northern Natural Gas Co., Omaha, Nebraska.

Literature:
DeVoto, *Across the Wide Missouri,* 1947, pl. XLV, (as *Trappers and Voyageurs at Their Meal of Buffalo Hump Rib*); William Rockhill Nelson Gallery and Atkins Museum of Fine Arts, *Last Frontier,* 1957, no. 38 (as *Trappers and Voyageurs at Their Meal of Buffalo Hump Rib*); Buffalo Bill Historical Center, *Land of Buffalo Bill,* 1959, no. 72; *National Geographic,* Vol. 128, no. 5, November 1965, p. 651; Blassingame, *Bent's Fort: Crossroads of the Great West,* 1967, p. 65; Schomaekers, *Der Wilde Westen,* 1972, p. 36; *Reader's Digest,* "The Story of America," 1975, p. 160; Bennett, *Adventurers in Buckskin,* p. 65; St. Stephens Indian Mission, St. Stephens, Wyoming, *The Wind River Rendezvous,* Vol. VI, no. 5, 1976, p. 7.

III. FORTS, ENCAMPMENTS, AND WAGON TRAINS

11. ALFRED JACOB MILLER
Fort Laramie or Sublette's Fort
Watercolor, gouache, ink, and pencil on paper
6½ x 9½ in. (16.5 x 24 cm.)
Inscribed u.r.: Fort Laramie or Sublette's Fort - near the

Nebraska or Platte River
The InterNorth Art Foundation/Joslyn Art Museum (PL 672)

Provenance:
Carrie C. Miller, Annapolis, Maryland.
Mrs. Clyde Porter, Kansas City, Missouri.
M. Knoedler & Co., Inc., New York.
Northern Natural Gas Co., Omaha, Nebraska.

Literature:
Hafen and Young, *Fort Laramie and the Pageant of the West, 1834-1890,* 1938, frontispiece; Hafen and Rister, *Western America: The Exploration, Settlement and Development of the Region beyond the Mississippi,* 1941, p. 229; Fortune, "West to the Rendezvous . . . ," Vol. 29, no. 1, January 1944, p. 118; DeVoto, *Across the Wide Missouri,* 1947, pl. VIII; City Art Museum of St. Louis, *Westward the Way,* 1954, p. 217; Denver Art Museum, *Building the West,* 1955, p. 11; American Heritage, *Book of Great Historic Places,* 1957, p. 342; William Rockhill Nelson Gallery and Atkins Museum of Fine Arts, *Last Frontier,* 1957, no. 34; Buffalo Bill Historical Center, *Land of Buffalo Bill,* 1959, no. 1; Gregg and McDermott, ed., *Prairie and Mountain Sketches,* 1957, cover and frontispiece; McCracken, *Portrait of the Old West,* 1962; *Museum News,* "Records of a Lost World," Vol. 42, no. 3, November 1963, p.16; Joslyn, *Catlin Bodmer Miller,* 1963, p. 30; Porter and Davenport, *Scotsman in Buckskin,* 1963, p. 148; Hafen, *The Mountain Men and the Fur Trade of the Far West,* Vol 1, 1965, p. 153; Ewers, *Artists of the Old West,* 1965, pp. 126-127; *Art in America,* ed., *The Artist in America,* 1967, p. 55; Hawgood, *The American West,* 1967, p. 128; *Real West,* "The West of Alfred Jacob Miller," Vol. XVI, no. 117, July 1973, p. 51; *Art News,* Vol 74, no. 10, December 1975, cover.

12. ALFRED JACOB MILLER
Scene Near Fort Laramie
Watercolor on paper
7 x 12⅛ in. (17.75 x 31 cm.)
Inscribed l.r.: AJM (monogram)
The InterNorth Art Foundation/Joslyn Art Museum (PL 691)

Provenance:
Carrie C. Miller, Annapolis, Maryland.
Mrs. Clyde Porter, Kansas City, Missouri.
M. Knoedler & Co., Inc., New York.
Northern Natural Gas Co., Omaha, Nebraska.

Literature:
DeVoto, *Across the Wide Missouri,* 1947, pl. VII; William Rockhill Nelson Gallery and Atkins Museum of Fine Arts, *Last Frontier,* 1957, no. 36; Buffalo Bill Historical Center, *Land of Buffalo Bill,* 1959, no. 20.

13. ALFRED JACOB MILLER
Cut Rocks
Watercolor, gouache, ink, and pencil on paper
5¾ x 8½ in. (14.5 x 21.5 cm.)
Inscribed u.r.: Cut Rocks
Inscribed l.l.: AJM (monogram)
The InterNorth Art Foundation/Joslyn Art Museum (PL 698)

Provenance:
Carrie C. Miller, Annapolis, Maryland.
Mrs. Clyde Porter, Kansas City, Missouri.
M. Knoedler & Co., Inc., New York.
Northern Natural Gas Co., Omaha, Nebraska.

Literature:
Fortune, "The Trail West: A Portfolio," Vol. 29, no. 1, January 1944, p. 111; Buffalo Bill Historical Center, *Land of Buffalo Bill,* 1959, no. 27.

14. ALFRED JACOB MILLER
Encampment on Green River at the Base of the Rocky Mountains
Watercolor on paper
8¼ x 14⅜ in. (21 x 36.5 cm.)
Inscribed u.r.: Encampment on Green River at the base of the Rocky Mountains
Inscribed u.l.: Blkfeet as hostages _____eds _____waters
The InterNorth Art Foundation/Joslyn Art Museum (PL 724)

Provenance:
Carrie C. Miller, Annapolis, Maryland.
Mrs. Clyde Porter, Kansas City, Missouri.
M. Knoedler & Co., Inc., New York.
Northern Natural Gas Co., Omaha, Nebraska.

Literature:
DeVoto, *Across the Wide Missouri,* 1947, pl. XXXIII; Buffalo Bill Historical Center, *Land of Buffalo Bill,* 1959, no. 53 (as *Encampment of Indians near the Rocky Mountains*); *Life,* "How the West Was Won: Part I," Vol. 46, no. 14, April 1959, p. 92; Porter and Davenport, *Scotsman in Buckskin,* 1963, p. 148; Hawgood, *America's Western Frontiers: The Exploration and Settlement of the Trans-Mississippi West,* 1967, p. 100; Hawgood, *The American West,* 1967, p. 112; St. Stephens Indian Mission, St. Stephens, Wyoming, *The Wind River Rendezvous,* Vol. VI, January-February 1967, p. 9; Hine, *American West: An Interpretive History,* 1973, p. 53 (as *Indian Encampment near Green River Rendezvous*); Joslyn, *Artists of the Western Frontier,* 1976, p. 15.

15. ALFRED JACOB MILLER
The Cavalcade or Caravan
Watercolor, gouache, and pen on paper
9 x 15 in. (23 x 38 cm.)
Inscribed u.r.: The Caravan
Inscribed l.c.: AJM (monogram)
The InterNorth Art Foundation/Joslyn Art Museum (PL 726)

Provenance:
Mrs. Clyde Porter, Kansas City, Missouri.
M. Knoedler & Co., Inc., New York.
Northern Natural Gas Co., Omaha, Nebraska.

Literature:
Buffalo Bill Historical Center, *Land of Buffalo Bill,* 1959, no. 55; *Life,* "How the West Was Won: Part I," Vol. 46, no. 14, April 1959, pp. 90-91; Porter and Davenport, *Scotsman in Buckskin,* 1963, p. 148; Joslyn, *Catlin Bodmer Miller,* 1963, p. 24 (p. 26 in 1967 ed.); Sprague, *A Gallery of Dudes,* 1966, p. 20; Hawgood, *The American West,* 1967, p. 128; Hawgood, *America's Western Frontiers: The Exploration and Settlement*

of the Trans-Mississippi West, 1967, p. 127; Blassingame, *Bent's Fort: Crossroads of the Great West,* 1967, p. 57; Bennett, *Adventurers in Buckskin,* pp. 22-23; Lakeview Center for Arts and Sciences, Peoria, Illinois, *Westward the Artist,* 1968, no. 95; *American West,* "Hunter and the Naturalist," Vol. 6, no. 6, November 1969, pp. 4-5; *Real West Magazine,* "The West of Alfred Jacob Miller," Vol, XVI, no. 117, July 1973, p. 50.

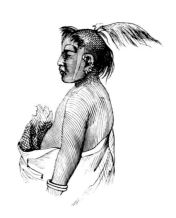

IV. INDIAN LIFE AND CUSTOMS

16. ALFRED JACOB MILLER
Kansas Tribe
Watercolor on paper
6⅛ x 7¾ in. (16.5 x 20 cm.)
Inscribed l.r.: Kansas
The InterNorth Art Foundation/Joslyn Art Museum (PL 701)

Provenance:
Carrie C. Miller, Annapolis, Maryland.
Mrs. Clyde Porter, Kansas City, Missouri.
M. Knoedler & Co., Inc., New York.
Northern Natural Gas Co., Omaha, Nebraska.

Literature:
Buffalo Bill Historical Center, *Land of Buffalo Bill,* 1959, no. 30.

17. ALFRED JACOB MILLER
Embroidering the War Costume
Watercolor, gouache, ink, and graphite on paper
6¼ x 5⅛ in. (16 x 13 cm.)
Inscribed u.l.: 77
Inscribed l.l.: AJM (monogram)
Inscribed l.r.: Embroidering the War Costume
The InterNorth Art Foundation/Joslyn Art Museum (PL 705)

Provenance:
Carrie C. Miller, Annapolis, Maryland.
Mrs. Clyde Porter, Kansas City, Missouri.
M. Knoedler & Co., Inc., New York.
Northern Natural Gas Co., Omaha, Nebraska.

Literature:
DeVoto, *Across the Wide Missouri,* 1947, pl. XXXVI; Buffalo Bill Historical Center, *Land of Buffalo Bill,* 1959, no. 34.

18. ALFRED JACOB MILLER
Trapper and Snake Indians Conversing by Sign
Watercolor, gouache, and ink on paper
9 x 13⅞ in. (23 x 35.25 cm.)
Inscribed u.l.: Trapper & Snake Indians Conversing by Signs
Inscribed l.r.: Trappers & Snake Indians
Inscribed l.l.: AJM (monogram)
The InterNorth Art Foundation/Joslyn Art Museum (PL 712)

Provenance:
Carrie C. Miller, Annapolis, Maryland.
Mrs. Clyde Porter, Kansas City, Missouri.
M. Knoedler & Co., Inc., New York.
Northern Natural Gas Co., Omaha, Nebraska.

Literature:
Buffalo Bill Historical Center, *Land of Buffalo Bill,* 1959, no.
41.

19. ALFRED JACOB MILLER
Indians Testing Their Bows
Watercolor and ink on paper
7¼ x 10¾ in. (18.5 x 27.25 cm.)
Inscribed l.r.: Indians testing their bows
Inscribed l.l.: AJM (monogram)
The InterNorth Art Foundation/Joslyn Art Museum (PL 737)

Provenance:
Mrs. Clyde Porter, Kansas City, Missouri.
M. Knoedler & Co., Inc., New York.
Northern Natural Gas Co., Omaha, Nebraska.

Literature:
Buffalo Bill Historical Center, *Land of Buffalo Bill,* 1959, no.
66; Muench and Pike, *Rendezvous Country,* 1975, pp.
104-105.

20. ALFRED JACOB MILLER
Indian Family
Watercolor on paper
7 x 9½ in. (17.75 x 24 cm.)
Inscribed l.r.: AJM (monogram)
The InterNorth Art Foundation/Joslyn Art Museum (PL 749)

Provenance:
Carrie C. Miller, Annapolis, Maryland.
Mrs. Clyde Porter, Kansas City, Missouri.
M. Knoedler & Co., Inc., New York.
Northern Natural Gas Co., Omaha, Nebraska.

Literature:
Buffalo Bill Historical Center, *Land of Buffalo Bill,* 1959, no.
78.

21. ALFRED JACOB MILLER
Pawnee Supplying Camp
Watercolor on paper
9 x 7¼ in. (23 x 18.5 cm.)
Inscribed l.c.: Pawnee Supplying Camp
Inscribed l.r.: A.J.M.
The InterNorth Art Foundation/Joslyn Art Museum (PL 761)

Provenance:
Carrie C. Miller, Annapolis, Maryland.
Mrs. Clyde Porter, Kansas City, Missouri.
M. Knoedler & Co., Inc., New York.
Northern Natural Gas Co., Omaha, Nebraska.

22. ALFRED JACOB MILLER
Crossing the Divide, Thirsty Trappers Making a Rush for the River
Watercolor, gouache, ink, and graphite on paper
8½ x 11½ in. (21.5 x 29.25 cm.)
Inscribed u.l.: 110
Inscribed u.r.: Crossing the Divide/Rush for water
The InterNorth Art Foundation/Joslyn Art Museum (PL 763)

Provenance:
Mrs. Clyde Porter, Kansas City, Missouri.
M. Knoedler & Co., Inc., New York.
Northern Natural Gas Co., Omaha, Nebraska.

Literature:
Ewers, *Artists of the Old West,* 1965, p. 122 (as *Crossing the Divide*), (p. 114 in 1974 ed.).

V. HUNTING AND RIDING

23. ALFRED JACOB MILLER
Yell of Triumph
Watercolor, graphite, and ink on tissue paper
9¼ x 13¾ in. (23.5 x 35 cm.)
Inscribed u.l.: Yell of Triump (sic)
Inscribed l.r.: AJM (monogram)
The InterNorth Art Foundation/Joslyn Art Museum (PL 713)

Provenance:
Mrs. Clyde Porter, Kansas City, Missouri.
M. Knoedler & Co., Inc., New York.
Northern Natural Gas Co., Omaha, Nebraska.

Literature:
Buffalo Bill Historical Center, *Land of Buffalo Bill,* 1959, no.
42.

24. ALFRED JACOB MILLER
Buffalo Chase by Snake Indians
Watercolor, graphite, and local glazes on paper
8¼ x 13¼ in. (21 x 33.5 cm.)
Inscribed u.l.: Buffalo Chase/ by Snake Indians Near Independence Rock
Inscribed l.r.: AJM (monogram)
The InterNorth Art Foundation/Joslyn Art Museum (PL 718)

Provenance:
Carrie C. Miller, Annapolis, Maryland.
Mrs. Clyde Porter, Kansas City, Missouri.
M. Knoedler & Co., Inc., New York.
Northern Natural Gas Co., Omaha, Nebraska.

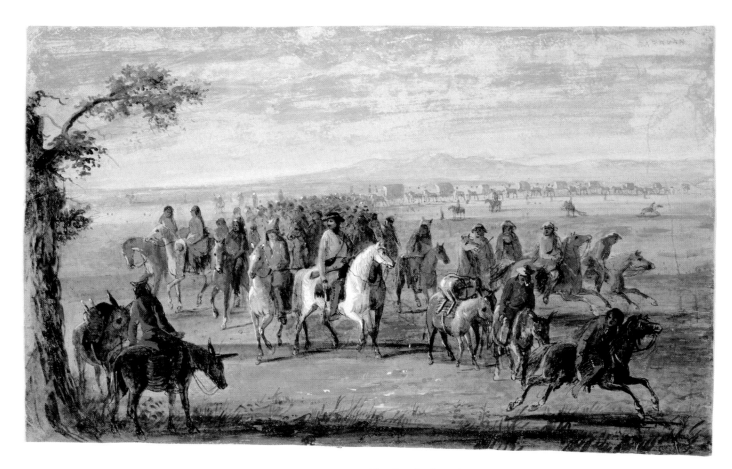

15. ALFRED JACOB MILLER, *The Cavalcade* or *Caravan*

Literature:
DeVoto, *Across the Wide Missouri,* 1947, pl. LVIII, (as *Buffalo Chase*); Buffalo Bill Historical Center, *Land of Buffalo Bill,* 1959, no. 47.

25. ALFRED JACOB MILLER
A Surround
Watercolor on paper
9¼ x 14⅝ in. (23.5 x 37.25 cm.)
Inscribed u.r.: Buffalo.--
Inscribed l.r.: A Surround
The InterNorth Art Foundation/Joslyn Art Museum (PL 729)

Provenance:
Carrie C. Miller, Annapolis, Maryland.
Mrs. Clyde Porter, Kansas City, Missouri.
M. Knoedler & Co., Inc., New York.
Northern Natural Gas Co., Omaha, Nebraska.

Literature:
Fortune, "West to the Rendezvous . . . ," Vol. 29, no. 1, January 1944, p. 119; DeVoto, *Across the Wide Missouri,* 1947, pl. V; Buffalo Bill Historical Center, *Land of Buffalo Bill,* 1959, no. 58, 74; *Museum News,* "Records of a Lost World," Vol. 42, no. 3, November 1963, p. 17 (as *A Surround of the Buffaloes*); *Real West Magazine,* "The West of Alfred Jacob Miller," Vol. XVI, no. 117, July 1973, p. 52.

26. ALFRED JACOB MILLER
Lassoing Wild Horses
Watercolor on paper
8⅛ x 10⅜ in. (20.75 x 26.5 cm.)
Inscribed l.l.: AJM (monogram)
The InterNorth Art Foundation/Joslyn Art Museum (PL 748)

Provenance:
Mrs. Clyde Porter, Kansas City, Missouri.
M. Knoedler & Co., Inc., New York.
Northern Natural Gas Co., Omaha, Nebraska.

Literature:
Buffalo Bill Historical Center, *Land of Buffalo Bill,* 1959, no. 77; Ewers, *Artists of the Old West,* 1965, p. 132 (as *Chasing Wild Horses*), (p. 112 in 1974 ed.).

27. ALFRED JACOB MILLER
Driving Herds of Buffalo over a Precipice
Watercolor, ink, and graphite on paper
7⅝ x 12⅛ in. (19.25 x 30.75 cm.)
Inscribed u.l.: 65
The InterNorth Art Foundation/Joslyn Art Museum (PL 783)

Provenance:
Banamy Mansell Power, Great Yarmouth, England.
Edward Power, Great Yarmouth, England.
Major G.H. Power, Great Yarmouth, England.
Parke-Bernet Galleries, New York.
Northern Natural Gas Co., Omaha, Nebraska.

Literature:
Ross, *The West of Alfred Jacob Miller,* 1951, pl. 207; Parke-Bernet Galleries, Inc., New York, Sale Number 2436,

no. 40, May 6, 1966, p. 29; Snyder, *In the Footsteps of Lewis and Clark,* 1970, p. 100; Reader's Digest Association, *Scenic Wonders of America,* 1973, pp. 12-13; Reader's Digest Association, *Best of the West, A Treasury of Western Adventure,* 1976, pp. 14-15.

VI. PORTRAITS AND FIGURE STUDIES

28. ALFRED JACOB MILLER
Indian Girl With Papoose Fording a Stream
Watercolor on paper
9½ x 7⅞ in. (24 x 19.75 cm.)
Inscribed u.r.: Indian Girl with papoose - fording a Stream
Inscribed l.r.: AJM (monogram)
Inscribed l.c.: 27
The InterNorth Art Foundation/Joslyn Art Museum (PL 679)

Provenance:
Carrie C. Miller, Annapolis, Maryland.
Mrs. Clyde Porter, Kansas City, Missouri.
M. Knoedler & Co., Inc., New York.
Northern Natural Gas Co., Omaha, Nebraska.

Literature:
Buffalo Bill Historical Center, *Land of Buffalo Bill,* 1959, no. 8.

29. ALFRED JACOB MILLER
Sioux Brave
Watercolor on paper
8¼ in. diameter (tondo)
Inscribed l.r.: AJMiller
The InterNorth Art Foundation/Joslyn Art Museum (PL 762)

Provenance:
Mrs. Clyde Porter, Kansas City, Missouri.
M. Knoedler & Co., Inc., New York.
Northern Natural Gas Co., Omaha, Nebraska.

Literature:
Ross, *The West of Alfred Jacob Miller,* 1968, jacket cover and frontispiece.

30. ALFRED JACOB MILLER
Antoine - Principal Hunter
Watercolor and pencil on paper
8⅞ x 7⅞ in. (22.5 x 20 cm.) oval
Inscribed l.c.: AJM (monogram)
Inscribed l.r.: Antoine/Principal Hunter to the Camp
The InterNorth Art Foundation/Joslyn Art Museum (PL 766)

Provenance:
Mrs. Clyde Porter, Kansas City, Missouri.
M. Knoedler & Co., Inc., New York.
Northern Natural Gas Co., Omaha, Nebraska.

Literature:
Porter and Davenport, *Scotsman in Buckskin,* 1963, p. 148.

31. ALFRED JACOB MILLER
Kansas Indian - Head
Watercolor on paper
6¼ x 5⅛ in. (16 x 13 cm.)
The InterNorth Art Foundation/Joslyn Art Museum (PL 776)

Provenance:
Mrs. Clyde Porter, Kansas City, Missouri.
M. Knoedler & Co., Inc., New York.
Northern Natural Gas Co., Omaha, Nebraska.

Literature:
Joslyn, *Catlin Bodmer Miller,* 1963, p. 30 (p. 31 in 1967 ed.).

32. ALFRED JACOB MILLER
Kansas Indian
Watercolor on paper
6⅛ x 4⅞ in. (15.5 x 12.5 cm.)
Inscribed l.r.: Kansas/Indian
The InterNorth Art Foundation/Joslyn Art Museum (PL 778)

Provenance:
Mrs. Clyde Porter, Kansas City, Missouri.
M. Knoedler & Co., Inc., New York.
Northern Natural Gas Co., Omaha, Nebraska.

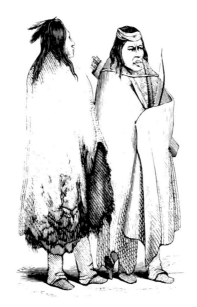

ARTISTS OF THE WESTERN FRONTIER

THOMAS ALLEN, 1849-1926. A man whose combined business experience and training in art fitted him to perform many public services on behalf of the arts, Thomas Allen was born in St. Louis, Missouri in 1849, the son of railroad builder and Congressman Thomas Allen.

He was educated at Washington University in St. Louis where, during his second year, he took advantage of an opportunity to accompany Professor J. W. Pattison on a sketching trip to the Rocky Mountains west of Denver. This experience, occurring in the summer of 1869, seems to have encouraged a latent interest in art, prompting Allen to seek further instruction in drawing and painting.

In 1871 he went to Paris for study and from there to Dusseldorf where he entered the Royal Academy in the spring of 1872. In Dusseldorf Allen was instructed by Professor Carl Muller in basic art classes and by Eugene Ducker in advanced painting. During vacations he traveled widely, visiting the art centers of the Continent and Great Britain.

Allen graduated from the Dusseldorf Academy in 1877, this same year exhibiting for the first time at the Paris Salon and at the National Academy of Design in New York City. Following a brief visit home and a trip to Texas in 1878-79, he returned to France for further study, again exhibiting at the Paris Salon in 1880 and 1882.

As a result of his sojourn in Texas, Allen produced several works for which he is best known today: *The Old Market Place, San Antonio,* first exhibited in Paris in 1881, and *Portals of Mission San Jose, Texas,* now in the collection of the Museum of Fine Arts, Boston. He was primarily devoted to city and landscape painting throughout most of his life.

Eventually returning permanently to the United States, he opened a studio in Boston where he became a member of the Boston Art Club and the American Society of Artists. In 1884 he was elected an Associate Member of the National Academy of Design. Having entered business as president of the MacAllen Company of Boston, and also later associated with the Wellesley Knitting Mills of Wellesley, Massachusetts, he became an acknowledged leader in both art and business circles, serving on various public boards involved in civic and cultural affairs.

In 1893 he was a member of the International Board of Judges of Awards at the World's Columbian Exposition in Chicago. In 1904 he served as chairman of the Jury of Paintings at the World's Fair in St. Louis. Allen also served over the years as vice president of the Boston Art Club, chairman of the School of Drawing and Painting at the Museum of Fine Arts, and chairman of the Arts Commission for the City of Boston. He was elected president of the Board of Trustees of the Museum of Fine Arts in 1924, the year of his death at Worcester, Massachusetts at the age of seventy-four.

The small watercolor entitled *Wagon Train* in the InterNorth collection is one of his early depictions of a western subject. It is dated 1878, the year in which he visited San Antonio, Texas.

1. THOMAS ALLEN
Wagon Train, 1878
Watercolor on paper
3⅞ x 5⅝ in. (9.7 x 14.3 cm.)
Signed l.r.: Allen 78
The InterNorth Art Foundation/Joslyn Art Museum (PL 785)

Provenance:
M. Knoedler & Co., Inc., New York.
Northern Natural Gas Co., Omaha, Nebraska.

ALBERT BIERSTADT, 1830-1902. Reportedly inspired to venture into the American West and capture its scenery after seeing an exhibition of the paintings of Frederic Church, Albert Bierstadt was among the first to depict for an increasingly appreciative public the visual splendors of the wilderness. Like Church, he became one of the most celebrated landscape painters of the latter half of the nineteenth century. Although largely neglected for over half a century following his death, his works today enjoy some of the critical acclaim they once received during his lifetime.

Born at Solingen, Westphalia, in the German Rhineland, Bierstadt was brought to the United States by his parents in 1832 and grew up in New Bedford,

Massachusetts. Discouraged in his early efforts to become a painter, he showed sufficient development at the age of twenty-one to exhibit at the New England Art Union in Boston in 1851 and again in 1853. In the latter year, he sailed for Europe to seek formal instruction. He studied at the famed Dusseldorf Academy in 1853-54 with Emmanuel Leutze and American landscape painter Thomas Worthington Whittredge. During this period he seems to have acquired a taste for the grandiose, so characteristic of his later work, absorbing much in terms of attitude and sentiment associated with the Romantic movement of the time.

After nearly four years spent abroad including a sketching tour of the Alps, a winter in Rome with Whittredge, and a walking tour through the Apennines with fellow artist Sanford R. Gifford, Bierstadt returned to Massachusetts in the spring of 1857 and spent a part of that summer in the White Mountains of New Hampshire with his brother Edward, a noted scenic photographer. In April of 1858, he traveled to St. Louis at the invitation of Frederick West Lander to join a military expedition being outfitted to survey an overland wagon route between Fort Laramie, Wyoming and the Pacific Coast.

Sketching in the Laramie Mountains and the Wind River country of southern Oregon through the summer of 1859, Bierstadt returned to the East and in 1860 exhibited the first of his Rocky Mountain landscapes at the National Academy of Design. Recognition of his work was immediate, and he was promptly elected to membership in the Academy that same year.

Encouraged by his initial success, Bierstadt again traveled westward in 1863 with journalist Fitz Hugh Ludlow, passing through Nebraska, Kansas, Colorado, and Utah on his way to California. By 1866, date of yet another western excursion, he was enjoying his greatest publicity, his works bringing higher prices than any American artist had commanded to that time.

Bierstadt married in 1866 and began the construction of a palatial thirty-five room mansion and studio overlooking the Hudson River near Irvington, New York. From this studio he produced a large volume of work over the next sixteen years. He continued to travel extensively in the United States, Canada, the Bahamas, and Europe, where he received numerous decorations and awards. At least twice between the years of 1867 and 1878, he went abroad on commissions from the U.S. Government to research the backgrounds of proposed historical paintings for the Capitol Building in Washington.

From 1871 to 1873 Bierstadt was again in California, maintaining a temporary studio in San Francisco where he produced a notable series of paintings of the Yosemite area, the Sierras, and Pacific coastal environs. It was during his return from California in 1873 that he stayed for a while as a guest at the Colorado ranch of the English Earl of Dunraven. He explored the vast country

he had visited a decade before and later painted a famous view of Long's Peak that is now in the collection of The Metropolitan Museum of Art.

Although spectacular, Bierstadt's popularity was relatively short-lived. His eclipse in the 1880s was nearly as swift as his earlier rise to fame and fortune. In 1882 his studio on the Hudson burned. He opened another studio in New York City, but from about this time gallery dealers began handling fewer of his large landscapes, preferring the work of the French painters then coming into vogue.

In 1884 he made another trip to the Pacific Coast and in 1885 began work on a series of paintings of the wild animals of North America. In 1889 a committee of New York artists refused to include his canvas, *The Last of the Buffalo*, in the forthcoming American Exhibit in Paris, regarding it as out of keeping with then current artistic trends.

His wife Rosalie died in 1893. Undaunted, the aging Bierstadt married again the following year. Despite a declining reputation, he continued to paint his romantic western views, selling at much reduced prices until his death in New York City in 1902. As with some other of his works, *The Last of the Buffalo* was reproduced commercially, and lithographic copies were sold to a public whose taste was less demanding than that of the professional academicians. The original may be seen today at the Whitney Gallery of Western Art in Cody, Wyoming.

A marked revival of interest in Bierstadt is evident among modern critics and collectors who now regard him as an outstanding exponent of what has come to be called the Rocky Mountain School of American landscape painting. The western landscape tradition itself is now viewed by many as a continuing expression of principles earlier espoused by such artists as Thomas Cole, Asher B. Durand, Church, Whittredge, and other Hudson River School painters with whom Bierstadt had a formative association.

Like other artists of his day, Bierstadt painted multiple versions of his more popular works and several were reproduced as lithographic copies for sale. *Indian Encampment in the Rockies,* one of his largest productions, was also one of his most widely shown and copied. First exhibited in New York City in 1863, it was shown with considerable attention in art circles and in the press. It quickly established Bierstadt as a formidable rival to Church, who to that time had been considered the unchallenged leader in America of the panoramic landscape view.

Works by Bierstadt are widely represented throughout the United States and Europe at the present time. Notable collections are found at the National Museum of American Art at the Smithsonian Institution, the Museum of Fine Arts, Boston, and the Thomas Gilcrease Institute of American History and Art in Tulsa, Oklahoma. The InterNorth collection at the Joslyn Art

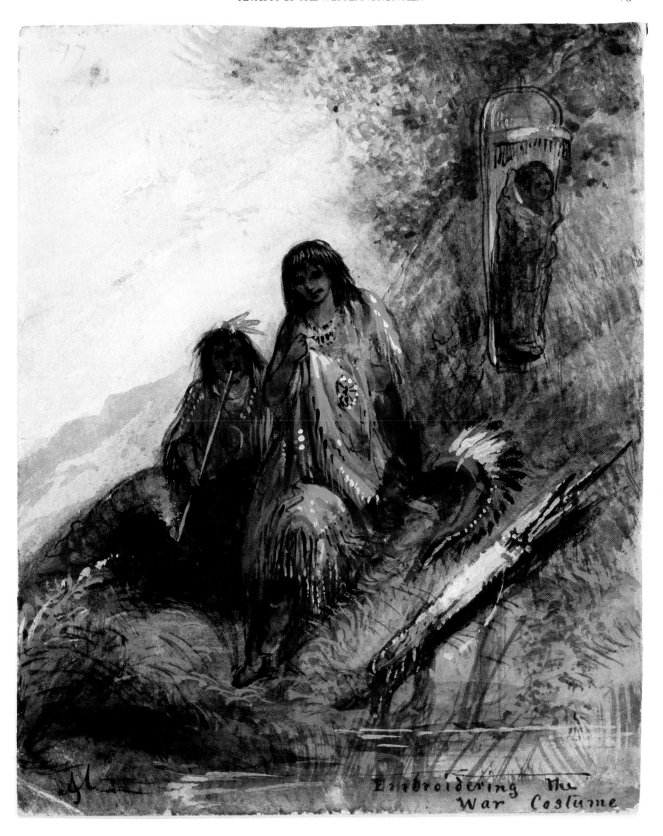

17. ALFRED JACOB MILLER, *Embroidering the War Costume*

Museum includes twelve studies and larger studio productions by the artist. Four works by Bierstadt are also listed in the Joslyn's permanent inventory along with a lithographic copy of *The Last of the Buffalo.*

2. ALBERT BIERSTADT
Chimney Rock
Oil on paper
4 x 9 in. (10.25 x 23 cm.)
The InterNorth Art Foundation/Joslyn Art Museum (PL 786)

Provenance:
M. Knoedler & Co., Inc., New York.
Northern Natural Gas Co., Omaha, Nebraska.

Literature:
Hendricks, *Albert Bierstadt,* 1973, p. 80; Joslyn, *Artists of the Western Frontier,* 1976, p. 8.

3. ALBERT BIERSTADT
Wagon Train
Oil on panel
11½ x 15½ in. (29.3 x 39.4 cm.)
Signed l.r.: ABierstadt
The InterNorth Art Foundation/Joslyn Art Museum (PL 787)

Provenance:
M. Knoedler & Co., Inc., New York.
Northern Natural Gas Co., Omaha, Nebraska.

Literature:
William Rockhill Nelson Gallery and Atkins Museum of Fine Arts, *The Last Frontier,* 1957, no. 8; Joslyn, *Artists of the Western Frontier,* 1976, no. 15.

4. ALBERT BIERSTADT
Head of Buffalo and Indian
Oil on panel
13⅞ x 19 in. (35.3 x 48.4 cm.)
Signed l.r.: ABierstadt
The InterNorth Art Foundation/Joslyn Art Museum (PL 788)

Provenance:
M. Knoedler & Co., Inc., New York.
Northern Natural Gas Co., Omaha, Nebraska.

Literature:
William Rockhill Nelson Gallery and Atkins Museum of Fine Arts, *The Last Frontier,* 1957, no. 4; Joslyn, *Artists of the Western Frontier,* 1976, no. 16.

5. ALBERT BIERSTADT
Scout
Oil on panel
13¼ x 9½ in. (33.75 x 24 cm.)
Signed l.r.: ABierstadt
The InterNorth Art Foundation/Joslyn Art Museum (PL 789)

Provenance:
M. Knoedler & Co., Inc., New York.
Northern Natural Gas Co., Omaha, Nebraska.

Literature:
Hendricks, *Albert Bierstadt,* 1973, p. 80; Joslyn, *Artists of the Western Frontier,* 1976, no. 17.

6. ALBERT BIERSTADT
Lake Angela
Oil on panel
10½ x 15¼ in. (26.6 x 38.7 cm.)
Signed l.l.: ABierstadt
The InterNorth Art Foundation/Joslyn Art Museum (PL 790)

Provenance:
M. Knoedler & Co., Inc., New York.
Northern Natural Gas Co., Omaha, Nebraska.

7. ALBERT BIERSTADT
Mountain Lake
Oil on panel
14 x 20 in. (35.5 x 50.75 cm.)
Signed l.l.: Bierstadt
The InterNorth Art Foundation/Joslyn Art Museum (PL 791)

Provenance:
M. Knoedler & Co., Inc., New York.
Northern Natural Gas Co., Omaha, Nebraska.

Literature:
Hendricks, *Albert Bierstadt,* 1973, p. 113; Joslyn, *Artists of the Western Frontier,* 1976, no. 18.

8. ALBERT BIERSTADT
Indians
Oil on panel
14 x 19 in. (35.5 x 48.3 cm.)
Signed l.r.: ABierstadt
The InterNorth Art Foundation/Joslyn Art Museum (PL 792)

Provenance:
M. Knoedler & Co., Inc., New York
Northern Natural Gas Co., Omaha, Nebraska.

Literature:
Joslyn, *Artists of the Western Frontier,* 1976, no. 19.

9. ALBERT BIERSTADT
Landscape with Indians
Oil on panel
13 x 19 in. (33 x 48.3 cm.)
Signed l.l.: AB 1859
The InterNorth Art Foundation/Joslyn Art Museum (PL 793)

Provenance:
M. Knoedler & Co., Inc., New York.
Northern Natural Gas Co., Omaha, Nebraska.

Literature:
William Rockhill Nelson Gallery and Atkins Museum of Fine Arts, *The Last Frontier,* 1957, no. 6; Joslyn, *Artists of the Western Frontier,* 1976, no. 20.

10. ALBERT BIERSTADT
Bison with Coyotes
Oil on panel
13¾ x 19¼ in. (35 x 48.8 cm.)
Inscribed l.l.: AB (monogram)
The InterNorth Art Foundation/Joslyn Art Museum (PL 794)

Provenance:
M. Knoedler & Co., Inc., New York.
Northern Natural Gas Co., Omaha, Nebraska.

Literature:
McCracken, *Portrait of the Old West,* 1952, p. 139; Los
Angeles County Museum of Art, *The American West,* 1971, p.
139; Joslyn, *Artists of the Western Frontier,* 1976, no. 21.

11. ALBERT BIERSTADT
Mounted Indian in Sunset
Oil on panel
9¾ x 13½ in. (24.7 x 34.2 cm.)
Signed l.r.: ABierstadt
The InterNorth Art Foundation/Joslyn Art Museum (PL 795)

Provenance:
M. Knoedler & Co., Inc., New York.
Northern Natural Gas Co., Omaha, Nebraska.

Literature:
Joslyn, *Artists of the Western Frontier,* 1976, no. 22.

12. ALBERT BIERSTADT
Elk Grazing
Oil on canvas
14 x 19 in. (35.5 x 48.3 cm.)
Signed l.r.: ABierstadt
The InterNorth Art Foundation/Joslyn Art Museum (PL 796)

Provenance:
M. Knoedler & Co., Inc., New York.
Northern Natural Gas Co., Omaha, Nebraska.

Literature:
Joslyn, *Artists of the Western Frontier,* 1976, no. 23.

13. ALBERT BIERSTADT
Sunset on the Plains
Oil on canvas
23 x 33 in. (58.5 x 83.7 cm.)
Signed l.r.: ABierstadt
The InterNorth Art Foundation/Joslyn Art Museum (PL 872)

Provenance:
Private collection, Sommerville, New Jersey.
Hank Chachowski, Cleveland, Ohio.
Bonfoey Co., Cleveland, Ohio.
Northern Natural Gas Co., Omaha, Nebraska.

Literature:
Joslyn, *Artists of the Western Frontier,* 1976, p. 17.

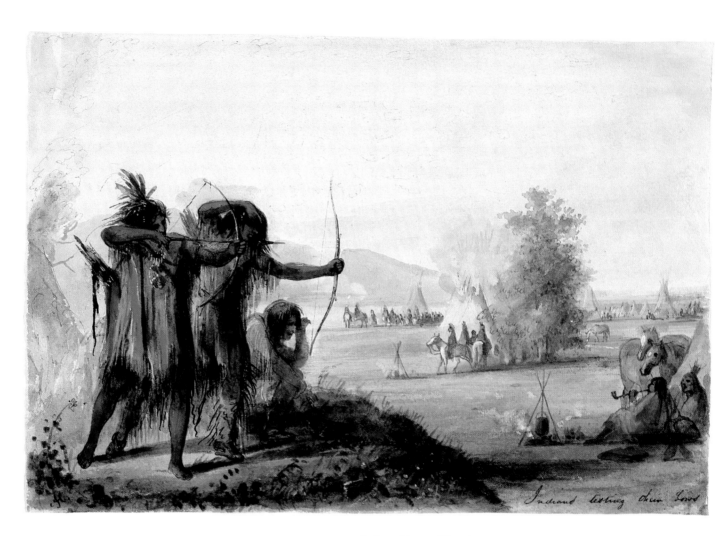

19. ALFRED JACOB MILLER, *Indians Testing Their Bows*

KARL BODMER, 1809-1893. For a complete biography see page 55.

14. KARL BODMER
Snags on the Missouri
Wash drawing
10⅛ x 12⅜ in. (25.6 x 31.4 cm.)
The InterNorth Art Foundation/Joslyn Art Museum (PL 797)

Provenance:
M. Knoedler & Co., Inc., New York.
Northern Natural Gas Co., Omaha, Nebraska.

JOHN EDWARD BOREIN, 1872-1945. One of the few native artists of the American West in the latter decades of the nineteenth century, Edward Borein was born in 1872 in San Leandro, California, across the bay from San Francisco. His father, Peter Borein, served as County Recorder at San Leandro, seat of Alameda County. When the county seat was moved to Oakland, the Borein family also moved.

Young Edward received his elementary schooling in Oakland. Later regarding his formal education as something of a waste of time, he left school and set out on his own at the age of seventeen, working at various jobs including that of a cowhand in California and Mexico. During this period, he became well acquainted with southwestern ranch life. Having shown a talent for drawing at a very early age, Borein began sketching horses, cattle, and cowboys while employed as a ranch hand. In 1894 at the age of twenty-two, he sold his first drawing to a local newspaper publisher.

About 1902 he opened a studio in Oakland and attempted to make a living as an artist. In 1907 he moved to New York City where he studied at the Art Students League under Childe Hassam and Ernest Roth. He later maintained a studio in the city and worked for several years as a commercial illustrator. It was during this time that he learned the technique of metal plate engraving, a medium in which he afterward excelled.

Never really at home in the East, Borein eventually returned to his native California and opened another studio in Santa Barbara. He also taught for a period of years during the 1920s at the Santa Barbara School of Arts under the directorship of Frank Morley Fletcher. There he continued to produce many fine illustrations of cowboys, Indians, and the remembered life of the Old West until his death in 1945.

Early acquainted with such notables as Buffalo Bill Cody, Annie Oakley, Theodore Roosevelt, and Charles M. Russell (who supposedly once advised him to "leave oil painting to others" and concentrate on drawing), Borein maintained such relationships throughout his life. In later years his studio in Santa Barbara became a mecca for old friends such as Irvin Cobb, Jimmy Swinnerton, Leo Carrillo, Will Rogers, and other artists, writers, and film stars of the period.

Today he is represented in collections throughout the United States chiefly by etchings, of which he is known to have produced over 300 in various editions. The pen and ink illustration entitled *Cowboy* in the InterNorth collection at the Joslyn Art Museum is one of his earlier efforts. Dated 1914, it is from the ex-collection of C. K. Post of Blue Point, New York.

Other works by Borein are found today at the Los Angeles County Art Museum; the M. H. De Young Memorial Museum, San Francisco; the Read Mullen Gallery of Western Art, Phoenix; the Thomas Gilcrease Institute of American History and Art in Tulsa, Oklahoma; and the Bradford Brinton Memorial at Big Horn, Wyoming.

15. EDWARD BOREIN
Cowboy
Ink and wash on paper
19¾ x 11¾ in. (50.3 x 30 cm.)
Signed l.r.: Edward Borein '14
The InterNorth Art Foundation/Joslyn Art Museum (PL 798)

Provenance:
C. K. Post, Blue Point, New York.
M. Knoedler & Co., Inc., New York.
Northern Natural Gas Co., Omaha, Nebraska.

GEORGE DE FOREST BRUSH, 1855-1941. A painter of western life chiefly in retrospect, George de-Forest Brush was born in Shelbyville, Tennessee, and spent his early childhood and youth in Connecticut and Ohio. Displaying a marked talent for painting, he was sent by his family to New York City when he was only sixteen years of age to study at the National Academy of Design. He was nineteen when he went abroad for further study, spending the years 1874 to 1880 in Paris, for the most part at the Ecole des Beaux-Arts.

Returning to the United States, he exhibited at the Society of American Artists in 1882 and became a

member of that body the same year. In 1888 he won the first Hallgarten Prize in an exhibition at the National Academy of Design and was elected an Associate Academician that year. Meanwhile, he traveled periodically to the northern plains region of the United States and Canada, visiting for much of the year of 1884 among the Crow Indians of Wyoming and Montana. Here he developed a keen interest in the Native American, not only as a subject for art from the pictorial standpoint, but also with reference to aboriginal culture and psychology.

Brush became a serious student of Indian traditions and folklore, and in his travels in the West is said to have participated in more than one native ceremonial. He found few buyers for Indian pictures, however, and in 1890 he looked to other fields of endeavor to support a growing family. Returning to Europe for further study and inspiration, he took up residence in Florence, Italy where he produced portraits and allegorical studies. His subsequent works show the influence of the Italianate style upon his later development as an artist.

Brush was elected to full membership in the National Academy in 1901 and later opened a studio in Dublin, New Hampshire, where he worked until a fire destroyed the studio in 1937. He afterward moved to Hanover, New Hampshire and continued to paint until his death at the age of eighty-five.

Brush maintained an interest in American Indian life throughout his career, striving in his pictures to reconstruct it as it was, or might have been, and depicting his Indian subjects in increasingly imaginative and poetic terms expressive of his own romantic temperament. He is principally represented today by works at the Museum of Fine Arts, Boston, The Metropolitan Museum of Art in New York City, and the Corcoran Gallery of Art in Washington, D.C.

16. GEORGE DE FOREST BRUSH
Indian Portrait
Oil on board
16 x 11 in. (40.6 x 28 cm.)
Signed l.r.: Geo. deF Brush
The InterNorth Art Foundation/Joslyn Art Museum (PL 799)

Provenance:
Collection of George D. Pratt.
M. Knoedler & Co., Inc., New York.
Northern Natural Gas Co., Omaha, Nebraska.

Literature:
Joslyn, *Artists of the Western Frontier,* 1976, p. 23.

ELBRIDGE AYER BURBANK, 1858-1949. Distinguished primarily as a crayon portraitist, Elbridge Ayer Burbank was born at Harvard, Illinois in 1858 and first studied art at the Chicago Academy of Design in 1874. In 1886 he began courses of instruction at the Royal Academy in Munich, Germany where he developed his technique in life drawing and portraiture.

Returning from Europe he exhibited regularly with the Society of Chicago Artists and in 1893 was awarded the Yerkes Prize from The Art Institute of Chicago. Specializing in genre scenes and children's portraits, he first turned to the subject of the American Indian when commissioned by his uncle, Edward E. Ayer, first president of the Field Columbian Museum of Chicago, to undertake a series of studies of the native peoples of the American Southwest.

From 1895 to 1897 Burbank traveled throughout Indian Territory, New Mexico, and Arizona making numerous portraits among the Cheyenne, Arapaho, Osage, Moqui, Ute, Navajo, and Hopi Indians. Later exhibiting his collection in Chicago and Philadelphia, he next traveled to the Pacific Northwest to sketch among the Crow, Flathead, Blackfoot, and Nez Perce tribes. He is said to have later produced portraits of more than one hundred types of North American Indians, devoting nearly fifty years to this work before his death in San Francisco in 1949.

Among his more notable portraits were those of Apache chief Geronimo, done in 1897 at Fort Sill in present day Oklahoma, Chief Joseph of the Nez Perce, painted at the Colville Reservation in the State of Washington, Sioux chief Stinking-Bear, and many others. Examples of his work are scattered today. Principal collections are found at the Field Musuem and the Newberry Library in Chicago, the Smithsonian Institution in Washington, D.C., and the Thomas Gilcrease Institute of American History and Art in Tulsa, Oklahoma. Another series of paintings is permanently exhibited in the Hubbell Trading Post National Monument at Ganado, Arizona.

Three pencil portraits by Burbank in the InterNorth collection in Omaha depict not Indians but celebrated western frontiersmen of the latter half of the nineteenth century. Signed but not dated, they are probably derived from photographs of the individuals represented.

17. E. A. BURBANK
Major General George A. Custer
Pencil on paper
26⅜ x 11¼ in. (67 x 28.6 cm.)
Inscribed u.l.: Bvt.-Major-General/George A. Custer/1876
Signed l.r.: E. A. Burbank
The InterNorth Art Foundation/Joslyn Art Museum (PL 800)

Provenance:
Private collection.
M. Knoedler & Co., Inc., New York
Northern Natural Gas Co., Omaha, Nebraska.

18. E. A. BURBANK
Colonel W. F. Cody
Red pencil on paper
26⅜ x 11¼ in. (67 x 28.6 cm.)
Inscribed u.l.: Col W. F. Cody/Buffalo Bill
Signed l.r.: E. A. Burbank
The InterNorth Art Foundation/Joslyn Art Museum (PL 801)

Provenance:
Private collection.
M. Knoedler & Co., Inc., New York.
Northern Natural Gas Co., Omaha, Nebraska.

19. E. A. BURBANK
Wild Bill Hickok
Pencil on paper
26⅜ x 11¼ in. (67 x 28.6 cm.)
Inscribed u.l.: Wild Bill Hickok/The Greatest of/Them All in/
The Sixties/and Seventies
Signed l.r.: E. A. Burbank
The InterNorth Art Foundation/Joslyn Art Museum (PL 802)

Provenance:
Private collection.
M. Knoedler & Co., Inc., New York.
Northern Natural Gas Co., Omaha, Nebraska.

WILLIAM DE LA MONTAGNE CARY, 1840-1922. William Cary was born at Tappan, New York in 1840 and grew up in Greenwich Village, New York City. Showing a talent for art, he was apprenticed at fourteen to a commerical engraver from whom he learned the rudiments of draftsmanship and composition. Before he was twenty, he had worked in watercolor and oil, experimented with sculpture, and contributed a number of illustrations, chiefly of domestic animals, to *Aldine's* and other British magazines of the period.

Urged by his family to go abroad for formal study, Cary decided instead to seek adventure on the western frontier inspired, as he later recalled, by the reading of the journals of Lewis and Clark and the novels of James Fenimore Cooper. His introduction to the wilds of the American West occurred in the spring of 1861 when, with two youthful companions, William H. Schieffelin and Emlin Lawrence, he set out on a sporting excursion from St. Louis, traveling by American Fur Company steamer to the upper reaches of the Missouri River in present day Montana.

Visiting the various fur company posts along the way, Cary and his friends left the river at Fort Benton and continued overland on foot and horseback across the northern Rockies to Fort Walla Walla, Washington. From here they traveled to Portland, Oregon where they took ship to San Francisco, returning home via the Isthmus of Panama in the early part of 1862. An account of this experience, illustrated by Cary, was published by Schieffelin in *Recreation Magazine* in 1895. The article describes in detail an adventure that for Cary furnished the basis for what proved to be a long and productive career as a painter of frontier life.

Cary returned to the West after the Civil War. He visited Fort Riley, Kansas in 1867, at which time he painted the portraits of George Armstrong Custer and William "Buffalo Bill" Cody, with whom he afterward maintained a lifelong friendship. In 1874 he again visited the Missouri frontier when invited by a friend to join in explorations being conducted at that time by the U.S. Northern Boundary Survey Commission.

Although not an official member of the survey team, Cary made studies of its activities and numerous sketches of riverboat life, Indians, animals, and scenery which he later incorporated into finished paintings at his New York studio. Among the many sketches made by Cary on the return voyage down the Missouri to Bismarck are portraits of several members of the survey party. They include his friend, Major W. J. Twining, Captain of Engineers and chief astronomer for the Survey Commission, and Dr. Elliott Coues of the Smithsonian Institution, who served as surgeon and naturalist to the Commission and later as secretary and naturalist to the U.S. Geological and Geographical Survey of 1876-80.

Returning again to New York City, Cary maintained a studio on West 55th Street where he associated with Albert Bierstadt, George Inness, and other notable contemporaries in his field. Throughout the 1870s his western views were regularly featured in such periodicals as *Harper's Weekly* and *Frank Leslie's Illustrated Newspaper,* and also reproduced lithographically for commerical distribution by Currier and Ives, Charles Clackner, Adler and Schwartz, and other art publishers.

After exhibiting abroad in Berlin and London, and in the United States at the Corcoran Gallery of Art in Washington, D.C., Cary held one of his last and biggest shows in New York City at the American Museum of Natural History in 1917. As late as 1921, he was reportedly still active at a studio on West 14th Street, surrounded by the souvenirs of his earlier western travels.

Cary left behind a considerable body of work following his death at Brookline, Massachusetts in 1922. The bulk of his estate in terms of paintings and drawings was later acquired by oil man Thomas Gilcrease from Clinton Cary, the artist's son, and may be seen today at the Thomas Gilcrease Institute of American History and Art in Tulsa, Oklahoma.

20. WILLIAM DE LA MONTAGNE CARY
View of a Fort
Oil on canvas
14 x 24 in. (35.5 x 61 cm.)
Signed l.l.: W. M. Cary/1866
The InterNorth Art Foundation/Joslyn Art Museum (PL 803)

Provenance:
M. Knoedler & Co., Inc., New York.
Northern Natural Gas Co., Omaha, Nebraska.

Literature:
Cedar Rapids Art Center, Iowa, *Artists of the Western Frontier,* 1968, p. 4; Joslyn, *Artists of the Western Frontier,* 1976, p. 25.

GEORGE CATLIN, 1796-1872. Initially trained as a lawyer, a profession he early abandoned in favor of a career in art, George Catlin was born at Wilkes-Barre, Pennsylvania in 1796 and began the study of law at Litchfield, Connecticut in 1817. Passing his bar examinations the following year, he practiced law with a brother in Lucerne County, Pennsylvania until 1821 when he moved to Philadelphia to pursue the private study of art.

In Philadelphia he reportedly received instruction in painting from Charles Willson Peale and possibly Thomas Sully, afterward specializing in portraiture and the production of miniatures in Philadelphia and New York City. Becoming interested in the American Indian as a subject for depiction, he made his first known Indian portrait of the famed Seneca orator Red Jacket at Buffalo, New York in 1826.

Following tours of several eastern reservations, Catlin set out in 1830 for St. Louis to explore the trans-Mississippi West. He traveled the rounds of Indian encampments west of St. Louis with former explorer William Clark, then serving as Superintendent of Indian Affairs for the western tribes. In the summer of 1832 he traveled more than 2,000 miles by steamer up the Missouri River to Fort Union near the mouth of the

Yellowstone, making numerous studies of that region and its inhabitants and penning a later published account of all that he observed.

Continuing throughout the next four years to make periodic excursions into the unsettled West, Catlin visited tribes and native encampments from the Texas border to the upper Mississippi and Great Lakes region, producing an extraordinary documentary of his wilderness travels. Returning again to the East in the latter part of 1836, he prepared his collection of western scenes and portraits for exhibition in Philadelphia, Boston, New York, and Washington. At this time he estimated that he had visited over forty-eight indigenous tribes and painted from life over 325 individual portraits as well as more than 200 other studies depicting all aspects of Indian life, occupations, and environment. This large and somewhat unwieldy collection was displayed along with countless costumes, artifacts, and other paraphernalia with much success between 1837-39. Catlin himself toured with his show as a lecturer and promoter.

At the urging of a friend who had accompanied him on one of his western tours, Catlin took his collection abroad in 1839 and early the following year opened a much publicized exhibition in London at the Egyptian Hall in Piccadilly where it remained, off and on, for the next five years. During this period he published the first edition of his *Letters and Notes on the Manners, Customs and Condition of the North American Indians* (2 vols., 1841) and *North American Indian Portfolio* (1844) which featured twenty-five hand-colored lithographic views of hunting and sporting amusements of the native peoples then inhabiting the western plains.

In 1845 he crossed the English Channel to exhibit his now celebrated show in Paris at the invitation of King Louis Philippe. The revolution of 1848 forced the artist, with some difficulty, to transport his collection back to London where he opened yet another show and published his *Eight Years' Travel and Residence in Europe* (2 vols., 1848) as a sequel to his *Letters and Notes.* Meanwhile, his wife Clara and his young son died while touring abroad, leaving Catlin with three small daughters to support.

Seeking relief from chronic indebtedness, Catlin began selling parts of his collection and creating specialty items such as his "albums unique" which featured reproductions of subjects in his Indian Gallery. In the spring of 1852, his debts finally caught up with him. Having mortgaged the collection many times over, borrowing against the expected sale of the Indian Gallery to either the U.S. or British governments, Catlin was thrown in jail. A brother-in-law escorted the children home to New Jersey. Catlin, having been freed from debtors' prison, again returned to Paris to issue an urgent appeal to the U.S. Senate Library Committee to prevent the pending auction of his collection.

Joseph Harrison, an American locomotive manufacturer in London at the time, acquired the bulk of the

collection by paying Catlin's major creditors. Harrison took possession of the Indian Gallery and shipped it back to Philadelphia where it remained in storage for the next twenty-seven years. Catlin himself, having salvaged a few paintings and notebooks from this transaction, remained for a period of time in Paris, probably to avoid those creditors who had not received payment from Harrison. Over the next several years, he undertook to recreate his lost collection from memory and looked elsewhere for new fields of exploration.

Between the years of 1853 and 1860, he made at least three excursions to South America and another trip, probably in 1854, to North America west of the Rockies, returning periodically to London, Berlin, and finally Brussels where he rented a small studio to work up paintings from the sketches obtained during these travels. In 1870 he returned for the last time to the United States, after an absence of nearly thirty-two years, and exhibited his pictures at the Smithsonian Institution at the invitation of its secretary and director, Joseph Henry. Henry allowed Catlin to use a portion of his offices as a temporary studio. Here he remained until he was taken seriously ill in the latter part of 1872 and remanded to the care of his daughters in Jersey City where he died in December of that year.

One of the artist's professedly great and lifelong ambitions had been to sell his collection of American Indian paintings to the U.S. Government "for the benefit of posterity" as he himself expressed it. As early as 1838, a proposal to that effect had been placed before Congress, but decided in the negative as were subsequent bills as late as 1847 and 1852. Joseph Harrison, who had acquired the bulk of the Indian Gallery in 1852, later actively promoted the creation of a national art gallery and offered Catlin's collection to the commissioners of Philadelphia's Fairmount Park on condition that they build a museum to house it. City councilmen refused to grant the necessary funds for this enterprise and Catlin's paintings remained, almost forgotten, in two of Harrison's factory warehouses until after his death in 1874. In 1879 officials of the Smithsonian Institution applied to Harrison's executors in the hope of obtaining the collection as a gift. Mrs. Harrison promptly announced the bequest to the nation, later donating other paintings in her late husband's collection to the Pennsylvania Academy of Fine Arts, notably Charles Willson Peale's famous self-portrait, *The Artist and His Museum,* and Benjamin West's large canvas of *Penn's Treaty with the Indians* which Catlin supposedly had been instrumental in bringing to Harrison's attention.

Today the Smithsonian owns the largest collection of Catlin material extant, chiefly as a result of the Harrison bequest of 1879. The American Museum of Natural History owns 417 oil paintings produced after Catlin lost his original collection to creditors. Another 221 of his drawings, similarly done, are preserved at the New York Historical Society.

Of special interest is the Catlin collection at the Thomas Gilcrease Institute of American History and Art in Tulsa, Oklahoma, for the most part obtained from the ex-collection of Sir Thomas Phillipps, wealthy and eccentric English collector who was one of Catlin's best friends and patrons during his first years abroad. Included are 137 watercolors and seventy-six oil paintings, all produced before 1852. A bound folio of replicas executed by Catlin in London before 1849 is a part of this inventory along with another, smaller album of sketches variously derived, collected, and bound by Phillipps. Also at Gilcrease is a collection of more than seventy letters from Catlin to Phillipps written between 1840 and 1858.

The InterNorth collection lists three paintings by Catlin in its catalogue. Six more paintings by this artist are included in the permanent inventory of the Joslyn Art Museum.

Almost forgotten today are Catlin's travels in South America and his account of these and other adventures published in *Last Rambles Amongst the Indians of the Rocky Mountains and the Andes* in 1868.

21. GEORGE CATLIN
Buffalo Hunting
Oil on canvas
16 x 21¼ in. (40.6 x 54 cm.)
Signed l.r.: G. Catlin/1863
The InterNorth Art Foundation/Joslyn Art Museum (PL 804)

Provenance:
Private collection.
M. Knoedler & Co., Inc., New York.
Northern Natural Gas Co., Omaha, Nebraska.

Literature:
Joslyn, *Artists of the Western Frontier,* 1976, p. 13.

22. GEORGE CATLIN
Spearing Fish by Torchlight, Gulf Coast
Oil on canvas
19 x 26½ in. (48.3 x 67.3 cm.)
The InterNorth Art Foundation/Joslyn Art Museum (PL 805)

Provenance:
Private collection.
M. Knoedler & Co., Inc., New York.
Northern Natural Gas Co., Omaha, Nebraska.

23. GEORGE CATLIN
Group of Deer
Oil on canvas
19 x 26¾ in. (48.3 x 68 cm.)
Signed l.r.: Catlin
The InterNorth Art Foundation/Joslyn Art Museum (PL 806)

Provenance:
Private collection.
M. Knoedler & Co., Inc., New York.
Northern Natural Gas Co., Omaha, Nebraska.

FELIX OCTAVIUS CARR DARLEY, 1822-1888. The best known book illustrator in America during the first half of the nineteenth century was F. O. C. Darley, as he usually signed his name. Son of English comedian John Darley, he was born at Philadelphia in 1822 and began his notable career there as a commercial artist some twenty years later.

Having shown, like so many of his contemporaries, a talent for drawing at an early age, he was apprenticed in his teens to a mercantile house in Philadelphia in the hope that he might become business oriented. His interest in art prevailed when he finally succeeded in bringing his studies of firemen and city life to the attention of local publishers who gave him continual employment for the next several years.

In the early 1840s he made at least one sketching trip into the trans-Mississippi West, afterward publishing his *Scenes of Indian Life* in 1843. In 1848 he moved to New York City where he illustrated a series of books by Washington Irving including *Rip Van Winkle* (1848), *The Legend of Sleepy Hollow* (1849), and *A History of New York . . . by Diedrich Knickerbocker* (1850), placing him in the front rank of commercial designers of his day.

By far his most popular series of pictures was done for the monumental *Works of James Fenimore Cooper* issued over a period of years in thirty-two volumes featuring more than 500 illustrations. Crayon copies of some of these were exhibited in 1858 at the National Academy of Design where Darley had first exhibited thirteen years earlier. He later illustrated other works by Irving including his *Life of Washington* and an edition of Longfellow's epic poem, *The Courtship of Miles Standish,* in 1858-59.

Darley married in 1859 and moved to Claymont, Delaware where besides continuing work on the volumes of Cooper, he also illustrated editions of the works of Charles Dickens. In the 1860s he produced some Civil War subjects. In the summer of 1866 he visited Europe for the first time, traveling extensively for a period of thirteen months and upon his return home publishing his letters and European studies in his *Sketches Abroad with Pen and Pencil.* In 1879 he again exhibited at the National Academy with a series of twelve pictures entitled "Compositions in Outline from Hawthorne's Scarlet Letter."

At his best with American subjects, Darley seems to have accepted the practical limitations of his profession while realizing its possibilities to the fullest, later describing his career to a newspaper reporter as "neither strange nor eventful." He died at his home in Claymont in 1888. Having practiced his art with great diligence, he was acclaimed as the equal of the most successful English illustrators of his time.

24. FELIX OCTAVIUS C. DARLEY
Indians Attacking Emigrants (Sic) Train
Ink and wash on paper
10¾ x 17¼ in. (27.5 x 43.75 cm.)
Signed l.r.: F. O. C. Darley - fecit
The InterNorth Art Foundation/Joslyn Art Museum (PL 807)

Provenance:
M. Knoedler & Co., Inc., New York.
Northern Natural Gas Co., Omaha, Nebraska.

Literature:
Taylor, *The Warriors of the Plains,* 1975, p. 87.

25. FELIX OCTAVIUS C. DARLEY
Fisherman Casting
Sepia wash over pencil on paper
10 x 14 in. (25.5 x 35.5 cm.)
Signed l.r.: F. O. C. Darley
The InterNorth Art Foundation/Joslyn Art Museum (PL 808)

Provenance:
M. Knoedler & Co., Inc., New York.
Northern Natural Gas Co., Omaha, Nebraska.

26. FELIX OCTAVIUS C. DARLEY
An Indian Raid
Pencil, ink and wash on paper
9 x 13 in. (23 x 33 cm.)
Signed l.r.: Darley fecit
The InterNorth Art Foundation/Joslyn Art Museum (PL 809)

Provenance:
M. Knoedler & Co., Inc., New York.
Northern Natural Gas Co., Omaha, Nebraska.

27. FELIX OCTAVIUS C. DARLEY
The Hunter
Ink and wash on paper
16⅛ x 12⅞ in. (41 x 32.75 cm.)
Signed l.l.: F. O. C. Darley - fecit
The InterNorth Art Foundation/Joslyn Art Museum (PL 810)

Provenance:
M. Knoedler & Co., Inc., New York.
Northern Natural Gas Co., Omaha, Nebraska.

28. FELIX OCTAVIUS C. DARLEY
Frontiersman with Long Rifle
Pencil on paper
10 x 9 in. (25.5 x 23 cm.)
Signed l.r.: F. O. C. Darley/1871
The InterNorth Art Foundation/Joslyn Art Museum (PL 811)

Provenance:
M. Knoedler & Co., Inc., New York.
Northern Natural Gas Co., Omaha, Nebraska.

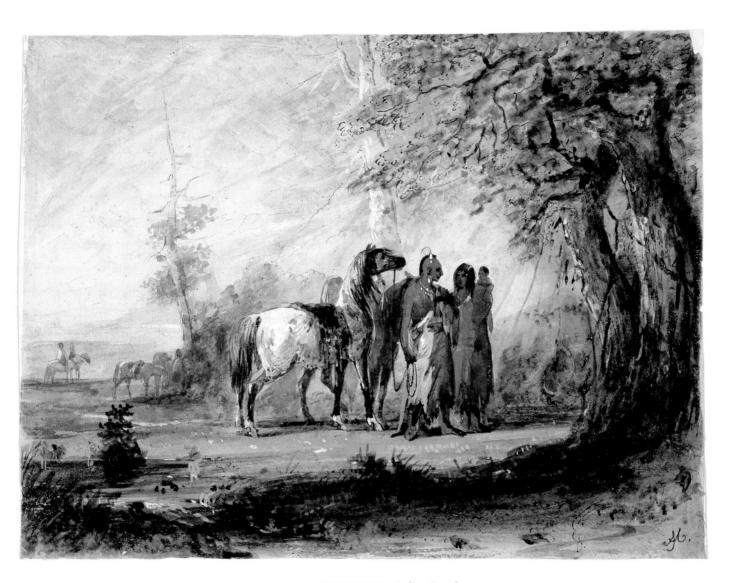

20. ALFRED JACOB MILLER, *Indian Family*

29. FELIX OCTAVIUS C. DARLEY
Indian Encampment - Return From the Hunt
Sepia and watercolor wash on paper
8⅛ x 12 in. (20.5 x 30.5 cm.)
Signed l.l.: F. O. C. Darley
The InterNorth Art Foundation/Joslyn Art Museum (PL 812)

Provenance:
M. Knoedler & Co., Inc., New York.
Northern Natural Gas Co., Omaha, Nebraska.

30. FELIX OCTAVIUS C. DARLEY
Return from the Hunt
Engraving proof (unfinished)
10½ x 14⅜ in. (27 x 36.5 cm.)
Inscribed l.c.: Return From the Hunt
The InterNorth Art Foundation/Joslyn Art Museum (PL 813)

Provenance:
M. Knoedler & Co., Inc., New York.
Northern Natural Gas Co., Omaha, Nebraska.

31. FELIX OCTAVIUS C. DARLEY
Illustration for The Chainbearer
Sepia wash on paper
18 x 14½ in. (45 x 37 cm.)
Signed l.l.: F. O. C. Darley fecit
The InterNorth Art Foundation/Joslyn Art Museum (PL 814)

Provenance:
M. Knoedler & Co., Inc., New York.
Northern Natural Gas Co., Omaha, Nebraska.

Literature:
Cooper, *The Chainbearer*, p. 266.

32. FELIX OCTAVIUS C. DARLEY
Attacked by Indians
Ink wash on paper
14 x 18⅞ in. (35.5 x 48 cm.)
Signed l.l.: F. O. C. Darley fecit
The InterNorth Art Foundation/Joslyn Art Museum (PL 815)

Provenance:
M. Knoedler & Co., Inc., New York.
Northern Natural Gas Co., Omaha, Nebraska.

33. FELIX OCTAVIUS C. DARLEY
The Trail
Sepia and watercolor wash on paper
8 x 11⅞ in. (20.25 x 30.25 cm.)
Signed l.r.: F. O. C. Darley
The InterNorth Art Foundation/Joslyn Art Museum (PL 816)

Provenance:
M. Knoedler & Co., Inc., New York.
Northern Natural Gas Co., Omaha, Nebraska.

34. FELIX OCTAVIUS C. DARLEY
Fighting with the Pick Axe
Pencil and sepia wash on paper
9¼ x 11½ in. (23 x 29.25 cm.)
The InterNorth Art Foundation/Joslyn Art Museum (PL 817)

Provenance:
M. Knoedler & Co., Inc., New York.
Northern Natural Gas Co., Omaha, Nebraska.

JO DAVIDSON, 1883-1951. Sculptor Jo Davidson was born in New York City in 1883 and during his early years worked as assistant to Hermon Atkins MacNeil on projects for the St. Louis World's Fair of 1904. He later designed the United States War Industries badge during World War I as well as the heroic group for the French Government commemorating the Battle of the Marne. Among his other commissions at this time was a portrait bust of President Woodrow Wilson and other bronzes of Allied leaders.

Probably his most widely known work today is his life-size bronze sculpture of humorist Will Rogers originally commissioned for the Will Rogers Memorial in Claremore, Oklahoma and completed in 1938. Subsequent castings and versions of this work were also produced including a casting of the Rogers bronze for Statuary Hall in the Capitol Building in Washington, D.C.

The original, full-figured portrait stands eighty-five inches in height. The version in the InterNorth collection is a partial casting or bust of head and shoulders of Rogers. It is twenty-seven inches high including its base and signed behind the right shoulder with the artist's name and date of casting. It was produced in Paris in 1938.

35. JO DAVIDSON
Will Rogers
Bronze casting
27¼ x 24½ in. (69.2 x 62.3 cm.)
Incised l.r.: Jo Davidson/Paris '38
The InterNorth Art Foundation/Joslyn Art Museum (PL 818)

Provenance:
Estate of the artist.
M. Knoedler & Co., Inc., New York.
Northern Natural Gas Co., Omaha, Nebraska.

Literature:
Joslyn, *Artists of the Western Frontier*, 1976, p. 39.

CHARLES DEAS, 1818-1867. Genre, landscape, and portrait painter Charles Deas is best known today for his scenes of Indian life on the western plains produced for the most part during the decade of the 1840s. Born in Philadelphia in 1818, he spent his early years there and in the Hudson River valley region. Failing to obtain an appointment to West Point in 1836, he decided to become a painter and studied briefly in New York City at the National Academy of Design. He first exhibited there in 1838, gaining recognition for a painting entitled *Turkey Shoot.* The work was subsequently reproduced in lithographic form and widely sold. Deas exhibited at the Academy again the following year, when he was elected an Associate Academician. In 1840 he made the first of many excursions into the American West.

Having chanced to view an exhibition of paintings in Philadelphia in 1837-38 by George Catlin, then recently returned from his western travels, Deas reportedly was inspired to follow in the older artist's footsteps. He first visited Fort Crawford at Prairie du Chien, Wisconsin, where a brother was then stationed with the 5th U.S. Infantry. Accompanying various military expeditions into the surrounding country, he witnessed during this time a council of the Sauk and Fox with the Winnebago at Fort Crawford presided over by the famed chief Keokuk. Deas afterward visited Fort Winnebago, located at the site of the old Fox-Wisconsin River portage first described by Louis Hennepin on his explorations with LaSalle some 150 years before. In 1841 he traveled northward to Fort Snelling on the Mississippi, near the modern St. Paul, Minnesota making additional studies among the Eastern Sioux of that area.

In the fall of 1841, Deas traveled downriver to St. Louis where he established a studio. He spent several months each year for the next six years sketching among the Indians of the trans-Mississippi West. In the spring of 1844, he accompanied a military expedition from Fort Leavenworth on the Missouri to the Pawnee villages then located along the upper Platte. An account of this expedition was later published from a journal kept by Lt. J. Henry Carlton. The journal was similar in many respects to the reports of the first U.S. Dragoon campaign from Leavenworth ten years earlier which Catlin had accompanied.

Between the years of 1838 and 1849, Deas exhibited regularly at the National Academy of Design, the American Art-Union, the Pennsylvania Academy of Fine Arts, and the Boston Athenaeum. Returning from St. Louis to New York in 1847, he afterward suffered a mental breakdown from which he never recovered. He spent the last fourteen years of his life in an asylum where he died in 1867.

Deas's paintings of American frontier life, more romantic than documentary in their emphasis, enjoyed considerable popularity during his lifetime. Only a relative few of his pictures can be positively identified today. Those found in the collections of Yale University, The Brooklyn Museum, and the Thomas Gilcrease Institute of American History and Art in Tulsa, Oklahoma, make up the principal inventories for present reference.

The painting attributed to Deas in the InterNorth collection at the Joslyn Art Museum is a typical example of this artist's work. Entitled *Indians at War,* it is expressive of Deas's romantic association with the American frontier of the mid-nineteenth century.

36. CHARLES DEAS
Indians at War
Oil on canvas
16⅞ x 21 in. (42.8 x 53.4 cm.)
The InterNorth Art Foundation/Joslyn Art Museum (PL 819)

Provenance:
Collection of Leslie Katz, New York.
M. Knoedler & Co., Inc., New York.
Northern Natural Gas Co., Omaha, Nebraska.

Literature:
Coen, *Painting and Sculpture in Minnesota 1820-1914,* 1976, p. 13.

EDWIN WILLARD DEMING, 1860-1942. Chiefly remembered as a painter of American Indian subjects, Edwin Willard Deming was born at Ashland, Ohio in 1860 and grew up in western Illinois. Having ambitions to become a painter, he reportedly produced his first pictures with house paint scraped from discarded cans and dug clay from the riverbanks with which to model his first figures of people and animals.

In 1880 his father sent him to Chicago to study business law. Deming decided instead to pursue a career in art. Returning home, he sold some personal belongings and with the proceeds paid his way to New York City and classes at the Art Students League. In 1884 he crossed the Atlantic to Paris where he attended lectures at the Ecole des Beaux-Arts and studied briefly under Gustave Boulanger and Jules Lefebvre.

In 1885 Deming was back again in the United States painting cycloramas for a living. Having visited as a teenager among the resettled tribes in Indian Territory,

he again traveled westward in 1887, touring the Apache and Pueblo settlements of the Southwest. In 1889 he stayed for a period of time with the Crow Indians in Wyoming and Montana. The following year he visited the Hunkpapa Sioux reservation at Standing Rock where he made portraits of several famous chiefs associated with the Custer battle at the Little Big Horn. Participating in many aspects of Indian life, Deming responded to the native philosophy of kinship with nature and adopted many Indian customs and habits of thought. During a visit to Montana in 1898, he was made an honorary member of the Blackfoot tribe.

Deming settled in New York City in 1891 and opened a studio where he could develop his studies of life in the West. In 1892 he married a woman who happily shared his interests in nature and outdoor life, as did all six of the children who were subsequently born to them. Until 1917 Deming maintained a studio in Greenwich Village where he illustrated magazine articles and books dealing with Indians, frontier, and wild animal subjects. Between the years of 1913-16, he again traveled extensively in the West on commission to produce a series of mural panels for the Plains Indian Hall at the American Museum of Natural History.

With the entrance of the United States into World War I, Deming volunteered for service and at the age of fifty-seven was commissioned a captain in the U.S. Army and assigned to the Camouflage Department of the Infantry School of Arms at Camp Benning, Georgia. After the war, he returned to New York City and opened another studio on West 9th Street, continuing to accept assignments to illustrate the works of such authors as George Bird Grinnell, Charles F. Lummis, Hamlin Garland, and others.

Commissioned to paint a set of historical panels for the Great Northern Railroad offices on 5th Avenue, he later painted at least three different versions of his concept of the Custer battle in Montana, one of which is now at the Buffalo Bill Memorial Museum in Golden, Colorado. He also illustrated a series of children's books on Indian subjects, authored by his wife, and another book by a daughter, Alden.

Following another period of travel, which included a seven-month tour of South America, Deming moved again to New York City. His last place of residence was at 36 Grammercy Park in New York City, where he died on October 16, 1942.

Deming was a member of a number of distinguished art and military societies including the Society of Mural Painters, and Society of New York Artists, the Society of American Military Engineers, and the Adventurers' Club, to name only a few. A prodigious painter, he is represented today by a variety of works, including sculptures, in the collections of The Metropolitan Museum of Art and the American Museum of Natural History in New York City and the National Museum of American Art in Washington, D.C.

The largest collection of his works, purchased from the artist's widow shortly before her death in 1945, is found today at the Thomas Gilcrease Institute of American History and Art in Tulsa, Oklahoma. Another extensive collection of correspondence, notes, and personal and family memorabilia was acquired in 1970 by the University of Oregon at Eugene. Similar materials are deposited at Dartmouth College and with The New York Public Library.

Reprinted in a biography of the artist published in 1925 is a letter from an Omaha Indian who frequently visited Deming in New York City. Written in 1924, the letter reads in part: There never was a time I visited your studio and examined your Indian pictures that I did not come away with a sense of pleasure and satisfaction, for they always carried me back to the days of my boyhood, when I witnessed such scenes as you portray... Indians charging over the prairies took me back to a summer day when the Omaha, Pawnee, and Ponca hunters charged upon a herd of buffalo at the head of Plum Creek, a tributary of the Platte....

The painting entitled *Indian Buffalo Hunt* in the InterNorth collection depicts such a scene. It is a small studio piece, signed but not dated, possibly a study for or a version of a larger work.

Indian Girl with Deer, also in the InterNorth collection, is an example of Deming's narrative mural painting style. Dreamlike in its effect, as are many of his paintings, it is from the ex-collection of Cornelius Vanderbilt who purchased it from the artist. It is said to have hung in the Vanderbilt Mansion on West 59th Street for many years until the imposing structure was torn down.

37. EDWIN WILLARD DEMING
Indian Buffalo Hunt
Oil on canvas
12 x 16 in. (30.5 x 40.6 cm.)
Signed l.l.: E. W. Deming
The InterNorth Art Foundation/Joslyn Art Museum (PL 820)

Provenance:
M. Knoedler & Co., Inc., New York.
Northern Natural Gas Co., Omaha, Nebraska.

38. EDWIN WILLARD DEMING
Indian Woman and Deer
Oil on canvas
34 x 95 in. (86.4 x 241.3 cm.)
Signed l.l.: E. W. Deming
The InterNorth Art Foundation/Joslyn Art Museum (PL 821)

Provenance:
Artist.
Cornelius Vanderbilt family.
M. Knoedler & Co., Inc., New York.
Northern Natural Gas Co., Omaha, Nebraska.

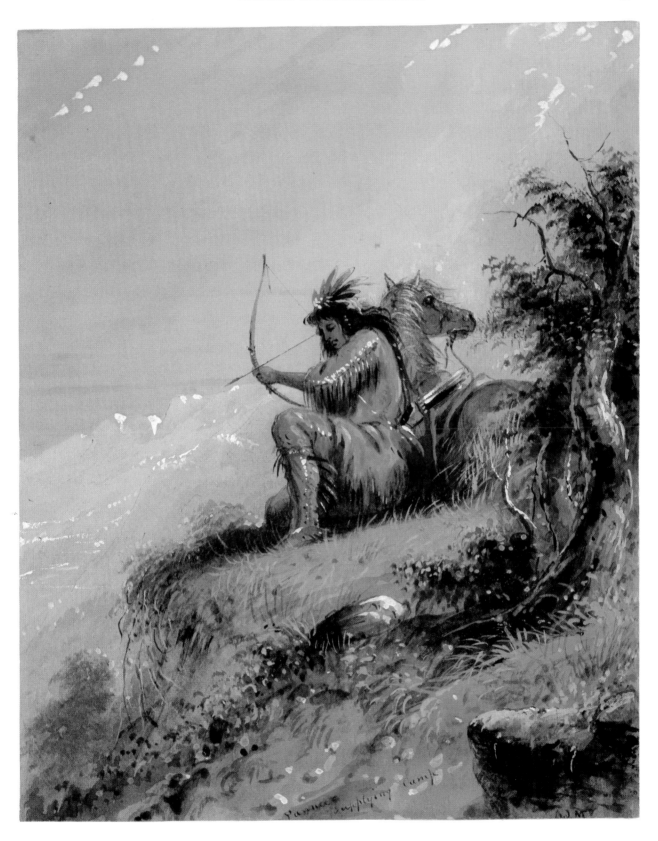

21. ALFRED JACOB MILLER, *Pawnee Supplying Camp*

HARVEY THOMAS DUNN, 1884-1952. One of America's best known book and magazine illustrators, Harvey Dunn was born on a family homestead near Manchester, South Dakota in 1884, and at the age of seventeen left home to attend South Dakota State University in Brookings where his talent for drawing was encouraged by art instructor Ada Caldwell. After a year of preparatory studies in Brookings, Dunn enrolled at The Art Institute of Chicago in 1902. In 1904 he was accepted by Howard Pyle as a student in Pyle's school at Wilmington, Delaware, where Dunn worked with other promising talents of his time, including such artists as William Henry Koerner, Frank Schoonover, and Newell Convers Wyeth.

After two years with Pyle, Dunn established his own studio in Wilmington in 1906 and began what proved to be a highly successful career as an illustrator of books and magazines. He married in 1908 and that same year began illustrating for *Saturday Evening Post.* In 1914 he moved with his wife and two children to Leonia, New Jersey in order to be closer to the New York publishers supplying him with most of his work. In Leonia Dunn set up his own studio and school of instruction and began teaching. He also taught at the Grand Central School of Art in New York City after 1925, numbering among his more successful students Dean Cornwell, Harold von Schmidt, and John Steuart Curry. By this time Dunn's work was appearing regularly in such periodicals as *Collier's, Harper's,* the *Post,* and *Scribner's.*

During World War I, Dunn was commissioned a captain and served as one of eight official artist-correspondents with the American Expeditionary Force in Europe. After the war, which seems to have been a turning point in his career, he established a permanent home at Tenafly, New Jersey and began making annual visits back to his South Dakota birthplace. The majority of paintings produced during this latter period, perhaps among the best known of his works today, depict pioneer life on the Dakota prairies and reflect a growing preoccupation with the past and the virtues of faith and hard work characteristic of many of those who settled the western plains.

In 1945 Dunn was elected a full member of the National Academy of Design. In 1950 a retrospective exhibition of his works, arranged by Dunn's long time friend and admirer, Aubrey Sherwood, was held at De Smet, South Dakota. Dunn later gave the greater part of this collection to the people of his home state to be maintained at South Dakota State University in Brookings. Afterward supplemented with gifts and purchases, Dunn's pictures, numbering thirty-eight in all from the original collection, were installed in the South Dakota Memorial Art Center when that facility opened on the campus in 1970.

Painting the subjects that he knew best, particularly his portrayals of life on the western prairies, Dunn was widely acclaimed as one of the nation's leading illustrators at the time of his death in 1952. Today he is represented chiefly by works in the Dunn Collection at Brookings, South Dakota. A collection of twenty-four documentary drawings and paintings produced during his service abroad in World War I are preserved in the archives of the Smithsonian Institution in Washington, D.C.

39. HARVEY DUNN
Indian Ambush
Oil on board
14¾ x 39½ in. (37.5 x 99.6 cm.)
Signed l.r.: H. Dunn
The InterNorth Art Foundation/Joslyn Art Museum (PL 822)

Provenance:
Collection of R. W. Apgar, Mendham, New Jersey.
M. Knoedler & Co., Inc., New York.
Northern Natural Gas Co., Omaha, Nebraska.

Literature:
Joslyn, *Artists of the Western Frontier,* 1976, p. 24.

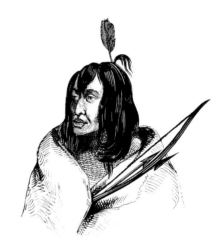

SETH EASTMAN, 1808-1875. A professional soldier who pursued a successful career in art in conjunction with distinguished military service, Seth Eastman was born at Brunswick, Maine in 1808. Appointed to the U.S. Military Academy at West Point in 1824, he was trained as a topographical draftsman, graduating from the Academy in 1828 as a second lieutenant.

Assigned to duty on the western frontier, he first served at Fort Crawford on the upper Mississippi in 1829. The following year he was at Fort Snelling near the modern twin cities of Minneapolis-St. Paul where he engaged in a topographical reconnaissance of the surrounding region and produced some of his first Indian studies.

Northernmost of a line of forts along what was then the "Indian Frontier" of the United States, Fort Snelling was visited by several artists during this early period, most notably Peter Rindisbacher and George Catlin. Eastman was one of the first to describe the country in

terms of its topography, however, and is believed at a later time to have been among the first to use photography as a practical alternative to field sketches.

In January of 1833, Eastman was reassigned to the teaching staff at West Point as an assistant drawing instructor under Charles R. Leslie and later Robert W. Weir. In 1837 he published his *Treatise on Topographical Drawing.* In 1838 he exhibited for the first time at the National Academy of Design in New York City and was promptly named an "honorary member, amateur" of that body.

Returning to active duty in 1840, Eastman served briefly in the Seminole War in Florida and was again at Fort Snelling as a captain in 1841. During his second stay in Minnesota he was joined by his wife Mary Henderson Eastman and their three children. At this time Eastman began to apply himself more seriously to the business of recording frontier scenes and activities, particularly those relating to Indian life, making studies that formed the basis for much of his later work.

Following a tour of duty in Texas in 1848-49, Eastman was ordered back to Washington where with his wife he collaborated on several books on Indian subjects. Mrs. Eastman, daughter of the Surgeon General of the U.S. Army, was considered an accomplished writer by her contemporaries. Her first book, illustrated by her husband and entitled *Dakotah: Life and Legends of the Sioux* (New York, 1849), is widely believed to have furnished the inspiration for Longfellow's epic poem, *Song of Hiawatha,* published six years later.

Subsequent books by the Eastmans included *Romance of Indian Life,* illustrated with twelve chromolithographs after Eastman, and *Aboriginal Portfolio,* featuring twenty-six of Eastman's pictures. Both were published in 1853. Yet another book by Mrs. Eastman appeared in 1854 under the title *Chicora and Other Regions of the Conquered and Unconquered* with twenty-one plates after Eastman's earlier studies.

At about this same time, Eastman was chosen as one of the artists to prepare illustrations for Henry Rowe Schoolcraft's lengthy *Historical and Statistical Information Respecting.... the Indian Tribes of the United States* (6 vols., Washington, 1851-57). Schoolcraft, a pioneer American ethnologist, had served for nearly twenty years as Indian Agent for the tribes in Michigan Territory, and during this period he had been instrumental in organizing a treaty-making expedition in 1826 to Fond du Lac on Lake Superior under the direction of Lewis Cass, then serving as Michigan's territorial governor, and Thomas L. McKenney, U.S. Commissioner of Indian Affairs in Washington. McKenney published an account of this expedition in *A Tour to the Lakes* (Baltimore, 1827), featuring illustrations after yet another artist to this area, James Otto Lewis of Detroit.

Returning eastward himself in 1841, Schoolcraft undertook to complete his voluminous statistical report for the Government. Both Eastman and another artist,

Edward Kern, contributed the majority of illustrations to this project.

Eastman served again in Texas during the Civil War, returning to active duty as a colonel in his old regiment, the First Infantry. After the war and a brief period in Washington with the office of the Quartermaster General, Eastman retired as a brevet brigadier general in 1867. He was later commissioned by Congress to execute a number of scenes of Indian life and views of frontier forts for the Senate and House chambers at the Capitol. His last years were spent in Washington where he died on August 31, 1875.

In addition to his decorations for the Capitol, Eastman is represented by works in a number of museum collections, chiefly the Smithsonian Institution and the Corcoran Gallery of Art in Washington, the Minneapolis Institute of Art, the Thomas Gilcrease Institute of American History and Art in Tulsa, Oklahoma, and the Stark Museum of Art in Orange, Texas. Of the four works by Eastman in the InterNorth collection at the Joslyn, three depict Fort Snelling or its environs, while the fourth represents an Indian subject.

Eastman spent more time among the Indians of the trans-Mississippi West than any other artist of his day and was one of the few to record the ordinary, everyday activities of nineteenth century Indian life. He was first an Army man and secondly a painter. A reliable reporter, if not particularly inspired, he produced his pictures for the most part without emphasizing the sensational or the dramatic.

40. SETH EASTMAN
Indian on the Lookout
Oil on canvas
22 x 29¾ in. (56 x 75.5 cm.)
The InterNorth Art Foundation/Joslyn Art Museum (PL 823)

Provenance:
Collection of Henrietta Thornhill, Alexandria, Virginia.
M. Knoedler & Co., Inc., New York.
Northern Natural Gas Co., Omaha, Nebraska.

Literature:
Connoisseur, "The Connoisseur in America," Vol. 144, August 1959, p. 69; Los Angeles County Museum of Art, *The American West,* 1972, p. 99; Joslyn, *The Growing Spectrum of American Art,* 1975, p. 31; Coen, *Painting and Sculpture in Minnesota 1820-1914,* 1976, pl. 6; Joslyn, *Artists of the Western Frontier,* 1976, p. 23.

41. SETH EASTMAN
Fort Snelling, Upper Mississippi
Watercolor on paper
4½ x 7 in. (11.5 x 17.7 cm.)
The InterNorth Art Foundation/Joslyn Art Museum (PL 824)

Provenance:
M. Knoedler & Co., Inc., New York.
Northern Natural Gas Co., Omaha, Nebraska.

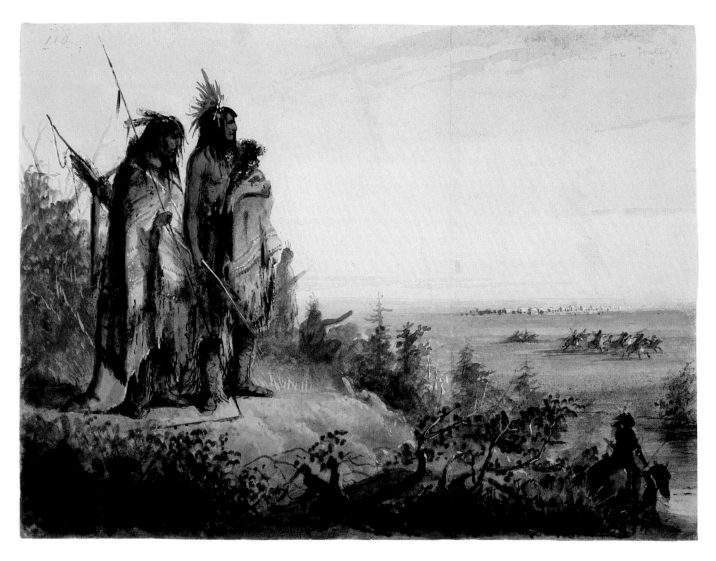

22. ALFRED JACOB MILLER, *Crossing the Divide, Thirsty Trappers Making a Rush for the River*

42. SETH EASTMAN
Village, Upper Mississippi
Watercolor on paper
4½ x 7 in. (11.5 x 17.7 cm.)
The InterNorth Art Foundation/Joslyn Art Museum (PL 825)

Provenance:
M. Knoedler & Co., Inc., New York.
Northern Natural Gas Co., Omaha, Nebraska.

43. SETH EASTMAN
Upper Mississippi Near Fort Snelling
Watercolor on paper
7¼ x 9¼ in. (18.4 x 23.5 cm.)
Inscribed l.r.: Upper Missi/near Ft. Snelling
The InterNorth Art Foundation/Joslyn Art Museum (PL 826)

Provenance:
M. Knoedler & Co., Inc., New York.
Northern Natural Gas Co., Omaha, Nebraska.

JAMES EARLE FRASER, 1876-1953. One of the most admired of American sculptors, James Earle Fraser was born at Winona, Minnesota in 1876. His father, an engineer for the Chicago-Milwaukee Railroad, moved his family in 1880 to Mitchell, South Dakota where the young Fraser is said to have carved his first figures out of chalk obtained from a nearby quarry. His early work impressed a visiting railroad company official who arranged for Fraser to enter the Art Institute of Chicago for study when the artist was only fifteen years of age. In Chicago Fraser also worked part time as an apprentice to a local sculptor and during this period executed what has come to be his most famous work, *End of the Trail*, before his seventeenth birthday.

The opening of the Chicago World's Fair in 1893, exhibiting acres of neoclassic buildings and heroic stat-

uary, is said to have fired Fraser's youthful imagination, prompting his desire to go to Paris for further study. Traveling abroad in 1895, he took his model of *End of the Trail* with him. Its exhibition in Paris won for him the $1,000 award from the American Art Association in Paris and brought the young artist to the attention of sculptor Augustus Saint-Gaudens, with whom Fraser soon after began to study and work. This association continued in Paris and later at Windsor, Vermont until Saint-Gaudens' death in 1907.

Fraser afterward set up a studio of his own in New York City where he began specializing in architectural sculpture. He received numerous public and government commissions that ranged over the next forty years in size and scope from the once familiar "Indian Head" or "Buffalo" nickel, first minted in 1913, to the sculpture group decorating the pediment of the Constitution Avenue side of the National Archives Building in Washington, D.C., one of the largest of its kind in the world.

With his wife Laura, an accomplished artist in her own right, Fraser adorned institutional facades, bridgeheads, parks, and public halls throughout the nation, furnishing it with some of its finest monumental sculpture. Notable examples appear today outside the U.S. Supreme Court Building and the Lincoln Memorial in Washington. Fraser also designed the sculpture of Alexander Hamilton for the Treasury Building in Washington, the statue of Theodore Roosevelt in front of the Museum of Natural History in New York City, the portrait of Benjamin Franklin for the Franklin Institute in Philadelphia, the General George S. Patton, Jr. Memorial at West Point, and the statue of Thomas Jefferson for the State Capitol in Jefferson City, Missouri.

His last large commission of this sort, completed when he was in his early seventies, is the pair of eighteen-foot winged horses in bronze, flanked by symbolic figures representing *The Peaceful Arts*, on the Arlington Memorial Bridge Plaza in Washington, D.C. Cast in Italy and paid for by the Italian Government as a gesture of friendship toward the United States, this grouping was installed on the approach to the bridge in 1950. The same year Fraser was awarded a golden medal from the National Institute of the Arts and Letters and further honored by a large retrospective exhibition in New York City.

Other examples of his work are found in both public and private collections throughout the United States. The James Earle and Laura G. Fraser Memorial at the National Cowboy Hall of Fame and Western Heritage Center in Oklahoma City contains original examples of the works of both artists, including a monumentally scaled plaster version of *End of the Trail* which long remained his most popular piece. Exhibited at the Panama-Pacific International Exposition in San Diego in 1915, it won a gold medal for Fraser and was seen by millions at the time. Catching the imagination of the public, it became one of the Exposition's most popular

exhibits and was widely copied over the next fifty years on everything from glass and silverware to ashtrays and bookends.

Following the Panama-Pacific Exposition, the plaster model was placed in a public park in Visalia, California, where it remained almost forgotten for the next several decades. The story of its recent restoration and placement in Oklahoma City is told by Dean Krakel in his *End of the Trail: The Odyssey of a Statue,* published by the University of Oklahoma Press at Norman. As part of the original bargain to obtain the piece for the Oklahoma City museum, a casting in bronze was made in Italy from the plaster version and placed in the California park where it may be seen today.

Although innumerable replicas of this work have been made, only a few were authorized by Fraser himself including a half-life-size version of which only three castings are known to be authentic. The casting in the InterNorth collection at the Joslyn Art Museum is one of many smaller authorized castings made by the Roman Bronze Works in New York City, which produced so many well-known sculptures by Frederic Remington and C. M. Russell, among others.

Twenty-six inches high, it is incised on the left rear of the base with the name of the artist and on the right with the name of the foundry.

44. JAMES EARLE FRASER
End of the Trail
Bronze casting
26 x 20½ x 7 in. (66 x 52 x 17.7 cm.)
Incised l.l.: ©Fraser/Roman Bronze Works, N.Y.
The InterNorth Art Foundation/Joslyn Art Museum (PL 828)

Provenance:
M. Knoedler & Co., Inc., New York.
Northern Natural Gas Co., Omaha, Nebraska.

Literature:
Sheldon Art Gallery, Lincoln, Nebraska, *American Sculpture,* 1970, no. 57; Joslyn, *Artists of the Western Frontier,* 1976, p. 38.

JOHN DARE HOWLAND, 1843-1914. A man of varied talents and adventurous exploits, John Dare Howland followed several careers during his lifetime including that of soldier, Indian scout, artist, and journalist. Born at Zanesville, Ohio in 1843, he was reportedly first inspired to explore the American West following a visit to his home by an uncle, Len Owens, friend of frontiersmen Kit Carson and Jim Bridger.

In 1857 at the age of fourteen, Howland left home and traveled to St. Louis where he made the acquaintance of fur trader Robert Campbell. Campbell arranged for Howland to accompany one of the American Fur Company steamers to Fort Pierre on the Missouri River where the young man observed the life of the remote frontier, participated in buffalo hunts, and traded with the Indians of the area.

From Fort Pierre, Howland traveled cross-country to Fort Laramie, Wyoming where he is said to have begun painting Indian pictures. News of a gold strike attracted him to the Pike's Peak area of Colorado, but discoveries were meager and discouraging, and Howland turned briefly to trapping for a living.

At the outset of the Civil War, Howland, then only eighteen, joined Company B of the First Colorado Cavalry and saw action in several campaigns in New Mexico as well as in the Indian wars that followed. He eventually rose to the rank of Captain of Scouts. In 1864 he left the military service and the following year traveled to Paris to study painting. Returning home, he served from 1867-69 as Secretary to the Indian Peace Commission, charged with negotiating treaties between the U.S. Government and the warring Plains Indian tribes.

During this and later periods, Howland worked intermittently as an artist-correspondent for several eastern publishers. His work appeared in *Harper's Weekly* and *Leslie's Illustrated Newspaper.* After another period of study abroad, he returned to Denver where he founded the Denver Art Club in 1886. Regarded by his many associates as a celebrated character, he became one of Denver's foremost civic leaders and promoters. During his latter years, he devoted more and more of his time to his art, continuing to paint until his death in Denver in 1914.

His large canvas entitled *A Western Jury* in the InterNorth collection at the Joslyn was originally commissioned by Moreton Frewen, who with his brother Richard, managed the once famed Powder River Cattle Company of Wyoming. According to some accounts, the title of this piece, executed in 1883, was originally *The Prairie Inquest.* Some confusion still exists because a similar picture by Howland with the latter title is said to have earlier been commissioned by Senator Edward Walcott of Colorado in 1880 or 1881.

A good account of Howland's life was recorded by a daughter, Kate Howland Charles, in an article entitled "Jack Howland, Pioneer Painter of the Old West" for *Colorado Magazine* in July of 1952. A further narrative of the career of Moreton Frewen, who was an uncle of Winston Churchill, is found in the book *Powder River* by Struthers Burt (New York, 1938).

45. JOHN DARE HOWLAND
A Western Jury
Oil on canvas
36 x 48 in. (91.5 x 122 cm.)
Signed l.l.: J. D. Howland/1883
The InterNorth Art Foundation/Joslyn Art Museum (PL 829)

Provenance:
Moreton Frewen, London, England.
Oswald Frewen, London, England.
Sir Shane Leslie, London, England.
M. Knoedler & Co., Inc., New York.
Northern Natural Gas Co., Omaha, Nebraska.

Literature:
Mumey, *The Art and Activities of John Dare (Jack) Howland*, 1973, p. 195; Joslyn, *Artists of the Western Frontier*, 1976, p. 23.

WILLIAM SMITH JEWETT, 1812-1873. A prolific portrait, landscape, and genre painter, William S. Jewett was born near South Dover, New York and first studied at the National Academy of Design in New York City. He pursued a career as a portrait painter from 1833 to 1849. Exhibiting throughout this period at the National Academy and the American Art-Union, he maintained a studio at New York University from 1841-49. In 1845 he was elected an Associate Member of the National Academy.

Reports of gold strikes in California prompted him to temporarily abandon his painting, and in 1849 he embarked by ship to San Francisco to seek his fortune in business or mining. He became instead California's first professional portraitist, maintaining studios in both San Francisco and Sacramento for the next twenty years. It was here he produced many landscapes as well as portraits, religious, and genre subjects relative to life in the West.

Jewett prospered in California, reportedly charging from $150 to $800 apiece for his portraits. Receiving all the commissions he could handle, he made friends of San Francisco's most important business and political leaders, becoming prominent in both spheres of activity. Investing wisely in real estate and agriculture, he returned to New York City in 1869 a wealthy man and thereafter retired from such pursuits.

Jewett married in 1870 and returned again briefly to the West Coast before traveling abroad for study and pleasure. His only child, William Dunbar Jewett, who also became a professional artist and writer, was born in England in 1873. Soon after returning to the United States, the elder Jewett died at Springfield, Massachusetts in December of the same year.

A great many of his paintings are said to have been lost in the San Francisco earthquake and fire of 1906.

Others are owned today by his descendants or may be seen in the collections of the National Academy of Design in New York City, the M. H. de Young Memorial Museum in San Francisco, at Sutter's Fort and in the State Capitol in Sacramento, and the Bowers Memorial Museum in Santa Ana, California.

Jewett's painting entitled *Pursued* in the InterNorth collection at the Joslyn represents an Indian subject, and was painted in California before Jewett returned East in 1869.

46. WILLIAM JEWETT
Pursued
Oil on canvas
29 x 36 in. (73.7 x 91.5 cm.)
Signed l.r.: W. S. Jewett/1863
The InterNorth Art Foundation/Joslyn Art Museum (PL 830)

Provenance:
Private collection.
M. Knoedler & Co., Inc., New York.
Northern Natural Gas Co., Omaha, Nebraska.

Literature:
Cedar Rapids Art Center, Iowa, *Artists of the Western Frontier*, 1968.

PAUL KANE, 1810-1871. Along with contemporaries George Catlin and John Mix Stanley, Paul Kane devoted a significant part of his career as an artist to the portrayal of North American Indian life. Born at Mallow in County Cork, Ireland in 1810, he immigrated with his parents in 1818 to the Canadian settlement of York, later Toronto, where he grew up and first supported himself as a coach and sign painter.

Later moving to Cobourg, where he worked briefly as a portraitist, Kane traveled to Detroit, Michigan in 1836 to meet artist James Bowman and accompany him on a proposed European tour. The trip abroad was postponed and Kane remained in and around Detroit for a period of time attempting to make a living at portrait painting in the hope of earning enough money to take him to Europe for formal study.

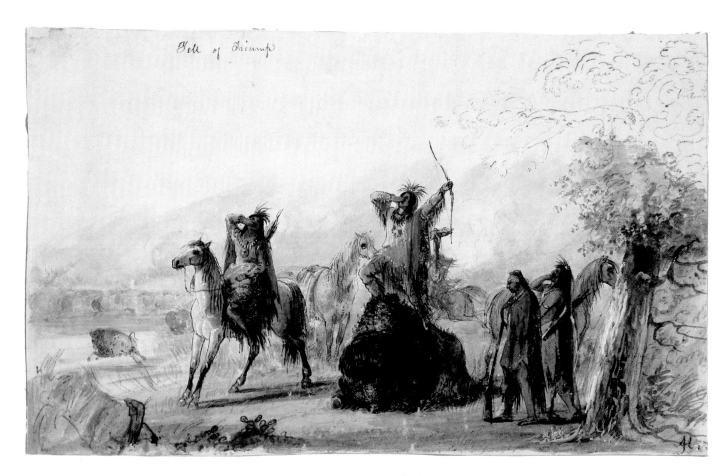

23. ALFRED JACOB MILLER, *Yell of Triumph*

He eventually made his way to Mobile, Alabama where he opened a studio and continued painting portraits. In 1841 he sailed for Italy and afterward visited London where he had occasion to view the much publicized exhibition of Catlin's Indian Gallery at the Egyptian Hall in Piccadilly. This experience seems to have had a pronounced effect upon Kane, for he thereafter resolved to undertake an exploration of the American West himself and create his own gallery of Indian pictures.

Returning home to Canada in 1845, Kane was successful in gaining the support of Sir George Simpson of the Hudson Bay Company to undertake his travels westward by means of the company's network of overland trails and outposts. His plans in this regard were greatly facilitated when he joined a brigade of river boats westward through the Great Lakes waterway to Sault Sainte Marie, an important point on the American-Canadian fur exchange between Lake Michigan and Lake Superior. From here he continued largely on his own across the continent, reaching Fort Vancouver on Vancouver Island, British Columbia in December of 1846.

Back again in Toronto in the fall of 1848 with a considerable collection of pencil sketches and watercolors documenting the character and culture of the Indian tribes he had encountered along the way, Kane immediately set to work to produce a series of over 100 large paintings illustrating his recent travels. Failing to sell his collection to the Canadian Government, which commissioned only about a dozen paintings from his studio, Kane sold the bulk of his pictures to a private patron, George William Allan of Toronto. Many of these were later acquired by the Royal Ontario Museum in Toronto where they may be found today.

Meanwhile, Kane settled permanently in Toronto and in 1859 published abroad his *Wanderings of an Artist Among the Indians of North America,* illustrated with reproductions of paintings in his Indian collection. He died at Toronto twelve years later, his reputation as a pioneer Canadian artist securely established.

Kane's accomplishments as an Indian artist-historiographer in Canada correspond closely to those of George Catlin in the United States, although he never became as well known. Kane's work is less widely known outside of Canada.

Approximately 200 of Kane's original field sketches and other paintings and the artist's original manuscript journal of his western travels are now owned by the Nelda C. and H. J. Lutcher Stark Foundation of Orange, Texas. Many of the above studies were reproduced in his subsequent *Wanderings of an Artist* (London, 1859) and again appear as illustrations in *Paul Kane's Frontier* published by the Amon Carter Museum of Western Art in Fort Worth in conjunction with the University of Texas Press at Austin in 1971. Edited by J. Russell

Harper, this publication also includes a reprinting of Kane's original narrative.

The large oil painting attributed to Kane in the InterNorth collection at the Joslyn is one that might be described as atypical of Kane's output from the standpoint of subject matter. It depicts an imagined scene of importance to the history of North America.

47. PAUL KANE
Columbus Discovering America
Oil on canvas
39½ x 50 in. (99 x 127 cm.)
The InterNorth Art Foundation/Joslyn Art Museum (PL 831)

Provenance:
Collection of Perkins Bull, Montreal, Canada.
Private collection.
M. Knoedler & Co., Inc., New York.
Northern Natural Gas Co., Omaha, Nebraska.

Literature:
American Heritage Magazine, "Columbus and Genocide," Vol. 26, October 1975, pp. 4-5.

JAMES OTTO LEWIS, 1799-1858. The American Indian as a subject for study long occupied the attention of the U.S. Congress, and a significant number of the Indian pictures produced during the first half of the nineteenth century were done by artists commissioned by the Federal Government. James Otto Lewis was so employed for nearly fifteen years, working for the most part in Wisconsin and Indiana. He painted portraits which eventually appeared as reproductions in his *Aboriginal Portfolio.* Issued in ten serial parts at Philadelphia in 1835-36, it was the first series of its kind ever published.

Born in Philadelphia in 1799, Lewis began his career there as an engraver in 1815. In 1819 he made his first excursion to the Great Lakes frontier with Governor Lewis Cass of Michigan Territory and from 1823-34 was officially assigned to paint Indian portraits in the West.

In this capacity he was present at the signing of the Treaty of Prairie du Chien in 1825 and at Fond du Lac in

1826. In October of the latter year, he was again present when treaties were negotiated with the Pottawatomi and Miami in Indiana. The following summer he was at Buttes des Morts on the Fox River in Wisconsin to witness the signing of the Treaty of Green Bay.

He is known to have also done some engraving at St. Louis during this period, probably as early as 1820 or 1821. He later settled in Detroit where he continued to paint portraits and was otherwise engaged in copperplate engraving and printing until about 1833. Although now regarded as a pioneer in the field of frontier portraiture, Lewis never received due recognition for his efforts during his lifetime and his final years were spent in relative obscurity in New York City where he died in 1858.

Lewis was unsuccessful in his efforts to follow up the initial publication of his *Port-folio* with subsequent editions in New York and London. His work was largely overshadowed by that of George Catlin in the West and of Charles Bird King in Washington, especially following the appearance of the reproductions of King's gallery of Indian portraits in the three-volume *History of the Indian Tribes of North America* published by Thomas L. McKenney and James Hall in 1836-44. Head of the Bureau of Indian Affairs in Washington from 1816-30, McKenney also had been with Governor Cass at Lake Superior to negotiate the treaty signed in 1826 with the Chippewa which released important copper deposits in the region to the whites. McKenney published an account of this expedition and its purposes in 1827 under the title *Sketches of a Tour to the Lakes . . . and of Incidents Connected with the Treaty of Fond du Lac*. The majority of the illustrations in this volume are credited to Lewis. Some other of his portraits, first reproduced in his own *Port-folio,* later appeared again in McKenney and Hall's *History.*

Ethnologist Martin Weitenkampf in a pamphlet entitled "Early Pictures of North American Indian," published by The New York Public Library in 1950, says that Lewis's work represents "by far the finest and largest effort to portray the Indian of the Central West to that time." He adds, however, with reference to Lewis's *Portfolio* that "the only disadvantage to the book, historically speaking, is that the Indians are dressed up to have their pictures painted . . . and probably never looked that way again."

Few of Lewis's original portraits are now available for study, and can be viewed only through surviving lithographs in various states, for the most part drawn by different lithographic artists for different printers. A collection of original pencil and oil studies by Lewis remains in the possession of Lucas Brothers, Inc., of Baltimore, Maryland. Copies of these were made in watercolor by printer Fielding Lucas to serve as models for the lithographs illustrating McKenney's *Tour to the Lakes* and later were included with a duplicate manuscript sent by McKenney to England for a proposed

European edition. Later returned to McKenney, the watercolors eventually were deposited with the American Philosophical Society in Philadelphia. They were recently reproduced by the Meriden Gravure Company for Barre Publishers in Barre, Massachusetts, to illustrate a reprinting of the McKenney account.

48. JAMES OTTO LEWIS
Indians of Western Algonquin Tribe, 1826
Oil on canvas
23 x 27 in. (58.5 x 68.6 cm.)
The InterNorth Art Foundation/Joslyn Art Museum (PL 832)

Provenance:
M. Knoedler & Co., Inc., New York.
Northern Natural Gas Co., Omaha, Nebraska.

Literature:
Joslyn, *Artists of the Western Frontier,* 1976, p. 22.

W. M. (UNIDENTIFIED ARTIST)

49. W. M.
Sault Sainte Marie Rapids (Upper Michigan)
Pencil on paper
10⅜ x 14⅞ in. (26.5 x 38 cm.)
Inscribed l.r.: Sault St. Marie Rapids/Augt—1850/Sketch on the spot by/W. M.
The InterNorth Art Foundation/Joslyn Art Museum (PL 833)

Provenance:
M. Knoedler & Co., Inc., New York.
Northern Natural Gas Co., Omaha, Nebraska.

THOMAS MORAN, 1837-1926. Regarded by many during his lifetime as a venerable dean of American landscape painters, Thomas Moran was born at Bolton in Lancashire, England in 1837 and emigrated to the United States with his parents in 1844. Moran's father, a handloom weaver, first settled his family in Baltimore and then Philadelphia where the young Thomas received instruction in the rudiments of art from his elder brother Edward and later was apprenticed to a wood engraver.

Encouraged by Edward's early success as a landscape painter, Thomas shared a studio with him for a time and also exhibited with Edward and another brother Peter at the Philadelphia Academy of Fine Arts. In the summer of 1860, he made his first trip into the West with artist

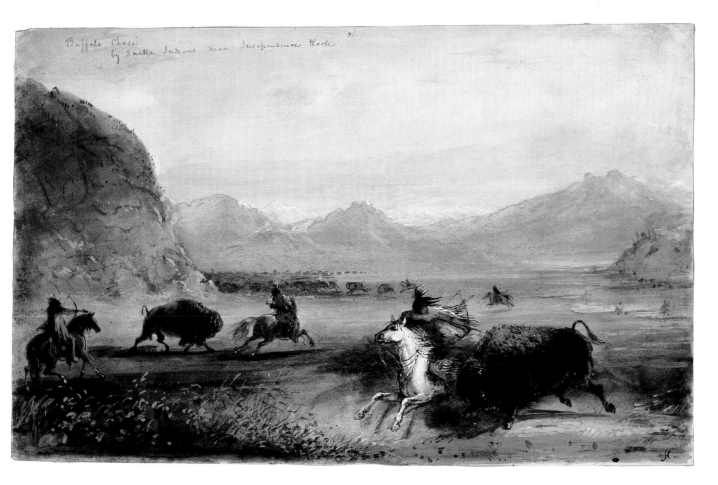

24. ALFRED JACOB MILLER, *Buffalo Chase by Snake Indians*

Isaac Williams to the Lake Superior area of upper Michigan to view the Pictured Rocks south of Sault Sainte Marie. He was reportedly influenced to undertake this excursion after having read Longfellow's epic poem *Hiawatha,* an edition of which he later illustrated.

In 1861 brothers Thomas and Edward went abroad to tour the English museums and galleries. At this time Thomas saw the works of Joseph Turner, whose manner of depicting the effects of light made a lasting impression upon him. Returning to the States in 1862, Thomas married and settled again in Philadelphia where he opened his own studio, continuing to exhibit regularly at the Academy of Fine Arts and at James Earle's gallery.

With his wife he made at least two more trips to Europe between 1863 and 1867 to study the Barbizon painters of France and the Italian painters of Rome, Naples, and Milan. Throughout this period he also made excursions into the Pennsylvania countryside to sketch views along the Schuylkill and Wissahickon Rivers, and later the Delaware and Susquehanna. He was represented by a portfolio of his work entitled *Studies and Pictures* issued in lithograph by a Philadelphia printer in 1869. This included earlier views of Lake Superior and scenes along the Wissahickon. At this time he also began contributing illustrations to *Scribner's Monthly* and other New York based magazines.

Scribner's carried its share of western frontier reportage and in 1871 planned to issue a report by N. P. Langford on "The Wonders of Yellowstone" following Langford's visit to that area the previous summer with a party of Montana explorers. With Langford's manuscript were a few rough sketches by one of the soldiers of the expedition which Moran was directed to work up into suitable illustrations for publication. Langford intended to make a second trip to the Yellowstone region with geologist Ferdinand V. Hayden to supply material for another article which Moran again was slated to illustrate. Desiring to venture to Yellowstone himself, Moran obtained the agreement of *Scribner's* and additional funding for the trip from Jay Cooke of the Northern Pacific Railroad which was then anxious to publicize the scenic wonders of the Far West.

Moran caught up with the survey party in June of 1871, accompanying Hayden on his subsequent exploration of the upper Yellowstone River and environs. Returning eastward with a portfolio of sketches describing the mountains, canyons, geysers, and hot springs of that distant country, he produced some illustrations for *Scribner's* and also for *Harper's Weekly.* Several of the illustrations for *Scribner's* appeared again in Hayden's official report of his explorations.

A collection of twenty-four watercolors was reproduced in chromolithograph by Louis Prang in Boston and published in 1876 in an oversize folio entitled *A Survey of Yellowstone Park, and the Mountain Regions . . . of Idaho, Nevada, Colorado, and Utah.* Hayden supplied the text. By the time it was issued,

Yellowstone Park had already been established by Congress as the first national park in the country. Proponents of the park bill in 1872 later declared that the studies by Moran and the official photographs by William H. Jackson had been important factors in persuading the Government to set this area aside as a natural preserve for the enjoyment of the American public.

Moran was again in the West in 1872 on assignment to produce illustrations of scenes along the routes of the Union and Central Pacific Railroads for Appleton's *Picturesque America* issued under the editorship of William Cullen Bryant. Explorer John Wesley Powell had invited the artist to join him on a proposed expedition down the Colorado River. Moran had declined because of commitments to Appleton's, traveling instead by train from Omaha to Salt Lake City and afterward visiting the Yosemite Valley, Lake Tahoe, and other areas of the West Coast. Moran's view of Half Dome at Yosemite later appeared in *Picturesque California,* issued by naturalist John Muir.

Still on assignment for Appleton's in February, 1873, Moran agreed to accompany Hayden and Jackson on a trip that summer down the Colorado River. Hayden meanwhile was reassigned to explore the higher elevations of the Colorado Rockies and Moran, recalling J. W. Powell's earlier invitation, joined him at Salt Lake in July of that year just in time to accompany the famous Powell exploration of the Colorado River including the Grand Canyon. Moran later returned to the Colorado Rockies and the Grand Tetons of western Wyoming on further assignments for *Picturesque America.* At the same time, some twenty-nine views, mostly by Moran, were published in serial form by *Scribner's* to illustrate Powell's account of his exploration of the Green River in Oregon and Idaho.

Moran also painted several large-scale landscapes during this period, two of which, *The Great Canyon of the Yellowstone* and *Chasm of the Colorado,* were exhibited with much public attention in New York City and Washington and afterward purchased by Congress for the Senate Lobby. Both pictures were painted between 1872 and 1873 on canvases measuring seven by twelve feet and both were purchased by the Government. Washington art critic Clarence Cook declared that Moran's view of the Grand Canyon of the Yellowstone was "the only good picture . . . to be found in the Capitol," comparing it to the better known view of Niagara Falls painted by Frederic Edwin Church who at that time was considered the leading landscape painter in America. F. V. Hayden also was said to have observed at about this same time that Moran's reputation as an artist "now was made."

Moran's part in the establishment of Yellowstone National Park has been well documented. Not so well known, perhaps, is his influence in regard to other areas of the scenic West. A tireless traveler, Moran journeyed

widely over the next forty years in search of natural vistas to paint, and many of his favorite sketching sites eventually were declared national parks or monuments, including the Yosemite Valley and the Grand Canyon of the Colorado River in Arizona. Director of the U.S. Park Service, Stephen Tyng Mather said of Moran: "More than any other artist, he has made us acquainted with the great West."

Elected a member of the National Academy of Design in 1884, Moran continued to travel to Europe and throughout the United States, touring the Atlantic seaboard, the Adirondacks, and the Southeast as far as Florida. At the time of his death in 1926, he had seen and described more of the wilderness landscape of North America than any other artist of his generation. Today important collections of his work are owned by the National Parks Service, The Metropolitan Museum of Art and The Museum of Modern Art in New York City, the Heckscher Museum at Huntington, Long Island, the Smithsonian Institution in Washington, D.C., the Walker Art Center in Minneapolis, and the Los Angeles County Museum of Art. The largest single collection of his paintings and studies is owned by the City of Tulsa, Oklahoma in the collection of the Thomas Gilcrease Institute of American History and Art.

Not to be overlooked is Moran's wife, Mary Nimmo Moran (1842-1899), who was also an accomplished landscapist and etcher. Their son Paul Nimmo Moran and nephews Edward Percy and Leon Moran all followed active careers as painters and engravers. The elder Edward later moved to New York City and spent the remainder of his life there as a marine and historical painter. Younger brother Peter Moran is said to have accompanied Thomas on at least one journey to the Grand Tetons in the summer of 1879. He was already well acquainted with the West at this time, chiefly the Southwest where he had first gone in 1864 with ethnologist John Gregory Bourke to study Indian life in that area. An admirer of English animal painter Edwin Landseer, Peter specialized in the depiction of animals and rural scenes, spending most of his career in Philadelphia. His wife, too, was an artist of some ability.

50. THOMAS MORAN
Colorado Mountain Peak (Sultan Mountain from Baker's Park)
Oil on panel
12½ x 16 in. (26.7 x 40.7 cm.)
Inscribed l.r.: TM
The InterNorth Art Foundation/Joslyn Art Museum (PL 834)

Provenance:
Private collection.
M. Knoedler & Co., Inc., New York.
Northern Natural Gas Co., Omaha, Nebraska.

Literature:
Joslyn, *Artists of the Western Frontier,* 1976, p. 19.

J. W. P. (UNIDENTIFIED ARTIST)

51. J. W. P.
Baltimore and Ohio Railroad, 1864
Ink, pencil and wash on paper
5 x 6½ in. (13 x 16.5 cm.)
Inscribed l.r.: J. W. P.
The InterNorth Art Foundation/Joslyn Art Museum (PL 835)

Provenance:
M. Knoedler & Co., Inc., New York.
Northern Natural Gas Co., Omaha, Nebraska.

WILLIAM TYLEE RANNEY, 1813-1857. Born in Middletown, Connecticut, William Tylee Ranney was one of an emerging group of painters in the nineteenth century whose works portrayed familiar aspects of American rural and frontier life. He spent his youth in Fayetteville, North Carolina where he was early apprenticed to a tinsmith. Little else is known of the first twenty years of his life, but by 1833 he had settled in Brooklyn, New York where he received his first instruction in art and began painting portraits for a living.

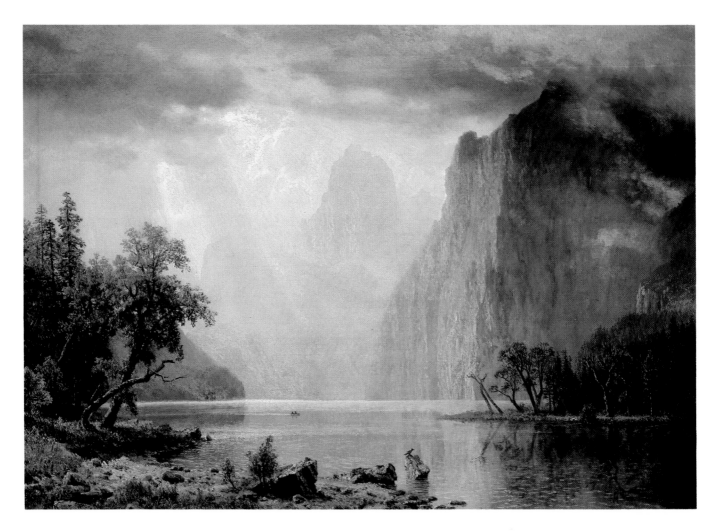

7. ALBERT BIERSTADT, *Mountain Lake*

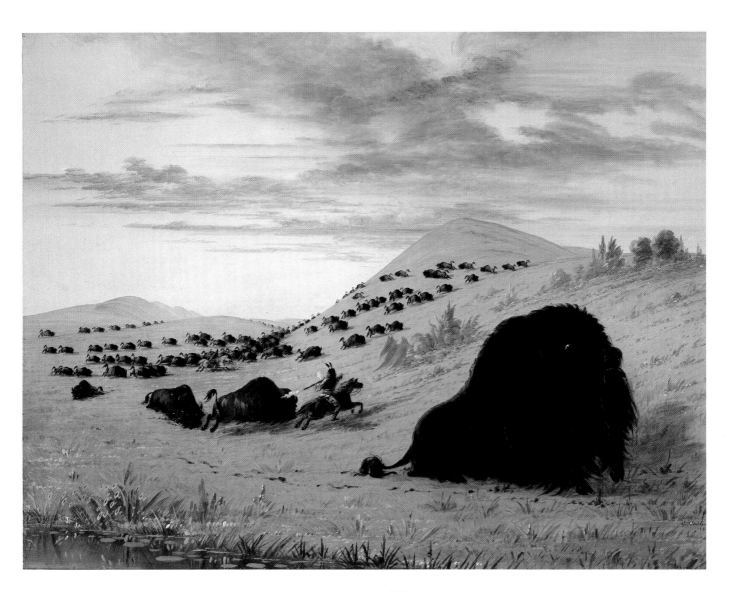

21. GEORGE CATLIN, *Buffalo Hunting*

Accounts vary with respect to his subsequent career, especially as to when he may have visited the West. Some sources indicate that as early as 1836 he interrupted his studies in New York to travel to Texas following the much publicized battle of the Alamo during the war for Texas independence. Arriving in New Orleans, he is said to have enlisted in Sam Houston's army and to have taken part in the battle of San Jacinto, afterward serving as a regimental paymaster in Texas. There he became well acquainted with the frontier characters represented in so many of his later paintings.

If this account is correct, he was back in Brooklyn in 1837 and later opened a studio at New York University which he seems to have maintained between the years of 1843 and 1846-47. According to some reports, he interrupted his career to enlist in the U.S. Army at the outbreak of the war with Mexico and was assigned to duty in the Southwest, possibly Texas. Whether or not he actually made two visits to this area while serving with the military is not clear from available information. In his *Book of the Artists* (New York, 1867), historian Henry Tuckerman only says that Ranney painted portraits in New York City from 1843 and fought in the Mexican War in Texas where he "caught the spirit of Border adventure and was enamoured of the picturesque in scenery and character outside the range of civilization . . ."

Yet another reference indicates that Ranney was active as a portraitist in New York City from 1843-46 and in the latter year enlisted in the Army and served a tour of duty in Texas. No mention of an earlier experience in Texas with Sam Houston's army is noted in either case.

In 1848 Ranney married, and in 1850 he was elected an Associate Member of the National Academy of Design. Moving to West Hoboken, New Jersey, Ranney built a large studio and decorated it with the memorabilia of his earlier adventures in the West. He devoted the last few years of his life to the painting of historical and western frontier scenes.

Ranney painted a white man's West, minimizing the role of the Indian in his pictures. At the time of his election to the National Academy of Design, he was one of the few artists making a career as an anecdotist along with such notables as William Sidney Mount and Thomas Matteson. His scouts and trappers display less of the romantic sentimentality usually associated with the storytelling paintings of this period. When he died at West Hoboken in 1857, he left a number of unfinished works which later were completed by his friend Mount.

The Trappers, painted at his studio in West Hoboken within a year of his death, is included in the Inter-North collection at the Joslyn along with an earlier and larger work titled *Hunting Wild Horses.*

52. WILLIAM TYLEE RANNEY

Hunting Wild Horses
Oil on canvas
36 x 54½ in. (91.5 x 138.5 cm.)
Signed l.l.: Ranney/1846
The InterNorth Art Foundation/Joslyn Art Museum (PL 836)

Provenance:
Mr. & Mrs. Marshall O. Roberts, New York.
M. Knoedler & Co., Inc., New York.
Northern Natural Gas Co., Omaha, Nebraska.

Literature:
U.S. Sanitary Commission, *Catalogue of Paintings, Drawings, Statuary, etc. of the Art Department in the Great Central Fair,* 1864, no. 213; City Art Museum of St. Louis, *Westward the Way,* 1954, p. 158; Grubar, *William Ranney, Painter of the Early West,* 1962, p. 28 and book jacket; Metropolitan Museum of Art, *19th-Century America—Paintings and Sculpture,* 1970, no. 81; Los Angeles County Museum of Art, *The American West,* 1972, p. 59; Whitney Museum of American Art, *The American Frontier: Images and Myths,* 1973, p. 36; Glubok, *The Art of America from Jackson to Lincoln,* 1973, p. 39; Joslyn, *Artists of the Western Frontier,* 1976, p. 26.

53. WILLIAM TYLEE RANNEY

The Trappers
Oil on canvas
23½ x 36 in. (59.7 x 91.5 cm.)
Signed l.c.: Wm. Ranney/1856
The InterNorth Art Foundation/Joslyn Art Museum (PL 837)

Provenance:
Collins Gallery, New York.
M. Knoedler & Co., Inc., New York.
Northern Natural Gas Co., Omaha, Nebraska.

Literature:
City Art Museum of St. Louis, *Westward the Way,* 1954, p. 183; Denver Art Museum, *Building the West,* 1955, p. 9; Davie, *Profile of America, An Autobiography of the U.S.A.,* 1957, p. 145; Grubar, *William Ranney, Painter of the Early West,* 1962, p. 39; Joslyn, *A Sense of Place,* Vol. II, 1973, p. 24; Joslyn, *Artists of the Western Frontier,* 1976, p. 36.

FREDERIC SACKRIDER REMINGTON, 1861-1909. The son of a newspaper publisher, Frederic Remington decided at an early age on a career in art instead of journalism. Born at Canton in upstate New York, he later lived at Ogdensburg, where his father edited the local *Journal* while serving as U.S. Collector of Customs for the Port of Ogdensburg. He attended a military prep school in Massachusetts before entering Yale University in 1878

to study drawing and otherwise distinguish himself as an athlete.

Following the death of his father in 1880, Remington dropped out of school and found employment for a time as a clerk in the Governor's office in Albany. Having already decided that the formalities of art school were not for him, he determined to see something of the world and to draw from life, not plaster models.

In 1881 he traveled by rail to Montana where he was introduced to the activities of the cowboy and prospector and came to realize that a colorful era in the history of the frontier West was swiftly passing away. It was a brief experience, but a formative one, and he resolved to return again to record this changing scene.

Back in Albany, he continued to work at the Capitol until shortly before his twenty-first birthday, when he announced to his family that he intended heading west once more, this time as part owner of a sheep ranch in Kansas with a college friend, Robert Camp. Again this was a short lived experiment. Remington was back in Canton in 1884 to marry his childhood sweetheart. The couple then moved to Kansas City where Remington opened a small studio and invested as a partner in a local saloon. Neither venture proved to be much of a success.

Anxious to break into the field of commercial illustration, Remington began submitting work to various magazines and sold his first western sketch to *Harper's Weekly* in the early part of 1886. Thus encouraged, the Remingtons moved back to New York and settled in Brooklyn. Remington enrolled briefly at the Art Students League in New York City, receiving instruction in painting from J. Alden Weir. At the close of the spring session, he set out again for the West, traveling to Arizona and into Mexico and visiting U.S. military establishments at Fort Grant, Camp Apache, and other outposts in the Southwest.

He may have participated in, and certainly observed, General Crook's campaign against the Apache at this time. He soon returned to New York City with illustrations for *Harper's* and *Outing* magazines. *Outing's* editor, Poultney Bigelow, had been Remington's friend at college and his brother had served in Crook's campaign against Geronimo. In the months that followed, other publishers began paying Remington for subsequent trips into the western territories. Over the next four years, he produced nearly 200 illustrations for the leading periodicals of his day.

In 1887 he toured the Pacific Northwest and the Canadian Rockies and in 1888 was again in the Southwest, chiefly Texas and Indian Territory. *Century* magazine sponsored the latter excursion and in the fall of 1888 published most of the illustrations that Remington had produced during the summer as well as several of his short stories and reports.

By this time Remington was becoming recognized as an illustrator of importance along with contemporaries Howard Pyle and Charles Dana Gibson. Ultimately, he became one of the world's most highly paid illustrators and widely acknowledged as America's foremost artist of the western scene.

Longing for recognition of a different sort, he began exhibiting regularly at the National Academy of Design in 1887 and in shows of the American Water Color Society and the Brooklyn Art Club. His painting, *General Crook in Indian Country,* exhibited at the National Academy in 1891, won for him election as an Associate Member of that body. Further exhibitions of his work in 1893 and 1895 failed to elevate him to the ranks of the professional academicians, however, and the stigma of commercial illustrator remained.

Having become interested in sculpture as a medium of expression, Remington produced his first bronze, *Bronco Buster,* in 1895. It was immediately acclaimed for its realism and sense of action. He produced twenty-two bronzes over the next fourteen years, ranging in subject from depictions of cowboys and cavalrymen to interpretations of the Plains Indian and the mountain man. *Comin' Through the Rye,* one of his larger pieces, cast in 1902, became the first of Remington's works in any medium to be acquired by a major American museum when it was purchased by the Corcoran Gallery of Art in Washington, D.C.

Remington continued throughout this period to travel on assignments from various publishers. He was in Mexico again in 1889 for *Harper's* to gather material on the Mexican Army to illustrate a series of articles on that subject. In 1890 he was back in Montana, for *Harper's,* with General Nelson A. Miles and a group of Indian commissioners visiting the Crow Reservation and the Cheyenne Agency at Lame Deer.

The U.S. Army's part in the Indian wars of this period was a recurring subject in Remington's pictures throughout the early 1890s. He departed briefly from familiar themes in 1896 when he traveled to Cuba on assignment for William Randolph Hearst's *New York Journal* to gather reports on the struggle then going on between Cuban nationalist insurgents and the Imperial Spanish force.

Returning to New York in 1897, Remington was back in Cuba as an artist-correspondent in 1898 when war broke out between Spain and the United States. The American West was, nevertheless, his primary field of interest and in 1899 he returned to the Rockies to spend part of the summer sketching in that area.

In 1902 Remington was approached by *Collier's* to produce exclusively for that publisher a series of paintings to be marketed as art prints. Freed at last from the constraints of commercial illustration, Remington began a notable collection of pictures representing historical characters and events in the annals of the Old West. At about this same time, a set of eight western character studies was issued in lithographic form by Robert Howard Russell for *Scribner's* in a portfolio entitled "A

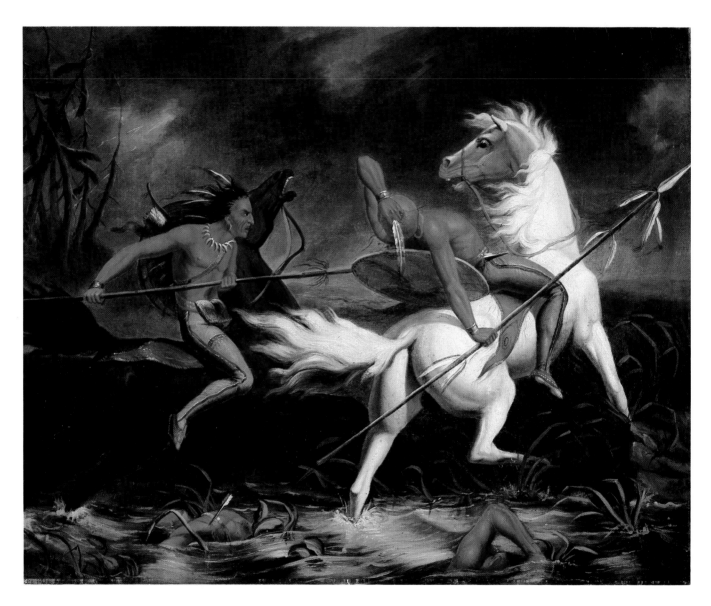

36. CHARLES DEAS, *Indians at War*

Bunch of Buckskins" with introductory notes by Owen Wister, Remington's long-time friend.

An avowed realist and reputedly possessing a near photographic eye for details, Remington followed the narrative tradition in his art and most of his pictures told a story. Also an avid horseman, he depicted horsemen of every type. Some years before his death, he suggested that his own epitaph should read simply "He knew the horse." His last sculpture, *Caught in a Stampede*, portrays a cowboy and his horse rushing headlong with a group of lunging cattle. It was cast shortly after his death of acute appendicitis in 1909. He was only forty-eight years old and at the height of his popularity.

During the last twenty years of his life, Remington produced over 2,700 paintings, drawings, and sculptures, utilizing a western theme in the majority of them. Also a successful writer of stories and articles, most of which he illustrated himself, he published a number of authentic narratives of the West as well as two historical novels and a book of collected short stories.

He was in great demand as an illustrator by such authors as Theodore Roosevelt, Francis Parkman, and Owen Wister, who once remarked that "Remington is not merely an artist—he is a national treasure." His illustrations appeared in forty-one different periodicals and 142 books.

Today works by Remington can be found principally at the Remington Memorial in Ogdensburg, New York; the Whitney Gallery of Western Art in Cody, Wyoming; the Thomas Gilcrease Institute of American History and Art in Tulsa, Oklahoma; and the Amon Carter Museum of Western Art in Fort Worth, Texas. An important collection of his bronzes is displayed at the Stark Museum of Art in Orange, Texas.

An oil painting entitled *The Waterhole* is included in the InterNorth collection with several previously published, original illustrations. A casting of his first bronze, *Bronco Buster*, is listed in the inventory of the Joslyn Art Museum.

One of the illustrations in the InterNorth collection, *Uhlan Officer in Field Trim*, documents Remington's only known trip abroad when he traveled in 1892 with Poultney Bigelow to North Africa, Germany, and Russia. Observing military activities of the French African colonies, Remington also studied cavalry tactics and field equipment at Kaiser Wilhelm's farm at Trakehnen where Prussian cavalry officers and mounts were trained. Bigelow later published an article, "Side Lights on the German Soldier," illustrated by Remington in *Harper's Monthly* in July of 1893. This illustration appeared again in Bigelow's book *Borderland of the Czar and Kaiser* (New York, 1895).

Yet another illustration in the collection, a watercolor, depicts Crow Indians with the U.S. military. Entitled *Troop L, First Cavalry*, this appeared with an article, "Our Indian Contingent," by a Lt. S. C. Robertson in *Harper's Weekly* in February of 1892, and dates from Remington's trip to Montana in 1890 with Nelson Miles.

Also included in the InterNorth collection is a set of the eight color lithographs after pastel drawings by Remington, published in 1902 as "A Bunch of Buckskins."

54. FREDERIC REMINGTON
Uhlan Officer in Field Trim
Wash and ink on paper
17¼ x 7 in. (43.8 x 17.8 cm.)
Signed l.l.: Frederic Remington
The InterNorth Art Foundation/Joslyn Art Museum (PL 838)

Provenance:
Walter S. Hay collection, Bronxville, New York.
M. Knoedler & Co., Inc., New York.
Northern Natural Gas Co., Omaha, Nebraska.

Literature:
Harper's Monthly, "Side Lights on the German Soldier," July 1893, p. 220; Bigelow, *Borderland of the Czar and Kaiser*, 1895, p. 156.

55. FREDERIC REMINGTON
Bunch of Buckskins
Portfolio of 8 lithographs on paper
19⅞ x 14⅞ in. (50.5 x 37.8 cm.)
The InterNorth Art Foundation/Joslyn Art Museum (PL 839)

Provenance:
M. Knoedler & Co., Inc., New York.
Northern Natural Gas Co., Omaha, Nebraska.

Literature:
Joslyn, *Artists of the Western Frontier*, 1976, p. 27.

56. FREDERIC REMINGTON
The Waterhole
Oil on canvas
20 x 26 in. (51 x 66 cm.)
Signed l.r.: Frederic Remington
The InterNorth Art Foundation/Joslyn Art Museum (PL 840)

Provenance:
Collection of Mrs. Natalie Marvin, New York.
M. Knoedler & Co., Inc., New York.
Northern Natural Gas Co., Omaha, Nebraska.

Literature:
Joslyn, *The Growing Spectrum of American Art*, 1975, p. 31; Joslyn, *Artists of the Western Frontier*, 1976, p. 28.

57. FREDERIC REMINGTON
Poster for Century Magazine Cover, January 1902
Color process lithography on paper
20½ x 14⅛ in. (52.2 x 36 cm.)
The InterNorth Art Foundation/Joslyn Art Museum (PL 841)

Provenance:
Collection of Howard S. Mott.
M. Knoedler & Co., Inc., New York.
Northern Natural Gas Co., Omaha, Nebraska.

58. FREDERIC REMINGTON
Leaving the Canyon
Wash and ink on paper
25½ x 20 in. (64.7 x 51 cm.)
Signed l.r.: Frederic Remington
The InterNorth Art Foundation/Joslyn Art Museum (PL 842)

Provenance:
Collection of John E. Tanck, Albany, New York.
M. Knoedler & Co., Inc., New York.
Northern Natural Gas Co., Omaha, Nebraska.

Literature:
The Cosmopolitan, Vol. XVII, no. 6, October 1894, opposite
title page; *Art in America,* "The Negro in American Art," no.
3, 1964, p. 81; Cedar Rapids Art Center, Iowa, *Artists of the
Western Frontier,* 1968; Amon Carter Museum of Western
Art, *Frederic Remington,* 1973, p. 14; Joslyn, *Artists of the
Western Frontier,* 1976, p. 27.

59. FREDERIC REMINGTON
Troop L, First Cavalry
Wash and ink on paper
10⅝ x 26⅛ in. (27 x 66.3 cm.)
Inscribed u.r.: Double Column of Four - Raise Sabre/"L"
Troop/1st Cavalry—/Crow Indians—
Signed l.r.: Frederic Remington—
The InterNorth Art Foundation/Joslyn Art Museum (PL 843)

Provenance:
M. Knoedler & Co., Inc., New York.
Northern Natural Gas Co., Omaha, Nebraska.

Literature:
Harper's Weekly, "Our Indian Contingent," Vol. XXXVI, no.
1843, February 1892, p. 156; Amon Carter Museum of
Western Art, *Frederic Remington,* 1973, p. 21; Joslyn, *Artists
of the Western Frontier,* 1976, p. 27.

PETER RINDISBACHER, 1806-1834. Swiss artist Peter
Rindisbacher received only a limited amount of formal
schooling before emigrating with his parents to North
America in 1821 to join a group of settlers bound for the
Earl of Selkirk's Red River Colony near the modern
Winnipeg, Manitoba. Having been briefly instructed in
art at Bern by watercolorist Jacob Weibel, the fifteen
year old Rindisbacher began making sketches of the
Indians and animal life of the northern wilderness
during the journey from Hudson's Bay to Fort Douglas
and over the next five years contributed to the support of
his family through the sale of his drawings and water-
colors.

He was commissioned in 1822-23 to paint views at
British forts and some of these later appeared in publica-
tion. Meanwhile, by 1826, many of the original settlers
had abandoned the Red River site and migrated
south into Wisconsin Territory. Some, including the
Rindisbachers, settled in St. Louis, Missouri where in
1829 Peter opened a studio and began contributing
sporting scenes to the *American Turf Register.* He was
just beginning to make a name for himself as an illus-
trator when he died in 1834 at the age of twenty-eight.

Surviving original examples of his work are rela-
tively scarce. The principal collections in the United
States are found at the U.S. Military Academy at West
Point, the Peabody Museum at Harvard University, and
the Thomas Gilcrease Institute of American History and
Art in Tulsa, Oklahoma. Other examples are found at
the Amon Carter Museum of Western Art in Fort Worth,
Texas and the National Cowboy Hall of Fame and
Western Heritage Center in Oklahoma City.

Forty watercolors depicting the journey from
Hudson's Bay to Fort Douglas and views of pioneer life
in and around the Red River settlement are preserved in
the Public Archives of Canada. These are considered to
be the earliest paintings to document English settlement
in western Canada and are probably the first genre
works by any artist in the interior of North America.

At least ten lithographic reproductions of his paint-
ings appeared in the *American Turf* magazine. A portfo-
lio of six others entitled *Views in Hudson's Bay* was
issued in London before his death. Still others of his
pictures were selected to illustrate Thomas L. McKenney
and James Hall's landmark *History of the Indian Tribes
of North America* (Philadelphia, 1836-44).

Although one of the earliest, Peter Rindisbacher was
not among the more accomplished frontier artists of his
day. His normal method of illustration was to first
execute his subject in pencil and then to either apply
color or produce a watercolor from the original sketch.

Versions of *War Dance of the Sauk and Fox* and
Buffalo Chase, two of three watercolors by Rindisbacher
in the InterNorth collection at the Joslyn, appeared in
McKenney and Hall's *History,* as frontispieces to Vol-
umes One and Two of this three-volume work. The
watercolors were acquired in 1962 with the larger collec-
tion of materials documenting Prince Maximilian of
Wied's expedition to North America in 1832-34. This
included more than 400 works by the artist Karl Bodmer
as well as the watercolors by Rindisbacher which were
probably acquired by Maximilian from Rindisbacher in
St. Louis shortly after his return from the Upper Mis-
souri frontier.

Also included with the Maximilian material were a
number of books from Maximilian's library at Neuwied
Castle in Germany, including a copy of Volume One of
the McKenney and Hall publication featuring *War
Dance of the Sauk and Fox* as the frontispiece. Other
versions of this are found in the collection at West Point,
but it is not known which may have actually served as
the original model for the published illustration.

60. PETER RINDISBACHER
War Dance of the Sauk and Fox
Watercolor on paper
11⅞ x 17¾ in. (30.3 x 45.2 cm.)
Signed l.l.: P. Rindisbacher
Signed l.r.: Rindisbacher fecit
The InterNorth Art Foundation/Joslyn Art Museum (PL 499)

Provenance:
Collection Schloss Neuwied, Germany.
M. Knoedler & Co., Inc., New York.
Northern Natural Gas Co., Omaha, Nebraska.

61. PETER RINDISBACHER
War Dance of the Sauk and Fox
Hand-colored lithograph on paper
14 x 19¾ in. (35.5 x 50.2 cm.)
The InterNorth Art Foundation/Joslyn Art Museum (PL 500)

Provenance:
Collection Schloss Neuwied, Germany.
M. Knoedler & Co., Inc., New York.
Northern Natural Gas Co., Omaha, Nebraska.

62. PETER RINDISBACHER
Chippeway Scalp Dance
Watercolor on paper
12 x 17¾ in. (30.5 x 45.2 cm.)
Signed l.l.: P. Rindisbacher
Signed l.r.: Rindisbacher fecit
The InterNorth Art Foundation/Joslyn Art Museum (PL 501)

Provenance:
Collection Schloss Neuwied, Germany.
M. Knoedler & Co., Inc., New York.
Northern Natural Gas Co., Omaha, Nebraska.

63. PETER RINDISBACHER
Buffalo Chase
Watercolor on paper
11⅞ x 18⅜ in. (30.3 x 46.6 cm.)
Signed l.l.: P. Rindisbacher
The InterNorth Art Foundation/Joslyn Art Museum (PL 502)

Provenance:
Collection Schloss Neuwied, Germany.
M. Knoedler & Co., Inc., New York.
Northern Natural Gas Co., Omaha, Nebraska.

CHARLES MARION RUSSELL, 1864-1926. Like that of Frederic Remington, the name of Charles M. Russell is synonymous today with the art of the frontier West and one name seldom is mentioned without the other in histories of latter day western reportage. Unlike Remington, however, Russell's view of the Old West was a familiar and personal one, and although later legend has represented him as a cowboy first and an artist second, Russell was a keen observer of life, a marvelous teller of stories, and as much a philosopher as a cowboy or an artist.

Born at St. Louis in 1864, the son of a prosperous brick manufacturer, he is said as a youngster to have frequented the city's riverside docks where he sketched or modeled in clay the river boatmen and travelers bound for the western territories. Later described as an indifferent student, he dropped out of school on more than one occasion and his father eventually enrolled him in a military academy in the hope that he would acquire the qualities of discipline and responsibility which he seemed to so noticeably lack.

Young Russell soon left or was dismissed from the academy. As a last desperate measure, his father allowed him to travel in the West for a time. Some biographers suggest that Russell was early influenced in this regard by the stories and family anecdotes of his great-uncle, William Bent, who had made history in the early West as builder of the famous trading post, Bent's Fort, on the upper Arkansas River.

Russell arrived in Helena, Montana in 1880, a teenager of sixteen years. Almost immediately he made the acquaintance of a local trapper, Jake Hoover, with whom he lived, off and on, for the next two years. Thereafter, from about 1884 to 1896, he worked for the most part as a night wrangler, spending his summers on the open range and his winters in various frontier towns, often painting pictures or trading sketches for food and lodging. It is said that he developed the habit of carrying around in his pockets pieces of modeling clay from which he fashioned small figures of people and animals in his leisure moments.

Having had less than a week of formal art instruction as a youngster in St. Louis, he was entirely self-taught. What would have been his student days were spent on the range and the trail drive. During the infamous severe winter of 1886-87, he produced what became his most famous piece from this period, *Waiting for a Chinook.* Depicting a lone, starving, snowbound cow surrounded by ravenous wolves, this sketch was reportedly sent to the absentee owner of the Bar-R Ranch in reply to inquiries on how the herd had survived the Great Blizzard of that fateful year.

In 1888 Russell spent about six months among the Blood Indians of the Blackfoot nation and afterward produced several notable Indian studies. This same year he was represented by his first published illustration in *Harper's Weekly.* His pictures also appeared in *Harper's*

and *Frank Leslie's Illustrated Newspaper,* as well as the local newspapers in the early 1890s, but it was not until after his marriage to Nancy Cooper in the fall of 1896 that he began to consider art as a serious occupation. From this time, his career took a definite turn for the better, due largely to Nancy's untiring efforts as a promoter and manager of his affairs.

By the following year, the Russells were settled in Great Falls where he continued to sketch and paint, frequenting the local "watering holes" such as the Brunswick Saloon, whose proprietor A. J. Trigg allowed Russell the use of one of his back rooms as a studio until the artist opened one of his own. Trigg proudly displayed several of Russell's paintings over his bar, as did Billy Rance, owner of the rival Silver Dollar Saloon.

Later, the Russells moved into a house next door to the Trigg residence and in 1903 Russell built a log cabin studio between the two houses, moved in his painting and camping equipment, and for many years afterward regularly entertained his coffee-drinking and story-telling friends in these familiar surroundings. The C. M. Russell Museum now stands on the original site of the Trigg house.

Russell's thirty-third birthday in March of 1897 was celebrated at the Silver Dollar, where he made the acquaintance of the young Danish-born Olaf Seltzer, who became Russell's only real "pupil" and protégé. The two artists maintained a lifelong friendship, making excursions into the surrounding countryside to camp, sketch, and paint. After 1921 Seltzer was a frequent guest of the Russells at their cabin on McDonald Lake, within the bounds of what is now Glacier National Park. Seltzer also later completed or continued to fulfill commissions and produce paintings for some of Russell's patrons in New York City after Russell's death.

From 1897 Russell's reputation as a western artist developed rapidly. That year he made his first trip east to New York City, perhaps to find buyers for his pictures. In 1904 his first sculpture was cast in bronze. He did not achieve wide recognition, however, until 1911 at the age of forty-seven, when an exhibition in New York brought him immediate acclaim as an authentic painter of the American West. It was during one of these trips east that he met actor and humorist, Will Rogers, with whom he afterward maintained a lifelong friendship.

Into the early 1920s, Russell made frequent trips to New York on commissions for such enthusiastic patrons as Malcom MacKay and Dr. Philip G. Cole, whose father also had been an early purchaser of Russell paintings in Helena. The Russells traveled widely in later years to New York, Florida, and the West Coast. Returning home to Montana, Charlie played host to such artists as Ed Borein and Maynard Dixson, and Nancy entertained international celebrities such as the Prince of Wales and the Duke of Connaught, and screen stars William S. Hart, Will Rogers, and Douglas Fairbanks.

Russell maintained a studio for a brief period of time in Pasadena, California, and in 1924 or 1925 visited Europe following a London exhibition of his work, probably at Nancy's insistence. Russell quickly lost interest in touring the museums and galleries of the Continent and the Russells cut short their stay abroad to return home to Great Falls. Here the ailing Russell continued to paint and sculpt until his death in October of 1926.

The majority of Russell's extant works document the life of the rancher and cowboy, although he also depicted earlier frontier types such as the explorer, trapper, and trader. In his later development, he turned more and more to the subject of American Indian life and, for his principal patrons, specific portrayals of episodes and events relative to the history of exploration and settlement of the western frontier.

Better known as an artist, he was also a colorful writer. He produced some poetry and published two books, *Rawhide Rawlins Stories* and *More Rawhides,* now considered by many as classics of western literature. Another book, *Trails Plowed Under,* appeared posthumously in 1927. His letters and notes to friends and patrons, many of which were illustrated, are now much sought after as collector items. A volume of such letters was published in New York by Doubleday in 1929 under the title, *Good Medicine,* with an introduction by Will Rogers and biographical notes by Nancy Russell.

Russell was a perfectionist who strove in all his works to represent the smallest details of his subjects as correctly as possible, seeking and studying his subject in barrooms, bunkhouses, and out on the range. He is said not only to have observed the life of the West, but to have lived it. The saloons he earlier frequented were his first galleries in which he displayed his initial efforts. His first patrons were saloon owners and bartenders.

When he first turned to writing for magazines, partly as a means of selling his pictures, he enjoyed using western colloquialisms and seldom worried about such things as spelling and punctuation. Although it was later claimed he could write as correctly as any other educated person of his day, and that his careless use of the language was for effect, the consistent misspellings in his private correspondence do not necessarily support this assumption. His later success in nearly all his efforts has been credited almost entirely to Nancy's drive and ambition and her role as his agent and promoter. She continued in this capacity for some years after his death, demanding increasingly high sums for his surviving works from dealers and private collectors.

Russell produced an enormous volume of paintings, drawings, and sculptures during his lifetime, and many of his works were widely reproduced in publication and for sale as art prints, as well as endlessly copied by other artists. Today original examples of his work are found in public and private collections throughout the United States, and reproductions of his paintings and letters still enjoy a lively sales.

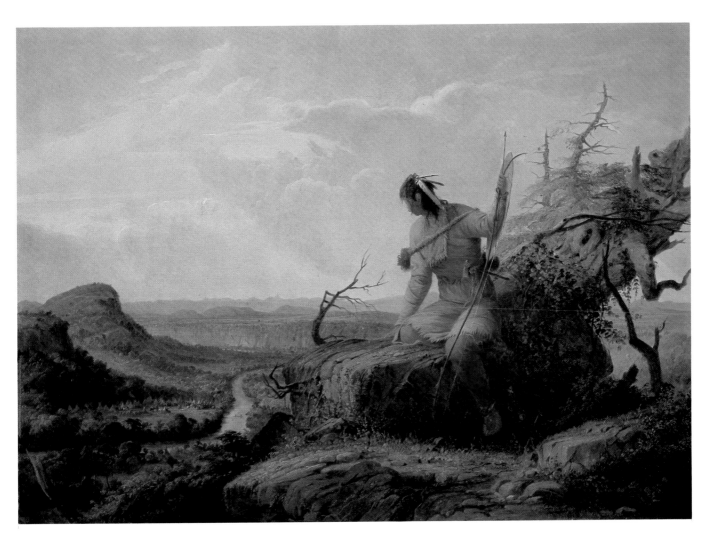

40. SETH EASTMAN, *Indian on the Lookout*

Important collections of Russell's work are found at the C. M. Russell Museum in Great Falls, the Montana Historical Society in Helena, the Whitney Museum of Western Art in Cody, Wyoming, and the National Cowboy Hall of Fame in Oklahoma City. One of the largest private collections of his work was acquired in 1944 by Oklahoma oil man Thomas Gilcrease from the estate of ex-Montanan, Dr. Philip G. Cole of Tarrytown, New York, and is now displayed at the Gilcrease Institute in Tulsa. The once famous Mint Saloon collection of Russell paintings later was acquired by newspaper publisher Amon Carter for the museum in Fort Worth, Texas.

An oil painting entitled *Piegan Indians on a Buffalo Hunt* is in the InterNorth collection at the Joslyn Art Museum, from the ex-collection of William Mellen, a former official of the Northern Pacific Railroad and close friend of the artist. Also included in the Inter-North inventory is a watercolor of a related subject, *The Returning Herd,* from the collection of a Mrs. J. A. Davis of Butte, Montana. A smaller oil study on wood of a young Indian girl, once a gift to a nephew, Austin C. Russell of St. Louis, Missouri, is also listed, along with an earlier painting on a tin sheet called *Deer and Bear in Landscape.* Also from the Davis collection are six previously published, original illustrations in pen-and-ink, two of which appeared in *More Rawhides* (Great Falls, 1925).

64. CHARLES MARION RUSSELL
Piegan Indians Hunting Buffalo
Oil on canvas
25 x 35 in. (63.5 x 89 cm.)
Signed l.l.: C. M. Russell (skull)
The InterNorth Art Foundation/Joslyn Art Museum (PL 844)

Provenance:
William Mellen.
Mrs. William Mellen (Mrs. Kales).
David Kales.
M. Knoedler & Co., Inc., New York.
Northern Natural Gas Co., Omaha, Nebraska.

Literature:
Cedar Rapids Art Center, Iowa, *Artists of the Western Frontier,* 1968; Joslyn, *The Growing Spectrum of American Art,* 1975, p. 29; Joslyn, *Artists of the Western Frontier,* 1976, p. 29.

65. CHARLES MARION RUSSELL
Indian Girl
Oil on panel
11½ x 5 in. (29.2 x 12.7 cm.)
Signed l.r.: CMR (skull)
The InterNorth Art Foundation/Joslyn Art Museum (PL 845)

Provenance:
Austin C. Russell, St. Louis, Missouri.
Mrs. Silas Bent Russell, Port Washington, New York.
M. Knoedler & Co., Inc., New York.
Northern Natural Gas Co., Omaha, Nebraska.

Literature:
Joslyn, *Artists of the Western Frontier,* 1976, p. 29.

66. CHARLES MARION RUSSELL
Deer and Bear in Landscape, 1890
Oil on tin
6 x 7½ in. (15.3 x 19 cm.)
Signed l.l.: CMR/90
The InterNorth Art Foundation/Joslyn Art Museum (PL 846)

Provenance:
Earl C. Adams, Pasadena, California.
M. Knoedler & Co., Inc., New York.
Northern Natural Gas Co., Omaha, Nebraska.

67. CHARLES MARION RUSSELL
The Returning Herd
Watercolor on paper
19½ x 32 in. (49.5 x 81.3 cm.)
Signed l.l.: CMRussell (skull)
The InterNorth Art Foundation/Joslyn Art Museum (PL 847)

Provenance:
Mrs. A. J. Davis, Butte, Montana.
M. Knoedler & Co., Inc., New York.
Northern Natural Gas Co., Omaha, Nebraska.

Literature:
Joslyn, *Artists of the Western Frontier,* 1976, p. 29.

68. CHARLES MARION RUSSELL
Pack Train
Ink and wash on paper
13 x 21 in. (33 x 53.3 cm.)
Signed l.l.: CMR (skull)
The InterNorth Art Foundation/Joslyn Art Museum (PL 848)

Provenance:
Mrs. A. J. Davis, Butte, Montana.
M. Knoedler & Co., Inc., New York.
Northern Natural Gas Co., Omaha, Nebraska.

Literature:
Joslyn, *Artists of the Western Frontier,* 1976, p. 28.

69. CHARLES MARION RUSSELL
The Whispering Disturbs Mr. Bear
Ink and wash on paper
13½ x 9¾ in. (34.3 x 24.7 cm.)
Signed l.l.: CMR (skull)
The InterNorth Art Foundation/Joslyn Art Museum (PL 849)

Provenance:
Mrs. A. J. Davis, Butte, Montana.
M. Knoedler & Co., Inc., New York.
Northern Natural Gas Co., Omaha, Nebraska.

Literature:
Russell, *More Rawhides*, 1925, p. 8.

70. CHARLES MARION RUSSELL
Bear in Gum Boots
Ink on paper
10 x 8 in. (25 x 20 cm.)
Signed l.l.: CMR (skull)
The InterNorth Art Foundation/Joslyn Art Museum (PL 850)

Provenance:
Mrs. A. J. Davis, Butte, Montana.
M. Knoedler & Co., Inc., New York.
Northern Natural Gas Co., Omaha, Nebraska.

71. CHARLES MARION RUSSELL
The Bark of Beaver's Henry Brings Me Out of this Scare
Ink on paper
8¾ x 10½ in. (22.2 x 26.7 cm.)
Signed l.l.: CMR (skull)
The InterNorth Art Foundation/Joslyn Art Museum (PL 851)

Provenance:
Mrs. A. J. Davis, Butte, Montana.
M. Knoedler & Co., Inc., New York.
Northern Natural Gas Co., Omaha, Nebraska.

Literature:
Russell, *More Rawhides*, 1925, p. 9.

72. CHARLES MARION RUSSELL
Crow Indian
Ink on paper
6¾ x 4⅞ in. (17 x 13 cm.)
Signed l.r.: CMR (skull)
The InterNorth Art Foundation/Joslyn Art Museum (PL 852)

Provenance:
Mrs. A. J. Davis, Butte, Montana.
M. Knoedler & Co., Inc., New York.
Northern Natural Gas Co., Omaha, Nebraska.

A. ZENO SCHINDLER, c. 1813-c. 1880. A painter of landscapes and a pastel portraitist, A. Z. Schindler was a native of Germany probably born about 1813. His career as an artist is difficult to document with any accuracy, but he is known to have worked as a drawing instructor in Philadelphia during the mid-nineteenth century. He exhibited at the Pennsylvania Academy of Fine Art

between the years of 1852 and 1863, represented for the most part by pastel portraits and European city scenes.

He later worked as a photographer for the Smithsonian Institution in Washington, D.C. and in 1870-71 accompanied Englishman William Blackmore on a tour of the American West. He afterward became a painter of Indian life.

An early watercolor view of Reading, Pennsylvania, done in 1834 was reproduced in lithograph by Philadelphia printer James T. Bowen in 1839. Schindler is also represented by paintings of the Pennsylvania countryside and rural New Hampshire and Virginia landscapes.

He is listed in most available sources simply as an artist and photographer in Philadelphia and Washington. Some evidence suggests that he also may have found employment for a period of time as a painter of movable panoramas before settling in Philadelphia.

A landscape view entitled *On the Wissahickon* in the InterNorth collection has been compared for similarities to a watercolor by Swiss artist Karl Bodmer in this same collection entitled *Cutoff River, Branch of the Wabash*, which later was reproduced as Vignette XVII in the atlas of aquatint engravings that accompanied the publication of Prince Maximilian of Wied's *Travels into the Interior of North America*.

73. A. ZENO SCHINDLER
On the Wissahickon
Gouache on paper
11¾ x 15½ in. (30 x 39.5 cm.)
Signed l.l.: AZS
The InterNorth Art Foundation/Joslyn Art Museum (PL 854)

Provenance:
Private collection.
M. Knoedler & Co., Inc., New York.
Northern Natural Gas Co., Omaha, Nebraska.

JOSEPH HENRY SHARP, 1859-1953. Noted today as a painter of American Indian subjects and a founding member of what came to be called the Taos School of American artists, Joseph Henry Sharp was born at Bridgeport, Ohio. At the age of fourteen, he enrolled at the McMicken School of Design in Cincinnati and spent the next several years in pursuit of his studies. He traveled abroad periodically to Antwerp to study with Charles Veriat and later with Carl Marr at the Munich Academy and in Paris with Jean-Paul Laurens, Benjamin Constant, and Frank Duveneck.

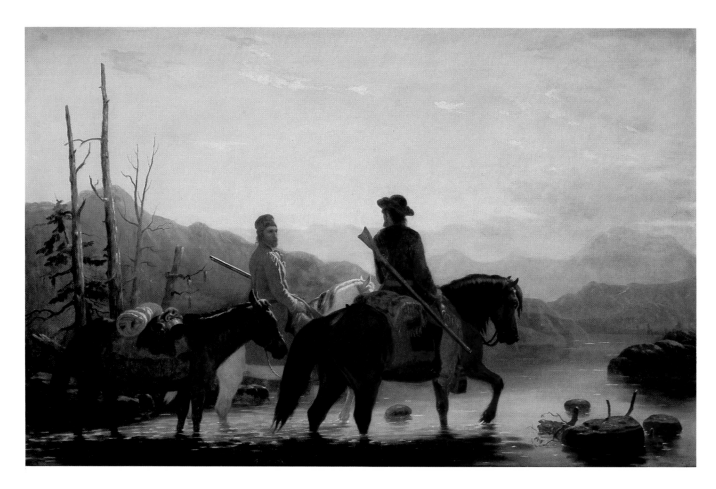

53. WILLIAM TYLEE RANNEY, *The Trappers*

Between his trips to Europe, Sharp made his first excursion into the western United States in 1883 when he visited Santa Fe, New Mexico and Tucson, Arizona. Impressed by the landscape, atmosphere, and native life of the Southwest, he made many Indian studies at this time and thereafter visited in the area whenever possible.

From 1892 he held a post as instructor at the Cincinnati Art Academy where he taught life drawing during the winter months for the next ten years. He visited Taos, New Mexico for the first time in 1893, and studied again in Paris from 1894-96.

During this period of study in Paris he met fellow American students Bert Phillips and Ernest Leonard Blumenschein, who with Sharp later formed the Taos Society of Artists in 1912. Meanwhile, Sharp exhibited several of his works in the Paris Exposition of 1900, attracting considerable attention with his Indian subjects.

Shortly afterward he was commissioned by the U.S. Government to paint a series of Indian life studies for its permanent collection at the Smithsonian Institution.

In 1901 President Theodore Roosevelt arranged for a studio to be built for Sharp's use on the Custer Battlefield site in eastern Montana near the Crow Indian Agency. Here Sharp spent a number of months each year over the next several years painting Indian scenes and portraits. In 1902 he resigned from his post at the Cincinnati Academy and for the remainder of his life devoted himself primarily to western subjects. He settled permanently at Taos in 1909 when he acquired a studio across the street from the old Kit Carson home.

In later years he traveled abroad once more and visited Hawaii and the Far East. He died at a winter home in Pasadena, California leaving behind a large body of works relating to western and Indian themes.

Although chiefly devoted to depictions of Southwestern Indian life, Sharp's extant work is also distinguished by a large number of landscapes, seascapes, floral, and still-life paintings. Some of the latter were produced while the artist visited Hawaii, although excellent examples of his still-life subjects were produced in Taos as well.

Of all the pictoriographers of the American Indian, Sharp was one of the most objective. His portraits are both accurate in representation and expressive of the individual characters of the sitters. Also a student of Indian customs and culture, he accurately depicted native costumes and ceremonials from an ethnological standpoint.

Eleven Indian portraits at the Smithsonian Institution in Washington, D.C. were acquired from the artist in 1900. In 1902 the University of California at Berkeley received a gift of more than eighty of Sharp's pictures from the collection of Phoebe Hearst. These are now owned by the University's Department of Anthropology. Yet another large collection is owned by the Bureau of American Ethnology in Washington. The two largest private collections of his work belong to the Thomas Gilcrease Institute of American History and Art in Tulsa, Oklahoma, and the Nelda C. and H. J. Lutcher Stark Foundation in Orange, Texas.

Other examples of Sharp's work are found in both private and public collections throughout the country, including the Cincinnati Art Museum, the Butler Museum in Youngstown, Ohio, the Los Angeles County Museum of Art and the Woolaroc Museum near Bartlesville, Oklahoma.

The single example of Sharp's work in the InterNorth collection is a pastel portrait of an Indian man, *Little Beaver,* obtained from a private collection.

74. J. H. SHARP
Little Beaver - Sioux
Pastel on paper
13¾ x 9 in. (35 x 23 cm.)
Signed l.l.: J. H. Sharp
Inscribed u.r.: Little Beaver/Sioux
The InterNorth Art Foundation/Joslyn Art Museum (PL 855)

Provenance:
Private collection.
M. Knoedler & Co., Inc., New York.
Northern Natural Gas Co., Omaha, Nebraska.

Literature:
Joslyn, *Artists of the Western Frontier,* 1976, p. 21.

JOHN MIX STANLEY, 1814-1872. John Mix Stanley had as wide an experience of the frontier West as any artist of his time. Producing a considerable body of work illustrative of American Indian life, he was rivaled in his accomplishments only by George Catlin, whose excursions into the western territories preceded Stanley's by several years. Stanley is hardly remembered today for his efforts in this field; the majority of his works were lost or destroyed during his lifetime. Even the relatively few of his western paintings that survive remain all but forgotten.

Born at Canandaigua, New York, where his father is thought to have operated a tavern, Stanley spent his childhood on what was then the settling edge of the western frontier. Orphaned at an early age, he was apprenticed at fourteen to a coachmaker in Naples, New York. During this period he probably had his first introduction to art as a decorator of signs and sideboards.

He moved in 1834 from Buffalo, New York to Detroit, Michigan where he worked variously as a house and sign painter until he met artist James Bowman who gave him his first lessons in portrait painting. Stanley and Bowman became partners of a sort, working as itinerant portraitists in and around Chicago, Philadelphia, Baltimore, and Troy, New York until about 1842. At some time during this period, Stanley visited Washington, D.C. There he seems to have associated briefly with a daguerreotypist and attempted experiments in photography, becoming one of the first to employ this method of recording landscape views on his subsequent travels into the Far West.

In 1839 Stanley visited Fort Snelling, Minnesota where he is supposed to have painted his first Indian subjects. In 1842 he ventured into what is now northeastern Oklahoma with Summer Dickerman, a friend and business associate from Troy, to make studies of the Indian tribes recently moved to that region by the Government. It is thought that he may have been influenced in this undertaking by the success of Catlin who had visited this same area some eight years before. Catlin's North American Indian Gallery may have been seen by Stanley in Baltimore or Washington sometime between 1836 and 1839. Setting up temporary studios first at Fort Gibson and then at nearby Tahlequah, Stanley attended the Grand Council of the tribes called by Cherokee chief John Ross in 1843. He later this same year accompanied P. M. Butler, Cherokee Agent, to a council of the Comanche and other tribes along the Red River near the modern Lawton, Oklahoma. Stanley remained in this general area until sometime in 1845 when he made a brief visit into New Mexico. By 1846 he had produced more than eighty portraits and scenes of Indian life which were exhibited in Cincinnati and Louisville in the spring of that year.

Leaving Dickerman in charge of touring his exhibition in the East, Stanley again returned to the West with a wagon train bound for Santa Fe. He reached Santa Fe in August of 1846 at about the same time that Colonel Stephan W. Kearney's troops arrived to take possession of the city following a declaration of war between the United States and Mexico. Stanley promptly joined Kearney's proposed expedition to California as a member of its scientific staff, replacing as official artist two others who had fallen ill en route to Santa Fe.

Assigned to William H. Emory's topographical unit, Stanley accompanied Kearney to California, arriving in December in San Diego, where he prepared a number of botanical plates to illustrate Kearney's report to the 30th Congress. The work mainly centered around San Diego, but a geographical reconnaissance of the then largely unexplored territories of New Mexico and Arizona was also done. Stanley was listed as "draughtsman" in Emory's subsequent report which also was illustrated with several of the artist's landscape views.

Stanley remained in the West at this time and continued his wanderings northward to San Francisco and then Oregon where he spent the winter of 1847-48. In the spring of 1848 he set sail for the Hawaiian Islands and remained there for the better part of a year. He returned to Boston and then to New York City in 1849. For the next two or three years, he occupied himself with exhibitions of his western paintings in various eastern cities. In November of 1850, he exhibited approximately 135 paintings in New York City, advertised under a promotional banner as "Stanley's North American Indian Gallery." This followed by eleven years Catlin's more famous collection which had been last shown in New York City in 1839 before going abroad for a European tour.

In 1852 Stanley exhibited his paintings in Washington at the Smithsonian Institution. At that time he attempted to interest the Congress in its purchase for the nation. With the help of Captain Seth Eastman, himself a noted Indian painter, Stanley was able to bring his work to the attention of the Senate Committee on Indian Affairs which recommended buying Stanley's paintings for the then substantial sum of $19,200. A bill to this effect was defeated in 1853 as were subsequent proposals in 1856 and 1860. Throughout this period, the collection of pictures, now numbering approximately 200, continued to remain on view at the Smithsonian.

Meanwhile, Stanley was appointed to accompany Isaac Stevens' survey of a northern transcontinental railroad route to the Pacific Coast in 1853. He returned in 1854 to assist in the preparation of the lithographic views illustrating Stevens' reports. These formed part of twelve illustrated volumes of four separate surveys published by the Government as *Reports of Explorations and Surveys . . . for a Railroad from the Mississippi River to the Pacific Ocean* (Washington, 1855-61), in which among a dozen contributing artists J. M. Stanley was principally represented. Shortly after returning from his travels with Stevens, Stanley produced a large-scale, moving panorama illustrating views along the future Northern Pacific Railroad route. Under the title *Scenes and Incidents of Stanley's Western Wilds* and comprising some forty-two separate panels or episodes, it is said to have taken the better part of two hours to view. Completed in the late summer of 1854, the panorama toured Washington, Baltimore, and New York City with much success.

Stanley married in 1854 and settled in Washington where he continued to reside and work until 1863 when he moved back to Buffalo, New York. In 1864 he settled permanently in Detroit, Michigan. In 1863 he produced another panorama of Civil War scenes and this same year began work on his largest and perhaps most famous work, *The Trial of Red Jacket*, which was successfully exhibited in Detroit and several eastern cities following its completion in 1868. Toward the end of the decade, he

turned to chromolithography as a practical means of reproducing his work for the commercial market. One of the last of his works to be commercially reproduced, *On the Warpath,* was issued in print by a local Detroit firm in 1871.

When he moved from Washington, Stanley had left behind his gallery of western pictures at the Smithsonian in a special wing built for that purpose. On the night of January 24, 1865 nearly all were consumed by fire except for five canvases displayed in another and unaffected part of the building. Another fire at P. T. Barnum's American Museum in New York City this same year and yet another at Stanley's studio in Detroit in 1872, the year of his death, destroyed nearly everything that he had ever produced illustrating his earlier experiences in the West. The cause of the first fire was fully detailed by the Secretary of the Smithsonian in his *Annual Report of the Board of Regents* for the year in question. A subsequent article in the *Annual Report* for 1872 again mentions the fire and estimates the monetary loss sustained by individuals such as Stanley, whom Congress was recommended to reimburse, at least in part. No record of restitution to Stanley seems to exist although Congress later passed a resolution allowing duty free entry for 21,000 chromolithographs of Stanley's paintings produced abroad as a compensation of sorts for the loss of his gallery in the Smithsonian fire.

Today five of his pictures remain at the Smithsonian Institution. Others are found at the Buffalo Historical Society, The Detroit Institute of Arts, and in the collection of the Thomas Gilcrease Institute of American History and Art in Tulsa, Oklahoma. Sixteen studies and paintings acquired from the artist's granddaughter, Mrs. Dean Acheson, are now owned by the Nelda C. and H. J. Lutcher Stark Foundation in Orange, Texas. A few scattered examples remain in private hands.

Three original oils by Stanley and one chromolithographic copy of *On the Warpath* are included in the InterNorth collection at the Joslyn. All date within about five years of the artist's death. Four portraits of Hawaiian royalty by Stanley are included in the collection of the Bernice P. Bishop Museum in Honolulu.

75. JOHN MIX STANLEY
On the Warpath
Chromolithograph on paper
21½ x 29¾ in. (54.5 x 75.5 cm.)
The InterNorth Art Foundation/Joslyn Art Museum (PL 856)

Provenance:
M. Knoedler & Co., Inc., New York.
Northern Natural Gas Co., Omaha, Nebraska.

76. JOHN MIX STANLEY
Young Chief Uncas
Oil on canvas
24 x 20 in. (61 x 51 cm.)
Signed l.r.: J. M. Stanley
The InterNorth Art Foundation/Joslyn Art Museum (PL 857)

Provenance:
Mrs. Edith Stanley Bayles, Oak Park, Illinois.
Mrs. Frances Q. Bayles, Oak Park, Illinois.
Mrs. Dorothy E. Bayles, Oak Park, Illinois.
M. Knoedler & Co., Inc., New York.
Northern Natural Gas Co., Omaha, Nebraska.

Literature:
Kinietz, *John Mix Stanley and His Indian Paintings,* 1942, p. 34; *The Art Quarterly,* Vol. XXXI, no. 3, Autumn 1968, front cover; Joslyn, *Artists of the Western Frontier,* 1976, p. 21.

77. JOHN MIX STANLEY
Crossing the Milk River
Oil on canvas
30½ x 42 in. (77.5 x 106.7 cm.)
The InterNorth Art Foundation/Joslyn Art Museum (PL 858)

Provenance:
M. Knoedler & Co., Inc., New York.
Northern Natural Gas Co., Omaha, Nebraska.

Literature:
Kennedy Galleries, New York, Exhibition catalogue, 1959, no. 32; Joslyn, *Artists of the Western Frontier,* 1976, p. 23.

78. JOHN MIX STANLEY
Snake in the Grass
Oil on canvas
11¾ x 18 in. (30 x 46 cm.)
Signed l.l.: J. M. Stanley/1868
The InterNorth Art Foundation/Joslyn Art Museum (PL 859)

Provenance:
Mrs. Edith Stanley Bayles, Oak Park, Illinois.
Mrs. Francis Q. Bayles, Oak Park, Illinois.
Mrs. Dorothy E. Bayles, Oak Park, Illinois.
M. Knoedler & Co., Inc., New York.
Northern Natural Gas Co., Omaha, Nebraska.

Literature:
Joslyn, *Artists of the Western Frontier,* 1976, p. 21.

ALFRED SULLY, 1821-1879. A soldier, draftsman, and watercolorist, Alfred Sully pursued an active life in the U.S. Army that spanned a period of nearly forty years,

much of which was spent in the West. Like his contemporary Seth Eastman, Sully was a career officer first and an artist second. A sensitive observer of U.S. Army and Indian activities, he was also an articulate writer. His surviving letters furnish a vivid description of conditions on the western frontier during the mid-nineteenth century.

The son of noted American portraitist Thomas Sully, he was born in Philadelphia and began painting at about the age of thirteen. Envisioning his son as an engineer, the elder Sully secured for him an appointment to the U.S. Military Academy at West Point where he graduated in 1841 as a second lieutenant.

Between the years of 1848 and 1852, Sully was stationed at Monterey, California where he met and married the daughter of a wealthy California family. Within a year of their marriage, his wife died giving birth to a son who lived only a few days. In 1853 Sully was reassigned to duty in the Midwest and promoted to the rank of captain.

Later active in the Indian wars, Sully was sent in 1862 to quell a Sioux uprising in southwestern Minnesota. The following year he commanded a large force against some 6,000 Sioux, Cheyenne, and Blackfoot warriors in the Dakota Territory. In 1877 he was again in the Far West involved briefly in efforts to capture an elusive band of renegade Nez Perce under Chief Joseph in Idaho. Sully afterward retired from active service, retaining the permanent rank of major general which he had attained in 1865.

Sully produced many views relative to his experiences in the West, painting primarily in watercolor. Among his extant works is a view of Monterey made in 1847 and a series of sketches of forts in Minnesota produced during the late 1850s. Ten views of western forts are owned by the Thomas Gilcrease Institute of American History and Art in Tulsa, Oklahoma. Others are found in the collections at West Point and at the Minnesota State Historical Society in St. Paul.

An oil painting attributed to Sully in the InterNorth collection at the Joslyn Art Museum depicts an Indian subject. An almost identical painting by the artist is in the permanent collection of the Joslyn.

79. ALFRED SULLY
Sioux Indian Settlement
Oil on canvas
17 x 21 in. (43.2 x 53.4 cm.)
The InterNorth Art Foundation/Joslyn Art Museum (PL 860)

Provenance:
Private collection.
M. Knoedler & Co., Inc., New York.
Northern Natural Gas Co., Omaha, Nebraska.

Literature:
Sully, *No Tears for the General,* 1974.

ARTHUR FITZWILLIAM TAIT, 1819-1909. A native of England, Arthur F. Tait became one of America's best-known artists during the latter half of the nineteenth century through the reproductions of his work by the New York lithographic firm of Currier and Ives. Born near Liverpool in 1819, he showed interest in art in his early years, and by the age of fifteen had found employment with a firm of picture dealers. He is thought during this period to have studied briefly at the Royal Institute in Manchester where he drew chiefly from plaster models. Beyond this limited instruction, he was otherwise self-taught.

In 1850 Tait emigrated to the United States and settled in New York City. He quickly found work as an illustrator. His pictures were soon in demand for reproduction by various publishers, chiefly Nathaniel Currier, who pioneered in the production of commercial art prints. Maintaining a studio on Broadway, Tait later established a camp in the Adirondacks where he retreated periodically to research the hunting and wildlife scenes that eventually made him famous. In 1852 he began exhibiting regularly at the National Academy of Design. Three years later he was elected an Associate Member of that body and a full member in 1858.

Tait's career closely paralleled that of Nathaniel Currier. Having established himself as a commercial printer in New York at the age of twenty-one, Currier had gained wide recognition in 1840 with the publication of a print depicting the destruction of the celebrated steamer *Lexington.* In 1852 Currier hired James Merritt Ives as a bookkeeper and accountant, making him a full partner in 1857. From this time until the turn of the century, the house of Currier and Ives published millions of reproductions of the works of such artists as George Durrie, F. O. C. Darley, William Cary, Tait, and many others.

Among the best of the many artists whose works were regularly copied by the lithographers, Tait specialized in animal and bird subjects and collaborated on several sporting scenes with landscape painter William Sonntag. Tait spent many hours in the wilds hunting, fishing, and studying nature first hand. Although he never ventured west of the Mississippi, or even west of New York state, he produced a popular series of pictures illustrating American frontier life derived largely from the works of such artists as George Catlin, Seth Eastman, and John Mix Stanley. Some of these were produced in collaboration with Louis Mauer who had some experience in the West. All were published and distributed by Currier and Ives.

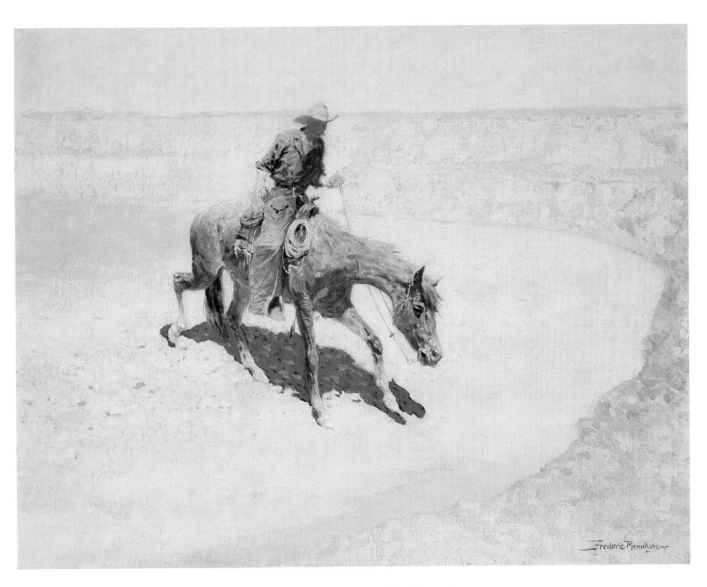

56. FREDERIC REMINGTON, *The Waterhole*

It was later said that few people in his day ever saw an original painting by A. F. Tait. Nevertheless, his work was known and recognized by millions through the medium of commercial prints. Tait worked in profitable association with his publishers for many years, representing the unspoiled wilderness and the adventurous life of the Far West to a whole generation of Americans. Currier and Ives was sold in 1907. Tait himself died two years later. Each had helped to make the other successful and in the process rendered inexpensive art prints almost as easy to obtain as the weekly illustrated magazine and the daily newspaper.

The painting by Tait in the InterNorth collection entitled *The Prairie Hunter, "One Rubbed Out,"* was reproduced by Nathaniel Currier in 1852 under the same title, a copy of which is included in the inventory of the Joslyn Art Museum. It is one of Tait's earlier prints of a western subject as well as one of his first to be published by Currier and Ives.

80. ARTHUR FITZWILLIAM TAIT
The Prairie Hunter, "One Rubbed Out"
Oil on canvas
14 x 20 in. (35.5 x 51 cm.)
Signed l.r.: A. F. Tait/1852
The InterNorth Art Foundation/Joslyn Art Museum (PL 861)

Provenance:
Private collection.
M. Knoedler & Co., Inc., New York.
Northern Natural Gas Co., Omaha, Nebraska.

Literature:
Joslyn, *Artists of the Western Frontier,* 1976, p. 19.

ROBERT WALTER WEIR, 1803-1889. A painter of religious and historical subjects who spent the greater part of his career as a teacher and drawing instructor, Robert W. Weir was born in New York City in 1803. He first studied art under American portraitist John Wesley Jarvis.

Weir later studied with the English heraldic artist Robert Cox and from 1824-27 was in Rome and Florence, where he studied with Pietro Beneventi. Returning home in 1827, he opened a studio in New York City and began exhibiting at the National Academy of Design. He was elected to membership in the Academy in 1829.

In 1834 he succeeded Charles R. Leslie as instructor of drawing at the U.S. Military Academy at West Point, holding this position for the next forty years. Among his many students were such varied talents and later prominent figures in American history and art as U. S. Grant, Robert E. Lee, Seth Eastman, and James A. McNeill Whistler.

Upon his retirement from West Point in 1876, Weir returned to New York City and opened another studio where he continued to work until his death in 1889. Many of his surviving works, unsigned and undated, have yet to be positively identified.

During the first half of his life, Weir was particularly active as a painter of religious subjects, executing easel pictures for private patrons, a few altarpieces, and related, larger commissions. His *Presentation in the Temple,* completed in 1853, was exhibited at the National Academy the following year and received high academic praise. It is now in private hands as are his *Infant John the Baptist,* painted in 1855, and at least two known versions of *Moses Looking into the Promised Land.*

Weir also produced some allegorical and native historical subjects, probably his best known being a large scale rendition of *Embarkation of the Pilgrims from Delft Haven* painted for the Capitol Rotunda in Washington in 1843. This was later damaged during the construction of a new Capitol dome in 1861 and afterward repaired. He also painted occasional landscapes and portraits on commission. His portrait of General Winfield Scott is now at The Metropolitan Museum of Art in New York City.

At least two of his sixteen children became successful artists in their own right. A son, John Ferguson Weir (1841-1926), maintained a studio in New York where he associated in painting with the Hudson River School and later became the first director of the School of Fine Arts at Yale University. Another son, Julian Alden Weir (1852-1919), who also maintained a New York residence, was largely influenced in his work by the exponents of the French Impressionist movement.

The elder Weir is represented today by paintings at West Point, the Capitol in Washington, D.C., and The Metropolitan Museum of Art as well as other public and private collections. A painting in the InterNorth collection at the Joslyn in Omaha depicts an American historical subject. Entitled *Landing of Henry Hudson, 1608, at Verplanck Point,* it is believed to have been painted during the artist's first year at West Point and was first exhibited at the National Academy in 1835.

The history of its ownership is well documented. The painting remained in the Verplanck family of New York and their descendants until acquired for the Joslyn Art Museum in 1962. It was probably first reproduced as a wood engraving. An engraving obviously taken from this subject appeared in the *New York Mirror* on December 2, 1837. It was later featured again in engraved form when published as an illustration in

J. A. Spencer's *History of the United States* (Vol. I, New York, 1858).

Yet another engraving, probably issued as an art print and entitled *The Landing of Hendrick Hudson,* was published in 1866 by Johnson, Fry and Company of New York.

A few of Weir's other works were reproduced during his lifetime. He is also to be remembered in this connection as the creator of the original illustrations for Clement C. Moore's poem, *The Night Before Christmas.*

81. ROBERT WALTER WEIR
Landing of Henry Hudson, 1608, at Verplanck Point, near Peekskill, N.Y.
Oil on canvas
33 x 48 in. (84 x 122 cm.)
The InterNorth Art Foundation/Joslyn Art Museum (PL 862)

Provenance:
Julian C. Verplanck.
William S. Verplanck.
Mrs. Benjamin Richards.
Louisa Verplanck Richards.
Mrs. Guy Richards.
M. Knoedler & Co., Inc., New York.
Northern Natural Gas Co., Omaha, Nebraska.

Literature:
Cadet Fine Arts Forum, United States Military Academy, *Robert Weir: Artist and Teacher at West Point,* 1976, p. 65.

THOMAS WORTHINGTON WHITTREDGE, 1820-1910.
Like so many American artists in the nineteenth century, Thomas Worthington Whittredge studied abroad, receiving his principal training in the art academies of Europe. He found the chief inspiration for his work in the United States, however, and established his reputation as one of the leading exponents of the Hudson River School of landscape painting.

Born at Springfield, Ohio in 1820, he later lived in West Virginia and during his early years made a living for a time as a sign painter. From 1840 to 1849 he was in Cincinnati where he studied briefly at the Cincinnati Art School and worked as a portraitist and daguerreotypist.

Encouraged by fellow artist Asher B. Durand to enlarge upon his formal studies, Whittredge went abroad in 1849, visiting in London, Paris, Antwerp, and at Dusseldorf where he spent the better part of four years. Following sketching trips through Switzerland and Italy, he settled in Rome for another period of time.

In Dusseldorf he studied under Emmanuel Leutze and may have modeled for the figure of George Washington in Leutze's famous depiction of Washington crossing the Delaware. He also studied with Andreas Achenback at the Dusseldorf Academy and with Carl Lessing, with whom he made periodic sketching trips into the surrounding countryside. It was during this time that he met the young Albert Bierstadt, who later spent a winter with Whittredge in Rome.

After ten years in Europe, which he came to regard as largely a wasted period in his life, Whittredge returned to the United States in 1859 and opened a studio in New York City. There he devoted himself almost exclusively to the depiction of American rural and wilderness subjects. He made frequent excursions into the Catskill Mountains to paint and sketch and into western Pennsylvania and New Jersey where he eventually settled at Summit.

Elected a National Academician in 1861, Whittredge served as president of the Academy in 1865 and again from 1874-77. During this period he made at least three trips into the trans-Mississippi West and was one of a handful of American artists at this time to have visited south of the U.S. border in Mexico.

Some confusion exists with respect to the dates of his first western excursion following the Civil War when he is believed to have accompanied General John Pope on a tour of inspection through Colorado and New Mexico. In his autobiography, later published in the *Brooklyn Museum Journal* in 1942, Whittredge states that he left Fort Leavenworth with Pope on a proposed tour of the Rocky Mountains and New Mexico in June of 1865. According to Robert Taft, in his book *Artists and Illustrators of the Old West, 1850-1900* (New York, 1953), recent evidence suggests that Whittredge accompanied Pope in the summer of 1866, not 1865. General Pope's official report to the War Department published in the *Annual Report of the Secretary of War* to the 39th Congress in 1866 makes no reference to the artist, although mention is made of the presence of Pope's party at Santa Fe in August of 1866 in the local *Weekly Gazette.*

Whittredge returned to the Colorado Rockies in 1870 with fellow artists John F. Kensett and Sanford R. Gifford and again on his own the following summer when he sketched primarily in and around the town of Greeley, Colorado. He afterward produced a number of works based upon his western experiences, chiefly landscapes depicting the broad prairies between the Mississippi and the Great Divide. When he died at his home in Summit, New Jersey in 1910, he left a number of unsigned paintings which later were signed and dated by a member of the family.

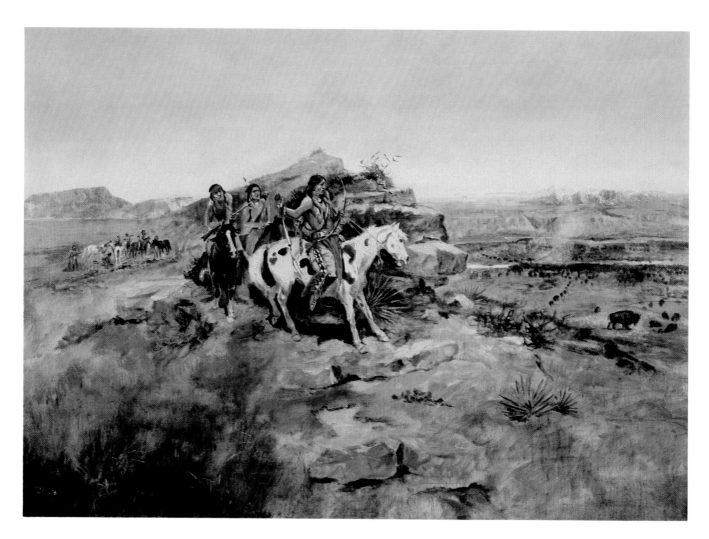

64. CHARLES MARION RUSSELL, *Piegan Indians Hunting Buffalo*

Works by Whittredge are found today principally in the collections of the Worcester Art Museum in Worcester, Massachusetts, the Museum of Fine Arts, Boston, the Peabody Museum at Yale University, and the Los Angeles County Museum of Art. He is also represented in numerous private collections.

Two small oils in the InterNorth collection at the Joslyn depict western scenes, one of which carries a date of 1865. Another oil by Whittredge in the Joslyn's permanent collection depicts a view of Long's Peak, Colorado dated June 18, 1866. This work corresponds in its dating to the period of time when General Pope seems to have made his tour of inspection in Colorado and New Mexico. One may suppose that Whittredge made his first trip West in 1865, according to the date of the painting in the InterNorth collection, and later joined Pope in Colorado, or that the artist is confused with regard to these dates. It is also possible that the dating of one of these works is incorrect, added perhaps by another hand after Whittredge's death in 1910.

82. WORTHINGTON WHITTREDGE
Encampment on the Plains
Oil on paper mounted on canvas
7½ x 23 in. (19 x 58.5 cm.)
Signed l.r.: W. Whittredge
The InterNorth Art Foundation/Joslyn Art Museum (PL 863)

Provenance:
George H. Pepper, New York.
M. Knoedler & Co., Inc., New York.
Northern Natural Gas Co., Omaha, Nebraska.

Literature:
Munson-Williams-Proctor Institute, *Worthington Whittredge Retrospective,* 1969, p. 36; Los Angeles County Museum of Art, *The American West,* 1972, p. 135; *American Art Journal,* "Fine Eastern Artists Out West," Vol. 2, November 1973, pl. 19; Brown, *The Westerners,* 1974, p. 90; Joslyn, *Artists of the Western Frontier,* 1976, p. 16.

83. WORTHINGTON WHITTREDGE
The Little Blue River
Oil on cardboard
8⅜ x 23 in. (22.3 x 58.4 cm.)
Signed l.r.: Little Blue River/W. Whittredge/1865
The InterNorth Art Foundation/Joslyn Art Museum (PL 864)

Provenance:
M. Knoedler & Co., Inc., New York.
Northern Natural Gas Co., Omaha, Nebraska.

Literature:
Joslyn, *Artists of the Western Frontier,* 1976, p. 16.

JOHN WILLIAMSON, 1826-1885. Reports of the scenic splendors of the Catskills, the Adirondacks, and the Rocky Mountains tempted many painters into America's wilderness areas throughout the nineteenth century. Such an artist was John Williamson who was born near Glasgow, Scotland in 1826, and emigrated as a child with his family to the United States in 1831.

Williamson spent the greater part of his life in Brooklyn, New York where he was the first secretary of the Brooklyn Art Association for some seven years and later a founding member of the Artists' Fund Society. He began exhibiting regularly at the National Academy of Design in 1850. In 1861 he was elected an Associate Member of this organization.

Biographical information on Williamson is limited, and there are no records indicating a date or dates for trips made into the trans-Mississippi West. A few paintings of western subjects suggest that he may have visited the Colorado Rockies during the latter decades of his life.

Represented chiefly by landscape views of the Catskills, the Hudson River Valley, and the Adirondacks, he exhibited for the most part in New York, Washington, and Boston. He died at Glenwood-on-the-Hudson in 1885.

84. JOHN WILLIAMSON
Overland Route to Rocky Mountains, 1880
Oil on canvas
14½ x 36½ in. (36.7 x 92.7 cm.)
Signed l.l.: JW 1880
The InterNorth Art Foundation/Joslyn Art Museum (PL 865)

Provenance:
M. Knoedler & Co., Inc., New York.
Northern Natural Gas Co., Omaha, Nebraska.

Literature:
Joslyn, *Artists of the Western Frontier,* 1976, p. 16.

NEWELL CONVERS WYETH, 1882-1945. Like Frederic Remington before him and Norman Rockwell after him, N. C. Wyeth became one of the nation's most popular artists during his lifetime. A prolific painter, muralist, and children's book illustrator, he was born at Needham, Massachusetts. He attended the Massachusetts Normal Art School and Eric and Pape's Art School in Boston before enrolling at the age of twenty as a private student in Howard Pyle's school for illustrators at Wilmington, Delaware. Here he studied with William Koerner, Frank Schoonover, and Harvey Dunn, all of whom later became successful commercial illustrators.

In 1902 Wyeth interrupted his studies for a time to visit Colorado and New Mexico where he participated in a cattle drive and worked briefly as a mail rider on the Navajo Reservation. His later depictions of western life reflect in part his early experience, although Wyeth also carefully researched his subjects, studying the works of Remington, C. M. Russell, and other artists and illustrators of the West.

In 1903 he sold his first picture, a western subject, to the *Saturday Evening Post* for a reported sum of $150. Thereafter, he was seldom without a commission from a book or magazine publisher. In 1906 he married and established residence at Chadds Ford, Pennsylvania, where he continued to work for the next forty years. In 1911, the year of Pyle's death, he produced the illustrations for a new edition of Robert Louis Stevenson's *Treasure Island.* The book brought him immediate recognition as one of the up-and-coming illustrators of his day.

Over the next thirty years, Wyeth illustrated editions of numerous classics of English and American literature ranging from *Robin Hood* and *Rip Van Winkle* to Francis Parkman's *The Oregon Trail* and *The Yearling* by Marjorie Rawlings. Now much sought after by collectors of illustrated editions, many of these were included in the eighteen volumes of Juvenile Classics published by Charles Scribner's Sons, which sold over 1.7 million copies of its Wyeth-illustrated books.

As a muralist, Wyeth executed a great many commissioned works, both public and private, including panels for the Museum of Fine Arts in Reading, Pennsylvania, The New York Public Library, the National Geographic Society in Washington, D.C., and the Missouri State Capitol at Jefferson City. He produced murals for a number of banks and insurance companies in New York, Boston, Philadelphia, Wilmington, and Trenton, New Jersey, as well as decorations for the grill room in the Traymore Hotel in Atlantic City and the dining room of the Hotel Roosevelt in New York City. He is also represented by a triptych in the Chapel of the Holy Spirit in the National Cathedral in Washington.

Awarded a gold medal at the San Francisco Exposition of 1915, Wyeth received the 4th Clark prize for painting at the Corcoran Gallery of Art in 1932. In 1945 he received first popular prize at the Corcoran and third popular prize at the Carnegie Institute in Pittsburgh. He was a member of the National Academy of Design, the American Society of Illustrators, the Wilmington Society of the Fine Arts, the Philadelphia Art Alliance, and the Pennsylvania Academy of Fine Arts where he received his first award in painting in 1910. In 1945, the year of his death, he received an Honorary Degree of Master of Arts from Bowdoin College.

Wyeth worked hard at his painting, often spending as much as seven hours a day, seven days a week, in his studio at Chadds Ford. An automobile accident at a railroad crossing ended his life shortly before his sixty-third birthday. He was survived by five children, three of whom became noted artists in their own right, including his youngest son, Andrew Wyeth, who is today one of America's best-known painters. A grandson, James, seems destined to keep the Wyeth name in the forefront of American artists for a third generation.

In retrospect, the list of Wyeth's accomplishments seems staggering: over 3,000 book and magazine illustrations, an impressive number of murals, as well as still life and landscape paintings. His illustrations for such books as *Treasure Island, Robinson Crusoe,* and *The Last of the Mohicans* are today considered classics.

Two paintings of western subjects by Wyeth are included in the InterNorth collection. *Indian Attack (An Indian War Party)* was featured as a color illustration in Parkman's *The Oregon Trail* published in Boston by Little, Brown and Company in 1925.

85. N. C. WYETH

Indian Attack (An Indian War Party)
Oil on canvas
38 x 27½ in. (96.5 x 70 cm.)
Signed l.r.: N. C. Wyeth
The InterNorth Art Foundation/Joslyn Art Museum (PL 866)

Provenance:
Private collection.
M. Knoedler & Co., Inc., New York.
Northern Natural Gas Co., Omaha, Nebraska.

Literature:
Parkman, *The Oregon Trail*, 1925; *The Art Quarterly,* April 1926, Vol. IV, no. 4; The Wilmington Society, *Paintings by N. C. Wyeth*, 1930, no. 46; Allen and Allen, *N. C. Wyeth, The Collected Paintings, Illustrations and Murals*, 1972; Taylor, *The Warriors of the Plains*, 1975, p. 59.

86. N. C. WYETH

Western Characters
Oil on canvas
34 x 38 in. (86.4 x 96.5 cm.)
Signed l.r.: N. C. Wyeth
The InterNorth Art Foundation/Joslyn Art Museum (PL 867)

Provenance:
Private collection.
M. Knoedler & Co., Inc., New York.
Northern Natural Gas Co., Omaha, Nebraska.

Literature:
Hearst's International Magazine, June 1923, p. 52; Joslyn, *Artists of the Western Frontier*, 1976, p. 27.

MAHONRI YOUNG, 1877-1957. A grandson of Mormon leader Brigham Young, Mahonri Young was born at Salt Lake City, Utah in 1877, the year of his famous grandfather's death. When his father died in 1891, Mahonri dropped out of school to help support his mother and brothers. Having as a child developed an interest in drawing and modeling, he eventually found employment as a staff artist with the *Salt Lake Tribune* where he learned the technical aspects of commercial illustration and engraving. Saving money toward future studies, he was able to pay his way to New York City in 1899, enrolling for a time at the Art Students League. From 1901 through 1905 he was in Europe, chiefly Paris, attending classes at various academies and making frequent excursions to the Louvre.

Never an abstract expressionist in theory or practice, Young became well acquainted with several such artists who, like himself, had gone abroad for study. Nevertheless, his associations at this time and the trends of the period seem to have had little influence upon the artist from Utah. His first notable productions were based upon studies of workmen, supposedly inspired by the earlier works of Millet. With these he enjoyed a modest acceptance, exhibiting and receiving prizes at the Paris Salon. Selling enough of his work to meet expenses, Young took time out from his studies for a trip home in 1903 and afterward visited England and Italy. He returned again to New York City where he taught briefly at the American School of Sculpture. Thereafter he pursued his career with increasing success in the United States.

Young won several honors over the next ten years including an award from the Utah Art Institute in 1906 and the Helen Foster Bennett Prize from the National Academy of Design in 1911. He was elected an Associate Member of the Academy the following year. In 1913 he took an active part in organizing the Armory Show in New York City, but remained largely unaffected by this second exposure to modernist, abstract art. His first important public commission, and still one of his best known, was the Sea Gull Monument at Salt Lake City. Completed in 1913, it represented a turning point in Young's career, as he later recalled. Located in Temple Square, the monument commemorates the deliverance of Mormon settlers in the Salt Lake Valley from a grasshopper plague by flocks of sea gulls in 1848.

Young accepted other commissions over the next several years, continuing as well to produce paintings, etchings, and sculptures based on his studies of construction workers, prize fighters, and the life of the city streets. Beginning in 1912 he made the first of several trips into the Southwest for the American Museum of Natural History to research material for the preparation of habitat groups relating to the Indian cultures of that area. He also executed a number of sculpture commissions for Fox Studios in Hollywood, California in the early 1920s.

Throughout this period, he maintained a studio in New York City on 59th Street close to the Art Students League where he taught intermittently from 1916 to 1943. The studio was also within walking distance of the Century Club; Young remained an active member of the Club for over forty years. Such associations apparently meant a great deal to him, especially following the death of his first wife.

Young was elected to full membership in the National Academy in 1923. This same year he returned briefly to Paris in connection with a commission to design a proposed monument to the Dean for the American Pro-Cathedral in Washington, D.C. In 1925 he again visited Paris, this time with his children, remaining abroad for approximately two and a half years and renewed old acquaintances with Leo Stein, Alfred Mauer, and sculptor Paul Manship, perhaps his closest friend of the period. In 1931 Young married his second wife, Dorothy Weir, daughter of artist J. Alden Weir. The Youngs later established a home at Branchville, Connecticut while continuing to maintain a New York apartment in Gramercy Park.

A commission in 1939 to create another memorial to Utah's Mormon pioneers entailed subsequent trips back to Salt Lake City. Young's sixteen-foot sculpture group entitled *This is the Place* was installed at the entrance to Emigration Canyon near the Great Salt Lake in 1947. His last public commission was a marble statue of Brigham Young for the Rotunda of the Capitol Building in Washington. From this last effort, produced at the American Academy in Rome, he returned home once again to resume his accustomed Gramercy Park-Century Club life. He died at Norwalk, Connecticut in 1957, ten years after the death of his second wife.

Young exhibited widely during his lifetime and is represented today by works in a variety of media in more than fifty museum collections in the United States and Europe. A retrospective exhibition was held at the Addison Gallery of American Art in 1940. Another was held at Brigham Young University in 1965. One of the principal inventories of his collected works remains in the Brigham Young University Art Collection at Provo, Utah.

Two of Young's sculptures are included in the Inter-North collection at the Joslyn. Representing western subjects, both are from the ex-collection of Mrs. A. J. Davis of Butte, Montana.

87. MAHONRI YOUNG
A Texas Longhorn
Bronze casting
8¾ in. (22.3 cm.)
Incised u.l.: Mahonri
The InterNorth Art Foundation/Joslyn Art Museum (PL 868)

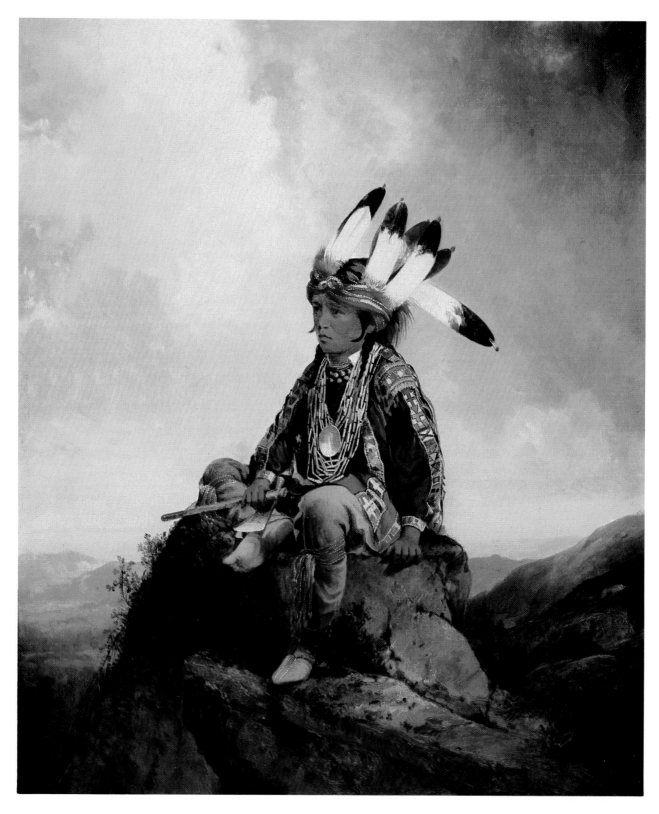

76. JOHN MIX STANLEY, *Young Chief Uncas*

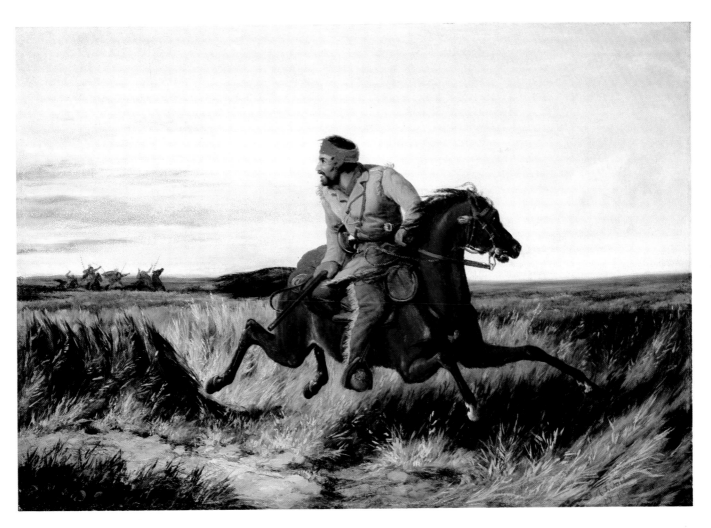

80. ARTHUR FITZWILLIAM TAIT, *The Prairie Hunter, "One Rubbed Out"*

Provenance:
Mrs. A. J. Davis, Butte, Montana.
M. Knoedler & Co., Inc., New York.
Northern Natural Gas Co., Omaha, Nebraska.

88. MAHONRI YOUNG
Rolling His Own
Bronze casting
13¼ in. (33.7 cm.)
Incised u.r.: Mahonri
The InterNorth Art Foundation/Joslyn Art Museum (PL 869)

Provenance:
Mrs. A. J. Davis, Butte, Montana.
M. Knoedler & Co., Inc., New York.
Northern Natural Gas Co., Omaha, Nebraska.

Literature:
Art in America, "Mormon Art and Architecture," May-June
1970, p. 69.

UNKNOWN ARTIST (American school)

89. UNKNOWN (American school)
Wood Block for Pony Express Poster 1860-61
Printing block
26¾ x 40 in. (67.9 x 101.5 cm.)
The InterNorth Art Foundation/Joslyn Art Museum (PL 870)

Provenance:
M. Knoedler & Co., Inc., New York.
Northern Natural Gas Co., Omaha, Nebraska.

UNKNOWN ARTIST (American school)

90. UNKNOWN (American school)
View of St. Louis
Watercolor
11 x 14¾ in. (28 x 37.5 cm.)
The InterNorth Art Foundation/Joslyn Art Museum (PL 871)

Provenance:
M. Knoedler & Co., Inc., New York.
Northern Natural Gas Co., Omaha, Nebraska.

ACKNOWLEDGMENTS

This is the first major publication from the newly established Center for Western Studies at the Joslyn Art Museum and as such, many individuals must be warmly acknowledged.

I would like to thank W. A. Strauss, Chairman of the Board of InterNorth, Inc., and Sam F. Segnar, President and Chief Executive Officer, for their support in the work of the Center. Working closely with James J. Finnegan, Executive Director of The InterNorth Art Foundation, and Dorothy McCormick, Assistant to the Director, has been rewarding and productive.

The Center's Advisor, Pulitzer prize-winning historian William H. Goetzmann, must be acknowledged for having suggested the interdisciplinary scope of the Center, making it the first of its kind to be established in an art museum in North America. His illuminating essay, "The West as Romantic Horizon," offers a new interpretation of Western art. Joseph C. Porter, Curator of Western American History and Ethnology, contributed the essay "The Romantic Horizon in History and Ethnology." David C. Hunt, Curator of Western American Art, has undertaken the arduous task of writing the artists' biographies, some of whom are familiar while others are little known. He also coordinated the selection of works represented in this publication which offers an interesting sampling from the three InterNorth art collections. Marsha V. Gallagher, Curator of Material Culture, offered valuable suggestions on the text.

The curators were greatly assisted by Jeanette Bauer and Suzanne Wise who researched the catalogue entries, in addition to being instrumental in the formative stages of the Center. Administrative Assistant Jan Trumm organized our conservation priorities, maintained valuable deadlines, and typed the entire text of this book, and deserves our warmest thanks. Theodore W. James, Associate Director of Art, proofread the complete manuscript as did Audrey S. Gryder, Assistant to the Director. My appreciation is also extended to Lorran Meares for his excellent photographic work, and Julie and Lou Toffaletti of Montgomery, Alabama who designed the book.

Henry Flood Robert, Jr.
Director
Joslyn Art Museum

INDEX OF ARTISTS

The Collection of
The InterNorth Art Foundation